ANTON HENNING

KERBER

Museum für Moderne Kunst, Frankfurt am Main Museum Haus Esters, Krefeld MARTa Herford

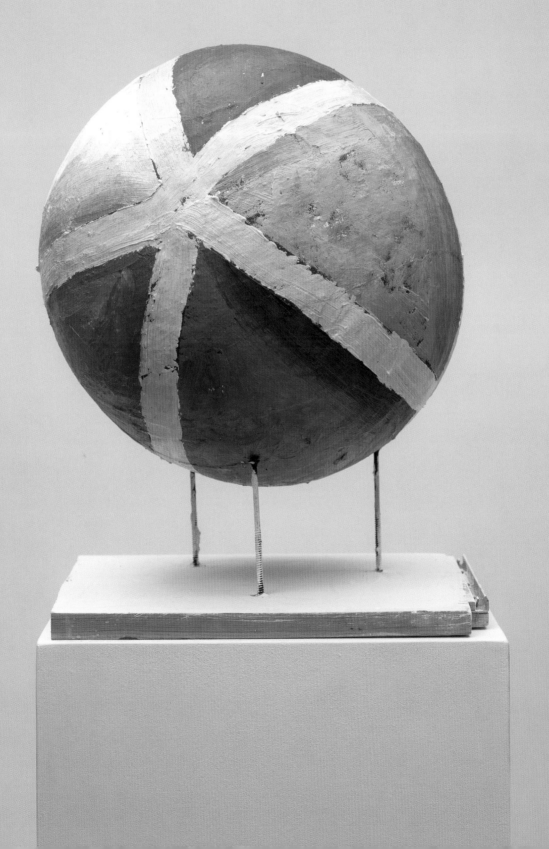

Museum für Moderne Kunst, Frankfurt am Main Museum Haus Esters, Krefeld MARTa Herford

ANTON

Herausgegeben von Edited by Martin Hentschel, Jan Hoet und and Udo Kittelmann

HENNING

Frankfurter Salon

31 Apotheotische Antiphrasen für Haus Esters

Oktogon für Herford

Foreword

Vorwort

Die vorliegende Publikation widmet sich drei ortsbezogenen Installationen von Anton Henning, die dieser allesamt 2005 an drei exponierten Orten der Kunst ausgeführt hat: dem Frankfurter Salon in dem von Hans Hollein erbauten Museum für Moderne Kunst (MMK) in Frankfurt am Main, dem Oktogon für Herford in dem von Frank Gehry erbauten, erst kürzlich eröffneten MARTa in Herford und den 31 Apotheotischen Antiphrasen für Haus Esters in der von Mies van der Rohe erschaffenen Villa Esters in Krefeld. Da in diesen Installationen zum Teil auch Werke aus früheren Schaffensphasen integriert sind, greift der Fokus über die aktuelle Produktion hinaus und zieht dergestalt ein erstes größeres Resümee über Hennings künstlerisches Schaffen im ganzen.

Die Kunst Anton Hennings besticht und verführt, aber sie verstört auch und zwingt den Betrachter in eine permanente Befragung seines eigenen Seh- und Bewußtseinshorizonts. Ausgehend von einer Malerei, die gleichermaßen in die Geschichte der Kunst wie in die Klischees der Alltagswahrnehmung ausholt, entwickelt Henning komplette Interieurs aus eigens gebauten Möbeln und Wanddekorationen, denen sich auch Skulpturen zugesellen, die wiederum den Status der Malerei hinterfragen. Zwischen den einzelnen Kunstgattungen spinnt sich ein verzweigtes und komplexes Geflecht gegenseitiger Bezugnahmen, die meist erst auf den zweiten Blick ihre Doppelbödigkeit und Abgründigkeit offenbaren. Was im ersten Eindruck als gepflegte, hochstilisierte Lounge anmutet, entpuppt sich näher besehen als furioses Crossover von kunst- und zeitgeschichtlichen Elementen, die mit Verve gegen den Strich gebürstet werden. Hennings Interventionen, ob sie sich wie in Herford als Raum im Raum oder wie in Krefeld und Frankfurt in unmittelbarer Auseinandersetzung mit architektonischen Elementen artikulieren, rollen die Thematik des White Cube erneut auf und bewegen sich auf Augenhöhe mit der Moderne wie der Postmoderne. Und indem der Künstler einerseits Rahmen und Sockel hervorhebt und andererseits Bilder und skulpturale Elemente in die von ihm geschaffenen Räume entgrenzt, stellt er die traditionelle Kategorienbildung auf eine Zerreißprobe.

The present publication is devoted to three site-specific installations by Anton Henning, all of which were presented in 2005 at high profile venues: his Frankfurter Salon at the Museum für Moderne Kunst (MMK) built by Hans Hollein in Frankfurt am Main, the Oktogon für Herford in the newly opened Frank Gehry building, MARTa in Herford, and the 31 Apotheotische Antiphrasen für Haus Esters in Mies van der Rohe's Villa Esters in Krefeld. And since these installations also partly include works from Henning's earlier periods, their focus extends beyond his current work to constitute the first larger résumé of the artist's overall production.

Anton Henning's art captivates and seduces, but at the same time it is unsettling and compels the beholder time and again to question his or her own visual and mental horizons. Starting out with an approach to painting that delves into both the history of art and the everyday clichés of how we see the world, Henning has developed complete interiors from purpose-built furniture and wall decorations, together with sculptures that question the status of the paintings. Henning links the various art genres by interweaving them in a fine and intricate web of mutual references, whose cryptic and sly humor is often only revealed on second glace. What initially appears to be an elegant, stylish lounge turns out on closer inspection to be an effervescent crossover of art elements and aspects of contemporary history that all goes gloriously against the grain. Henning's interventions – whether articulated as in Herford in the form of a space within a space, or as in Krefeld and Frankfurt in a direct confrontation with given architectural elements – reexamine the issue of the White Cube and treat both Modernism and Postmodernism as peers. And by emphasizing the frame and the pedestal while simultaneously breaking the bounds of the paintings and sculptural elements in his spaces, he puts the traditional ways we categorize art to the test.

Das geschieht auf andere Weise in der thematischen Konzeption seiner Malerei. Was „Interieur" heißt, kann durchaus Landschaft oder aber abstrakte Malerei sein, was „Blumenstilleben" heißt, kann Aktdarstellung oder Porträt sein, usf. Unter diesem Horizont vereint der Künstler mühelos Motive, die von Tizian bis Picabia, von Matisse bis zum Pin-up, von der Pleinairmalerei bis zur Freikörperkultur reichen. Gelassen und ohne Skrupel setzt er sich ebenso über den Kitschverdacht wie über den Vorwurf der Appropriation hinweg, wobei er auch sein eigenes Œuvre als Steinbruch behandelt. Was an einer Stelle als Tischdekor wahrgenommen wurde, kann an anderer Stelle autonomes Bild sein, was autonomes Bild war, kann anderweitig in eine bildhafte Skulptur einfließen. So gesehen befindet sich sein Werk in ständiger Metamorphose. Henning konterkariert die Anmutung von Behaglichkeit, mit der sich der Besucher in seinen Räumen einzurichten sucht, er unterzieht diesen einer *Tour d'horizon*, die alles Vorgewußte auf die Probe stellt. Es ist insbesondere diese Spannung zwischen Affirmation und Destruktion, mit der seine Kunst gleichzeitig betört und irritiert – eine Position, die Anton Henning zum herausragenden Protagonisten einer Künstlergeneration macht, die konzeptuell ausgerichtet ist und im selben Maße einer elaborierten Praxis Genüge tut.

This also occurs in a somewhat different manner on the conceptual level of his paintings. A work referred to as an "interior" may clearly be a landscape or even an abstract, while a "flower piece" may be a nude or a portrait, and so on. This perspective allows the artist to effortlessly combine a range of motifs that stretches from Titian to Picabia, from Matisse to the pin-up, or from plein-air painting to nudism. With an unruffled lack of scruples, he casts every suspicion of kitsch to the wind, just as he does with accusations of appropriation, while treating his own œuvre as a personal quarry to be mined for his work. What may be perceived at one place as a table decoration can turn up elsewhere as an autonomous painting, and what once was an autonomous painting may transform into a graphic sculpture in another location. As such, his work undergoes constant metamorphosis. Henning thwarts every feeling of coziness that the visitors seek to find to his spaces, exposing them to a *tour d'horizon* that turns a critical light on our preconceptions. It is particularly this tension between affirmation and destruction that makes his work simultaneously captivating and vexing – a position that has established Anton Henning as one of the leading exponents of a generation of artists that is not only at home with conceptualism, but also satisfies the expectations of an elaborated artistic practice.

Wir danken dem Künstler für sein großes Engagement bei der Einrichtung seiner Installationen und Räume und bei der Vorbereitung dieser Publikation, die etwa zehn Jahre seines künstlerischen Schaffens dokumentiert. Der FRANKFURTER SALON wurde überdies von *Dornbracht Installation Projects®* großzügig gefördert, wofür sich das Museum für Moderne Kunst, Frankfurt, ausdrücklich bedankt. Die Ausstellungen im MARTa Herford und im Museum Haus Esters, Krefeld, sowie das Katalogbuch wurden gefördert durch die *Kunststiftung NRW*, der wir ebenfalls zu großem Dank verpflichtet sind.

We wish to thank the artist for his great commitment while setting up these installations and spaces, and during the preparation of this publication, which documents some ten years of his artistic production. The FRANKFURTER SALON was generously supported by *Dornbracht Installation Projects®*, to whom the Museum für Moderne Kunst, Frankfurt, extends its special thanks. The exhibitions in MARTa Herford and Museum Haus Esters, Krefeld, together with this catalogue received the financial support of the *Kunststiftung NRW*, to whom we also give our heartfelt thanks.

MARTIN HENTSCHEL
Kunstmuseen Krefeld

JAN HOET
MARTa Herford

UDO KITTELMANN
Museum für Moderne Kunst, Frankfurt am Main

FRANKFURTER SALON

Museum für Moderne Kunst, Frankfurt am Main

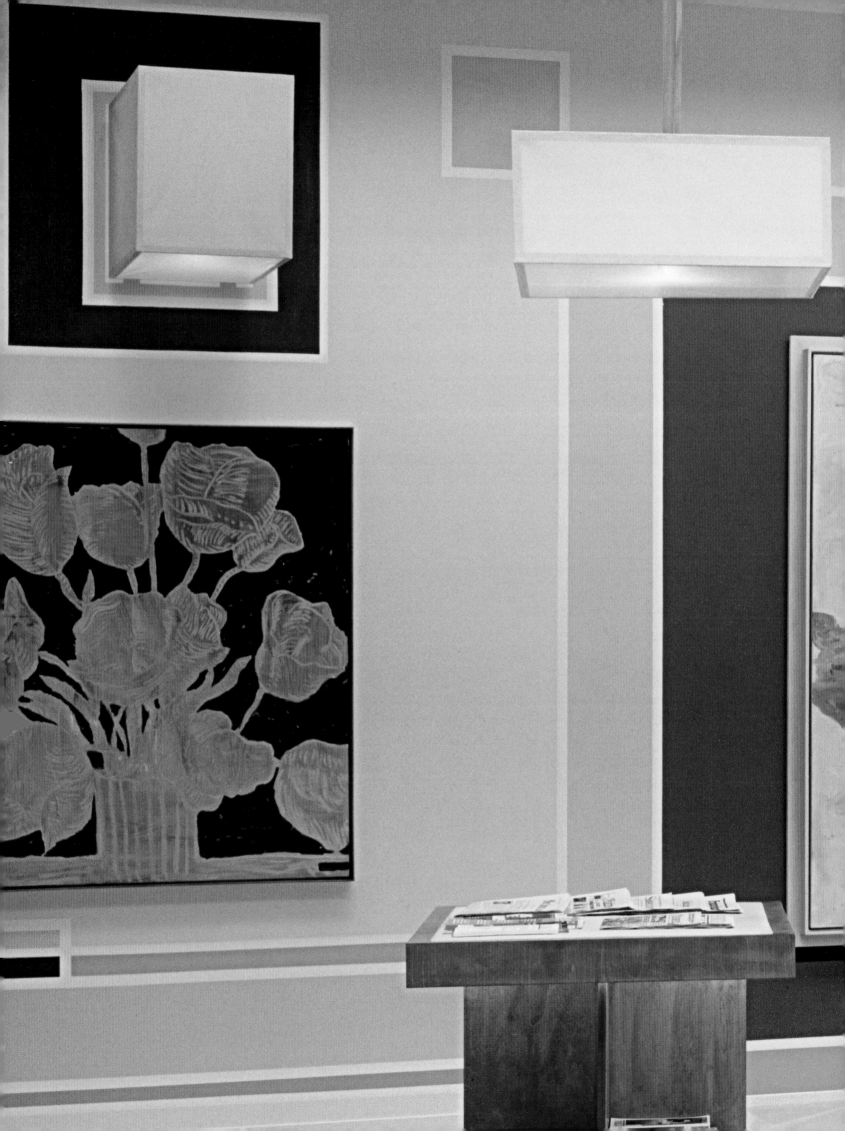

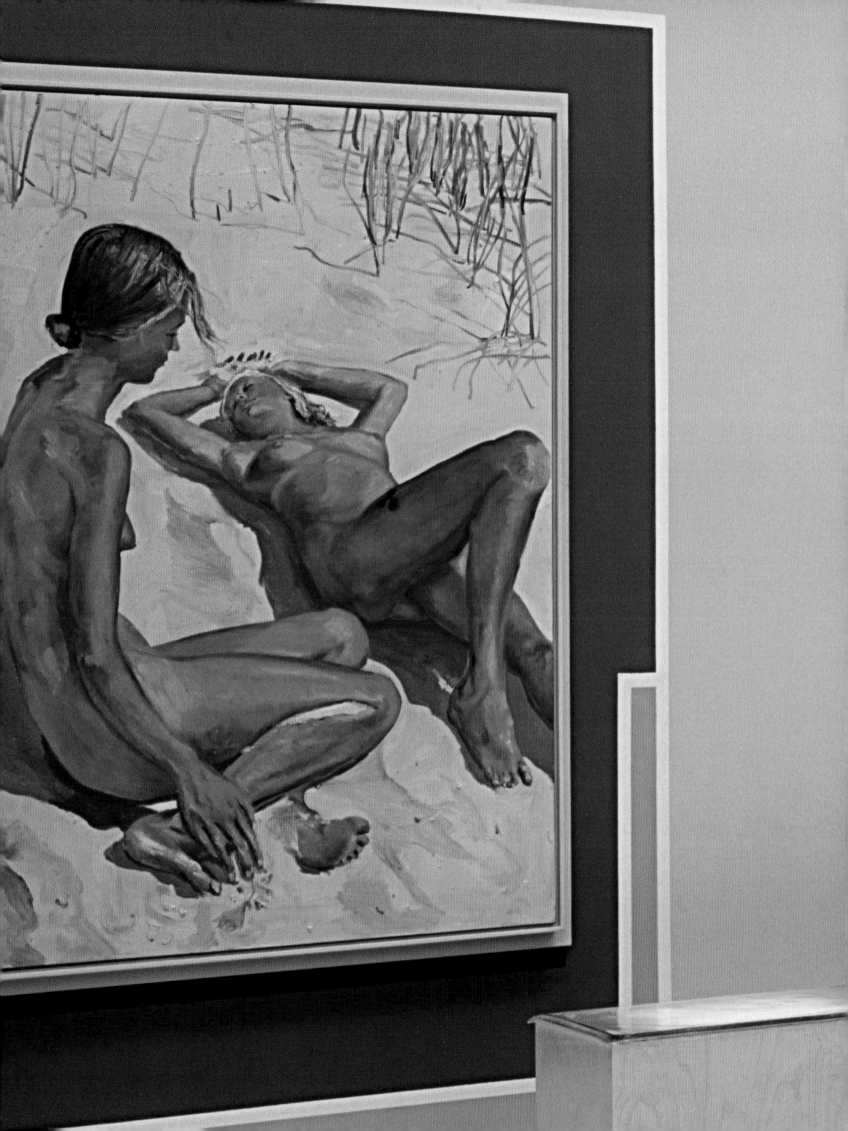

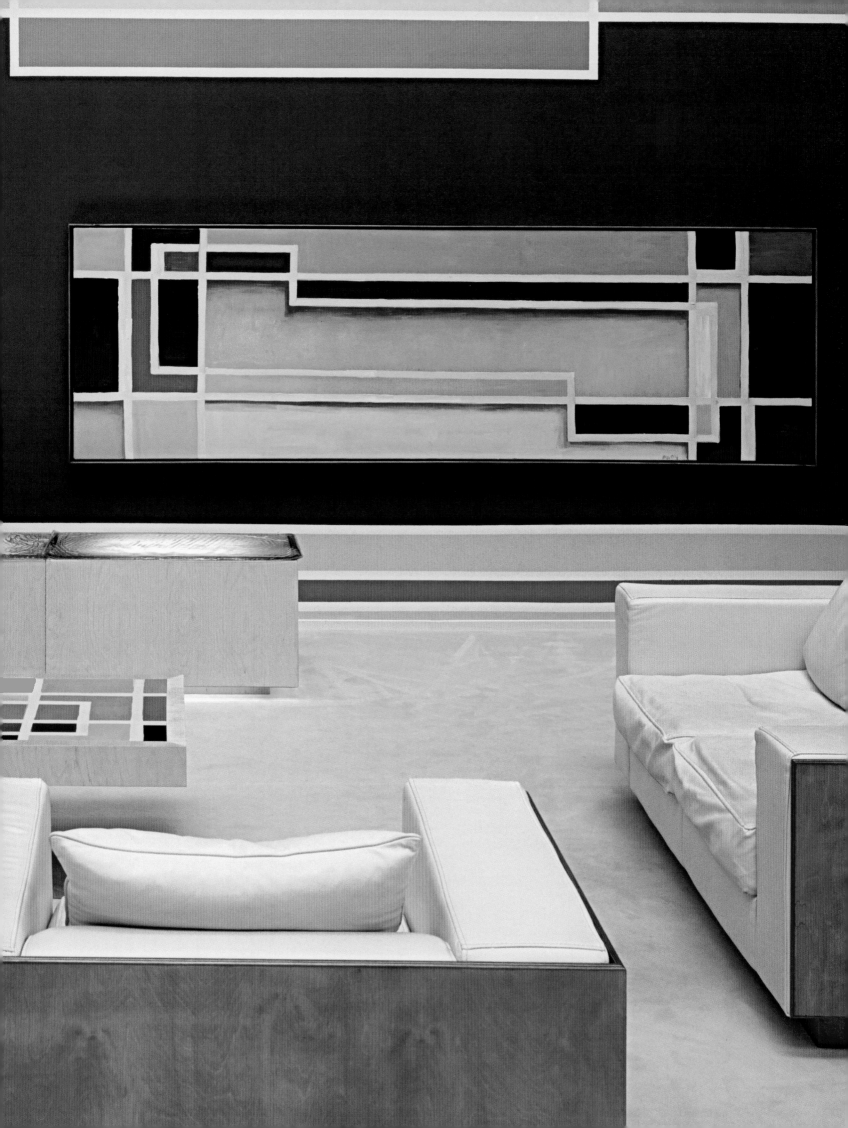

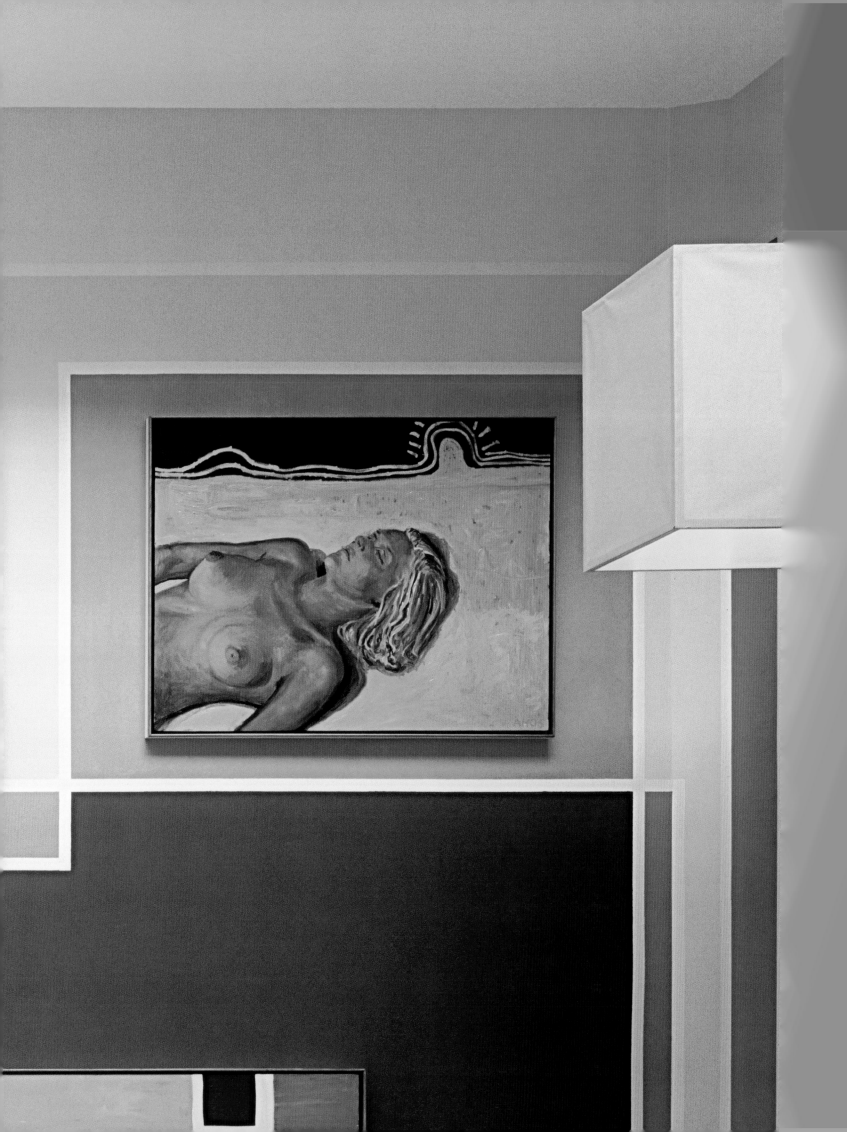

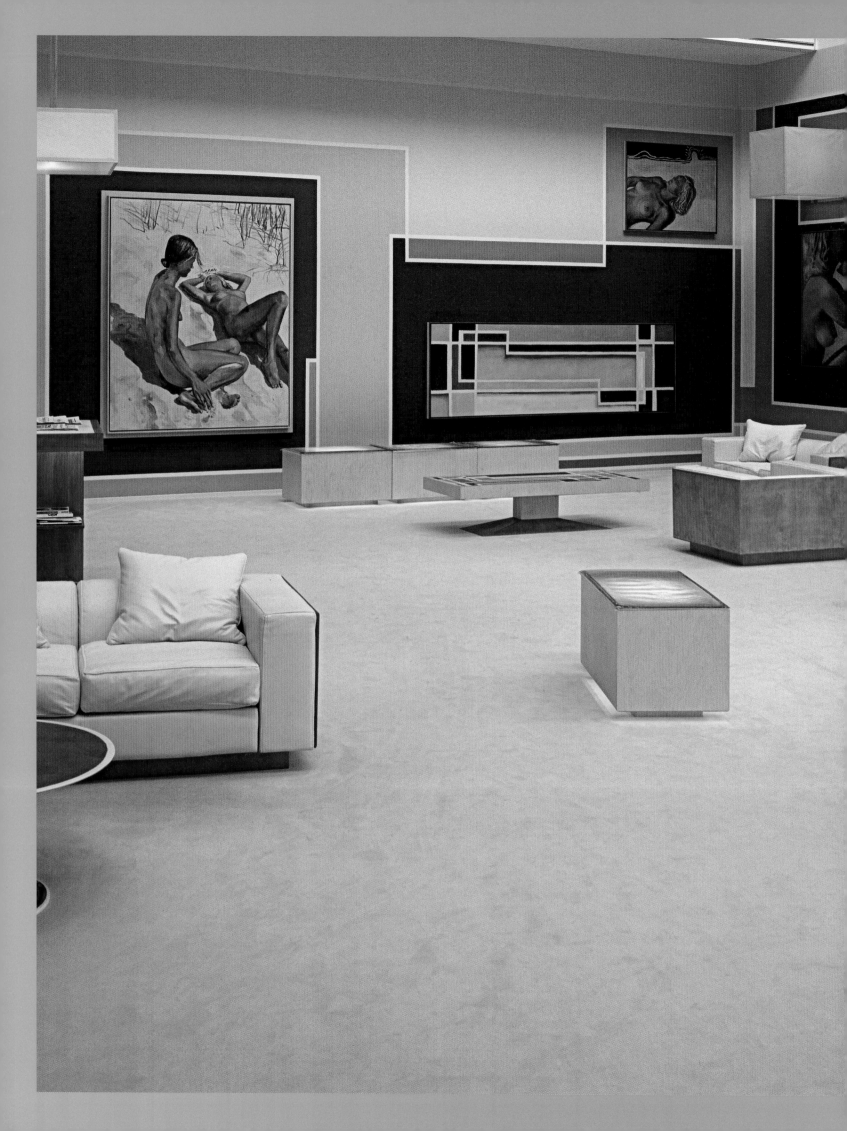

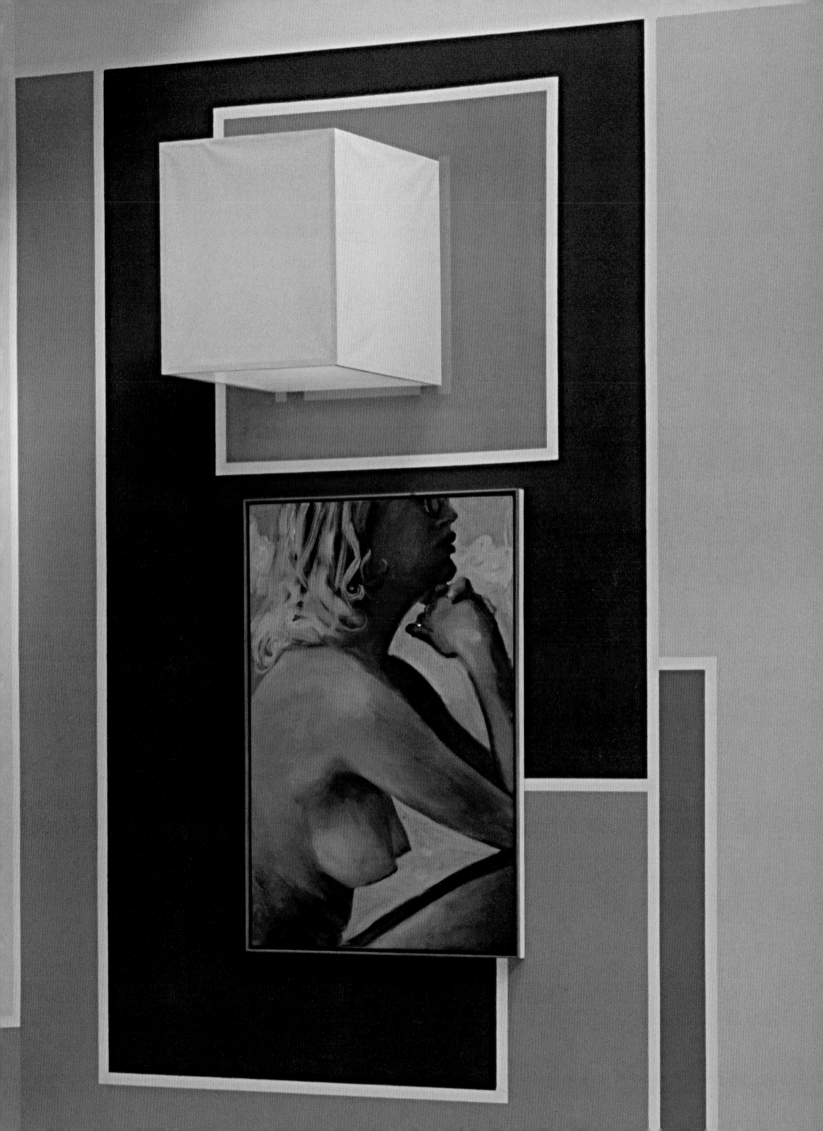

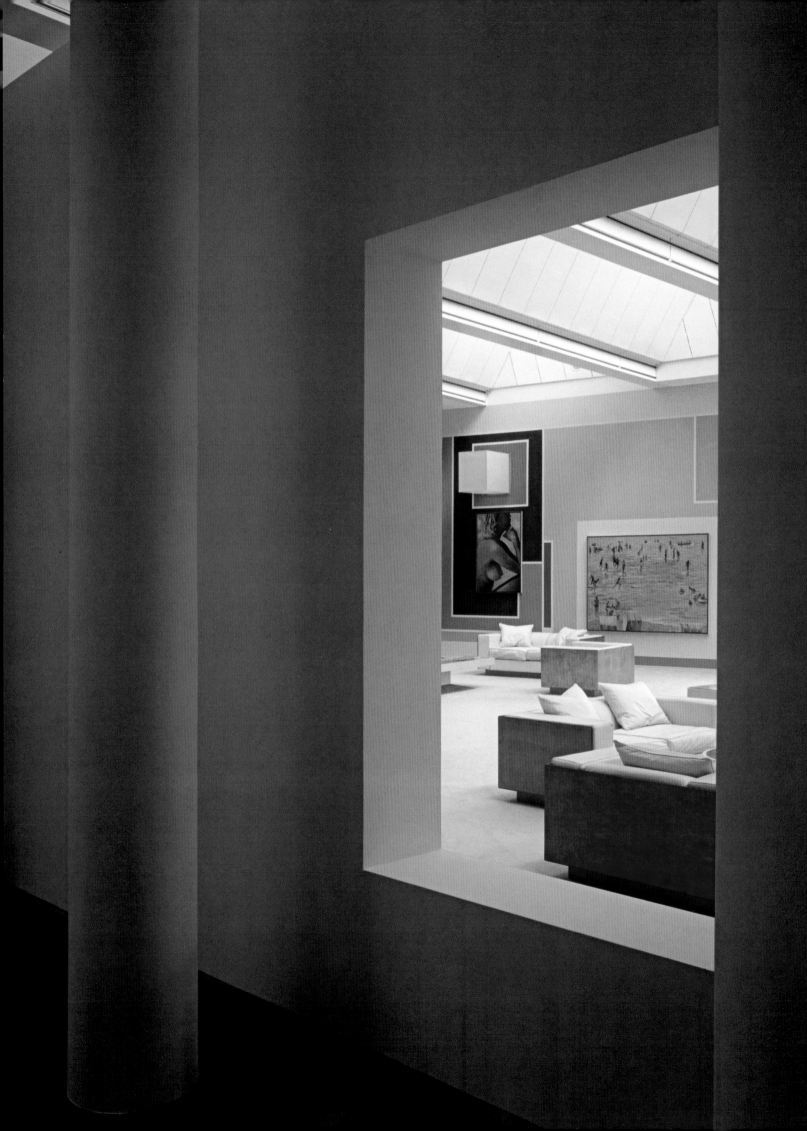

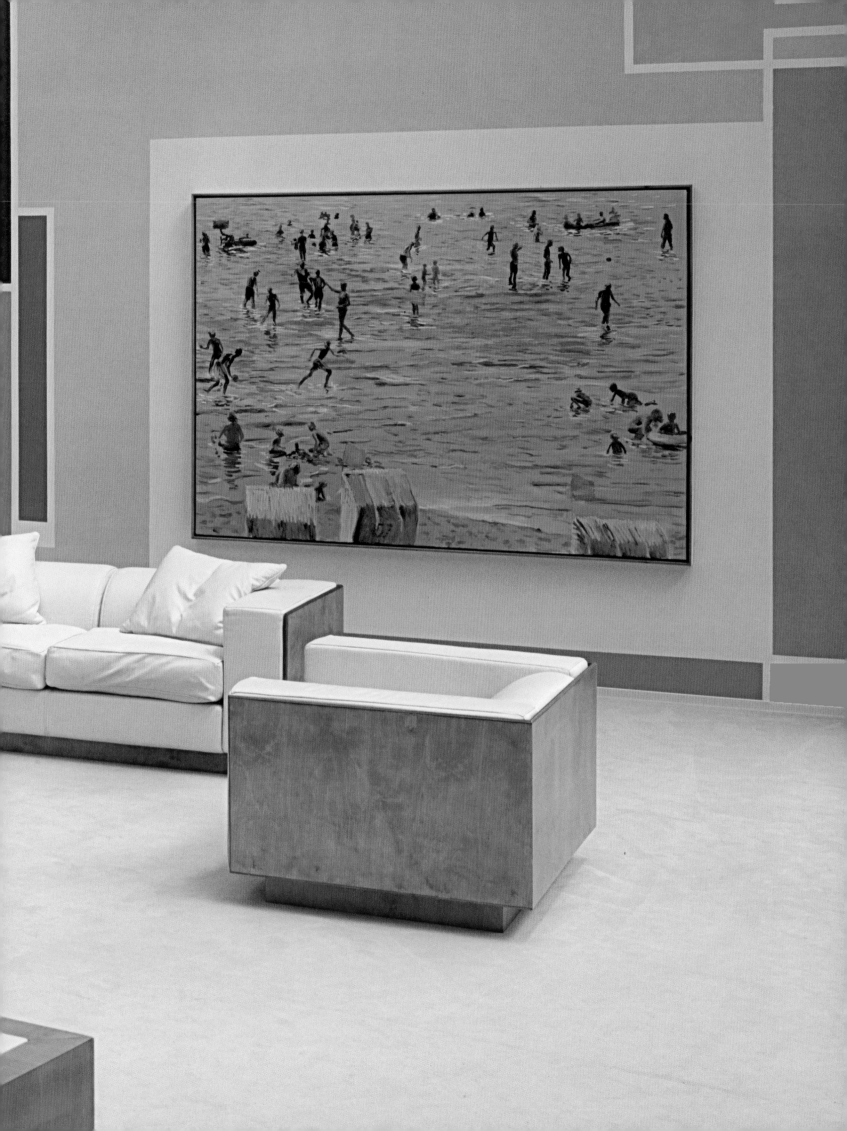

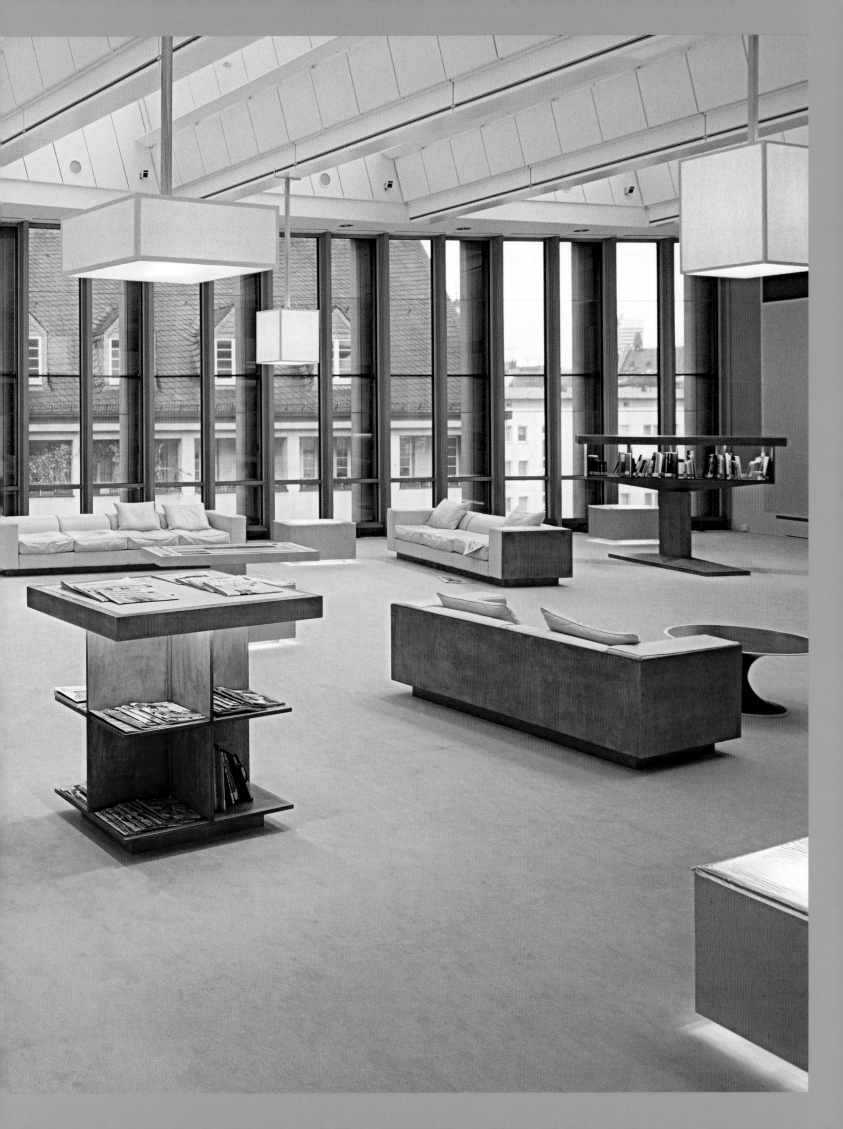

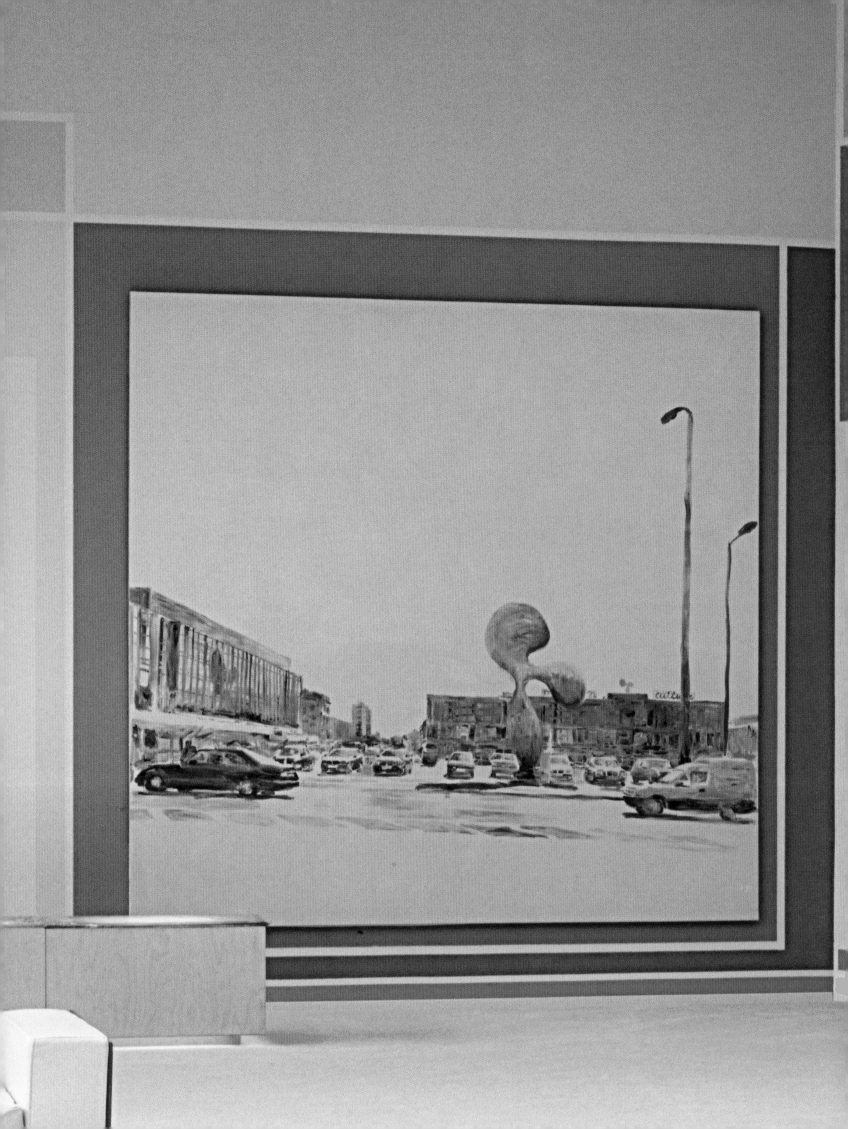

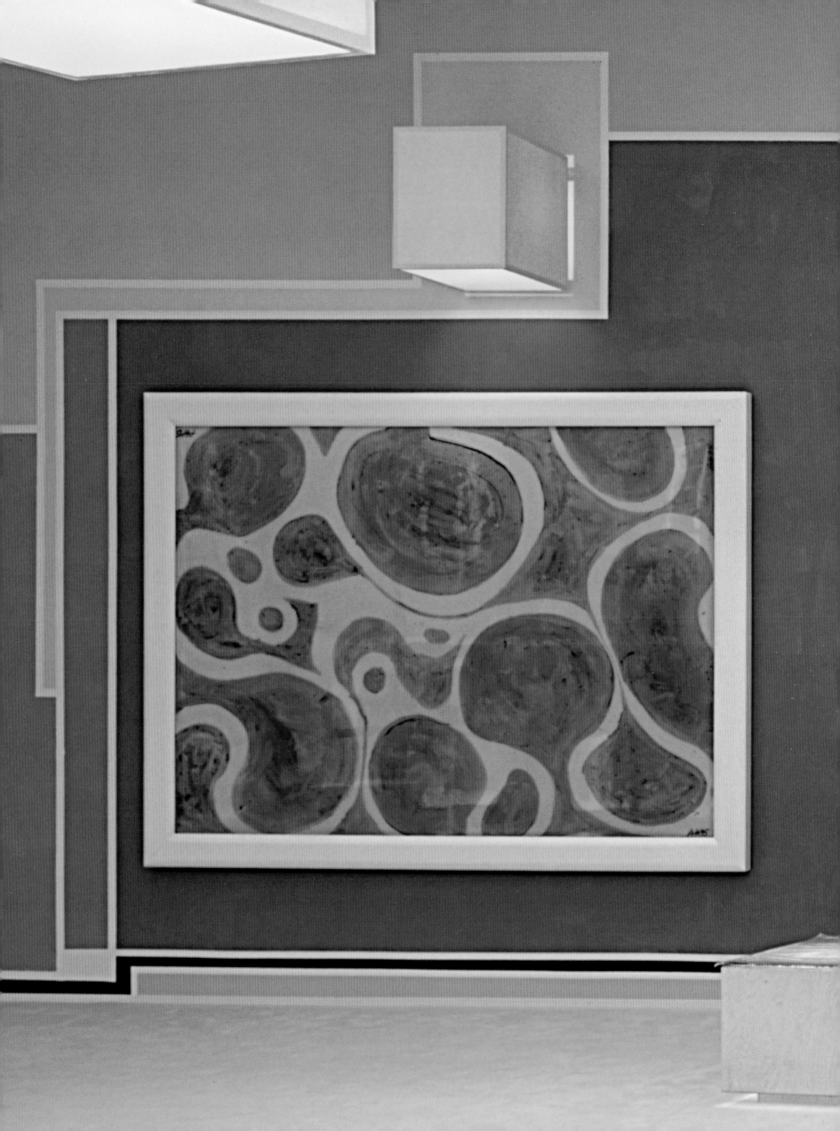

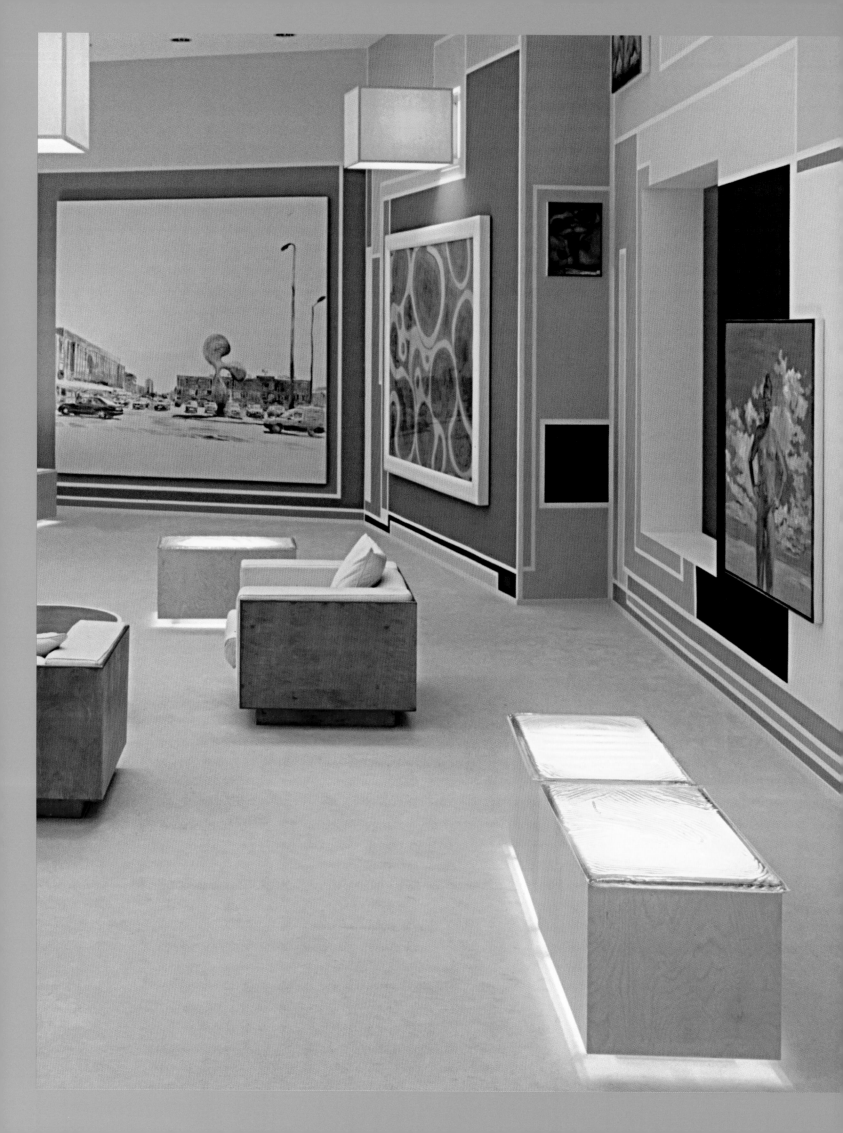

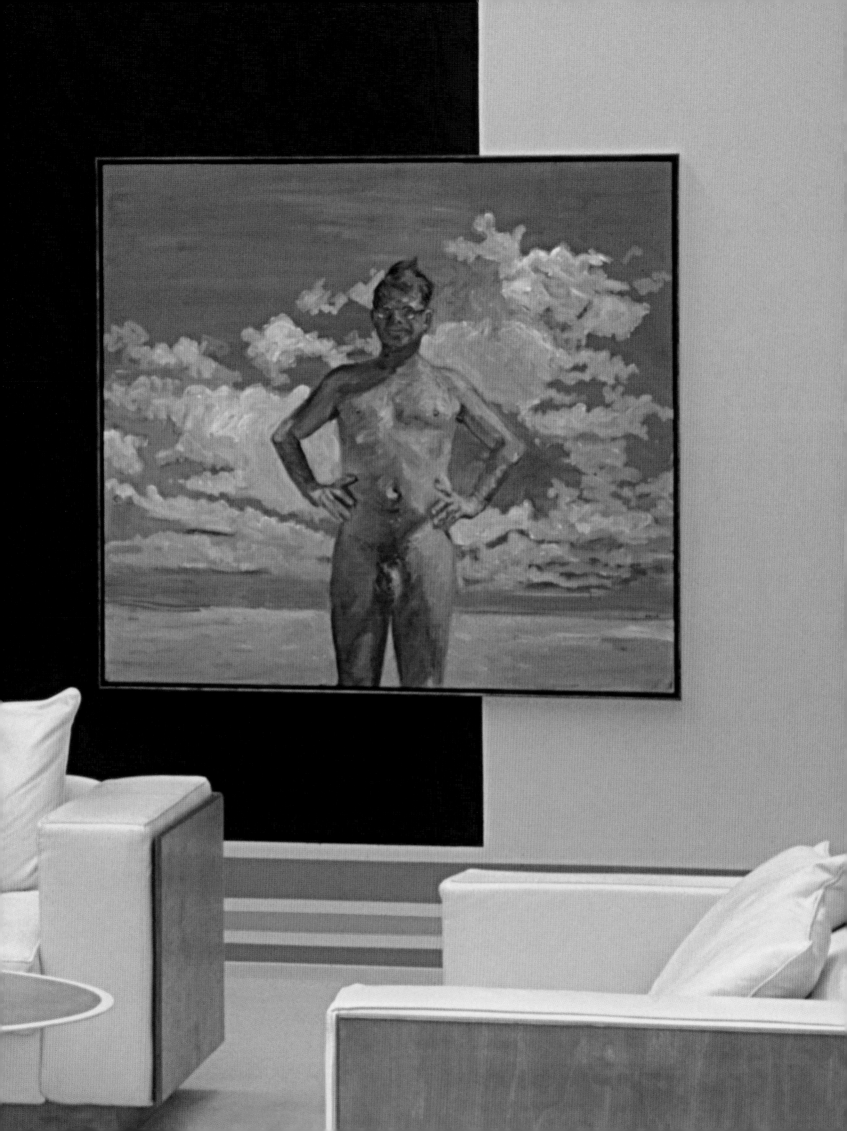

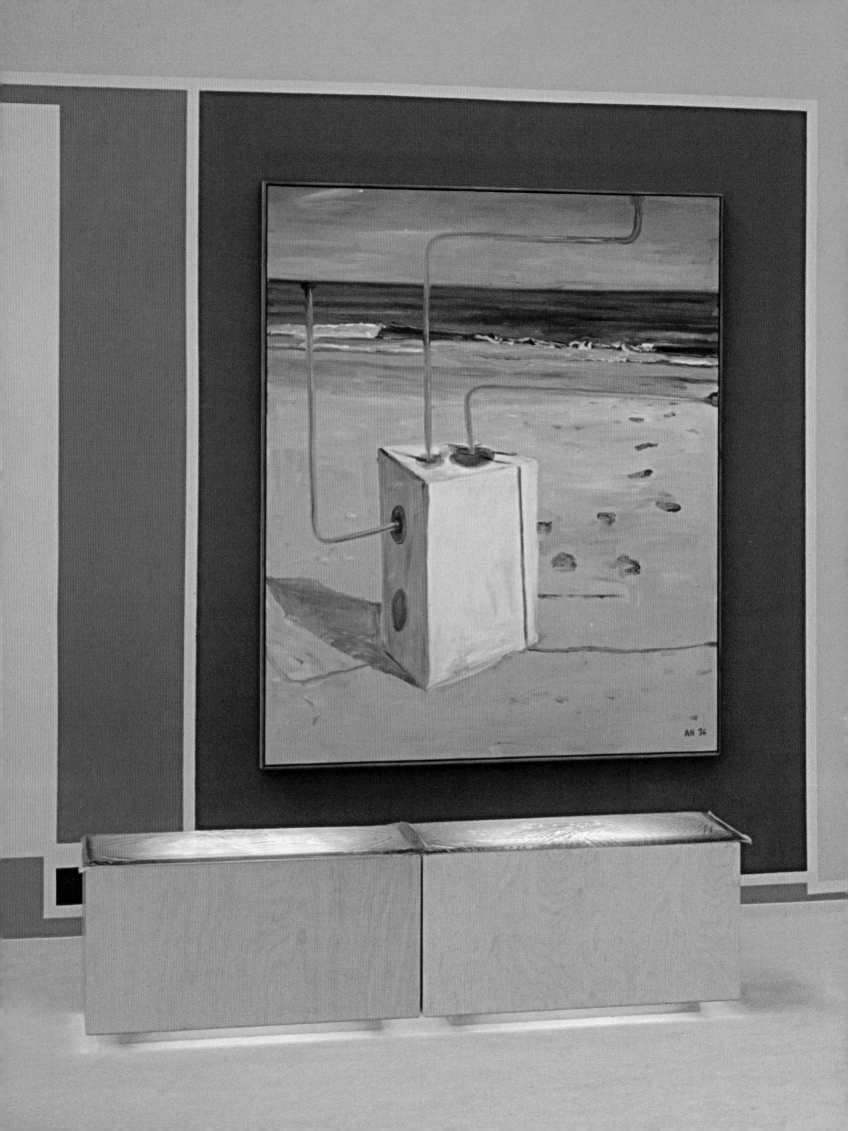

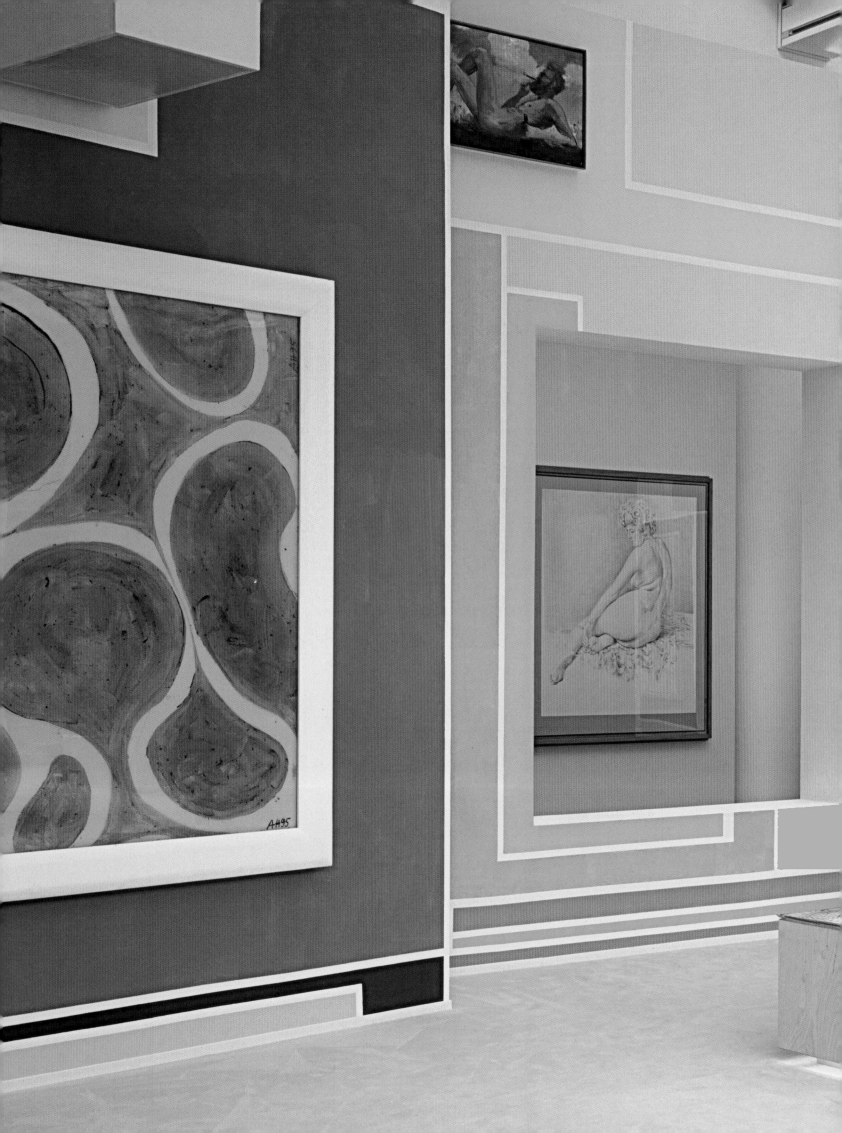

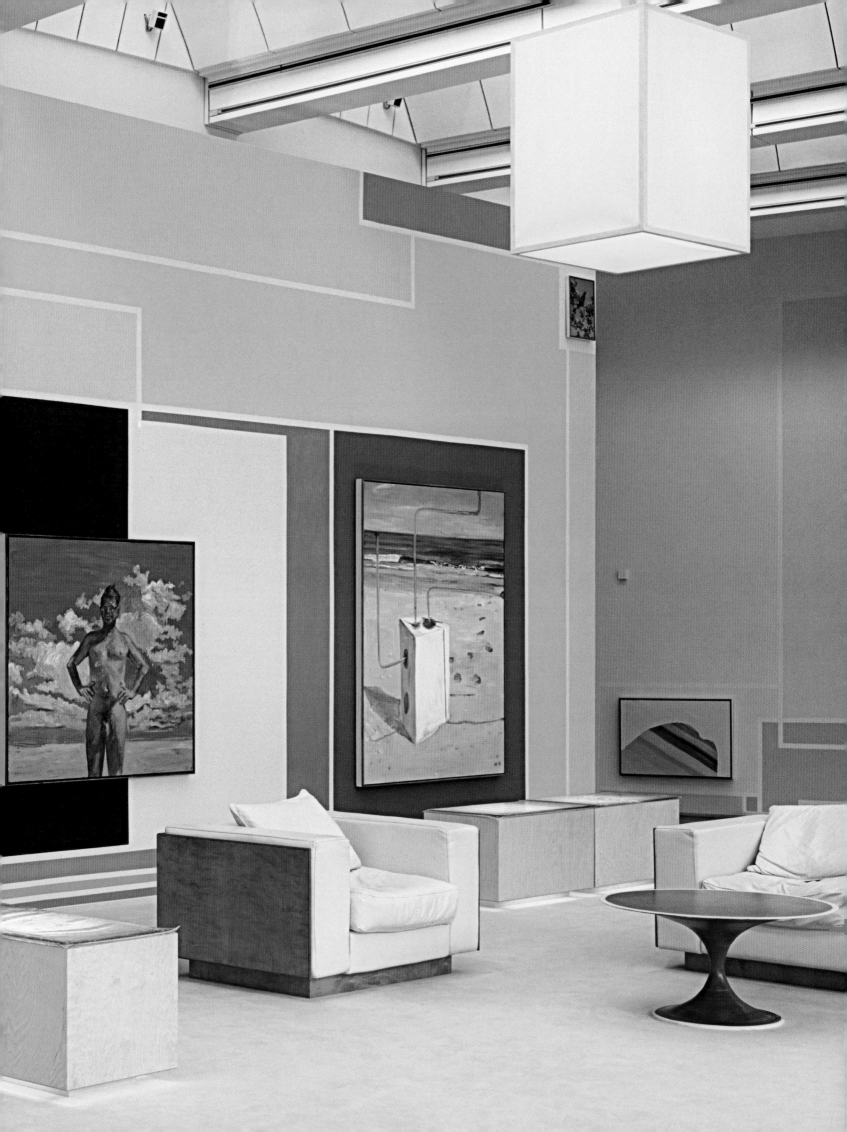

MARTIN HENTSCHEL

IN MANKER
AND THE
WORLD : ANTON
HENNING
AND HIS ART

IN MANKER
UND IN
DER WELT:
DIE KUNST
ANTON
HENNINGS

Anything goes?

At a time when Neo-liberalism has deconstructed and absorbed all other ideologies in the Western world, there is a danger of fundamentally misunderstanding Anton Henning's painting. Against that, the artist does more than a little to propagate such misunderstandings. He appears to be slipping most precariously into the skin of that new stolid citizen who, faced with an increasingly convoluted international situation, dreams of being back in the safety of his own four walls. How else can one accept, or – what's more – paint motifs with titles like *Still Life with Flowers*, *Sunset* and *Evening Song*?

Only once we have grasped that these paintings are parts of a far broader artistic concept can a clearer light be shed on the Henning phenomenon. For this we should recall that the major art movements of the 1960s went to any lengths to shatter the belief in progress that inhered to the historical avant-gardes. "The avant-garde", as Umberto Eco notes, "destroys and distorts the past: Picasso's DEMOISELLES D'AVIGNON are typical of the avant-garde's opening gestures; then the avant-garde goes a step further and destroys the figure, annuls it, arrives at abstraction,

Alles geht?

In einer Zeit, da der Neoliberalismus alle restlichen Ideologien innerhalb der westlichen Welt dekonstruiert und absorbiert hat, besteht die Gefahr, Anton Hennings Malerei gründlich mißzuverstehen. Umgekehrt tut der Künstler nicht wenig, um derlei Mißverständnissen Vorschub zu leisten. Auf geradezu prekäre Weise scheint er jenen neuen Biedermann zu bedienen, der sich angesichts der unübersichtlich gewordenen Weltlage in den Schutzraum seiner eigenen vier Wände zurückträumt. Wie sonst kann man Sujets akzeptieren – und malen, die *Blumenstilleben*, *Sonnenuntergang* und *Abendlied* heißen?

Erst wenn wir derartige Bilder als Bestandteile eines weitergehenden künstlerischen Konzepts begreifen, wird das Phänomen Henning transparenter. Vergegenwärtigen wir uns, daß die wesentlichen Kunstströmungen der 1960er Jahre alles Erdenkliche getan haben, um mit dem Fortschrittsdenken, das den historischen Avantgarden immanent war, aufzuräumen. „Die Avantgarde", so konstatiert Umberto Eco, „zerstört, entstellt die Vergangenheit: Picassos DEMOISELLES D'AVIGNON sind die typische Auftrittsgebärde der Avantgarde; dann geht die Avantgarde weiter, zerstört die Figur, annulliert sie, gelangt zum Abstrakten, zum Informellen, zur weißen Leinwand, zur zerrissenen Leinwand, zur verbrannten Leinwand ... Es kommt jedoch der Moment, an dem die Avantgarde (also die Moderne) nicht mehr weitergehen kann, weil sie inzwischen eine Metasprache hervorgebracht hat, die von ihren unmöglichen

Texten spricht ... Die postmoderne Antwort auf die Moderne besteht in der Einsicht, daß die Vergangenheit, nachdem sie nun einmal nicht zerstört werden kann, auf neue Weise ins Auge gefaßt werden muß: mit Ironie, ohne Unschuld."[1] Im Stimmengewirr der Metasprachen exponiert sich Pop Art als die stärkste und nachhaltigste Kraft. Sie macht sich jene Grenzüberschreitungen, die seinerzeit von Duchamp und Dada noch mit aufrührerischem Impetus vorgetragen wurden, auf nonchalante Weise zu eigen. Pop Art ist cool und bringt dennoch aufs neue sämtliche Parameter, welche den Kontext Kunst über Jahrzehnte begleitet haben, zu Fall.[2] Nicht nur Darstellungsformen und Themen sind davon betroffen, sondern auch die Produktionsmittel. Feierte man in den 1950er Jahren die Geste des Pinselstrichs als Ausfluß künstlerischer Subjektivität, so wird sie jetzt eingefroren und als Comicfigur auf die große Leinwand projiziert. In die Herstellung von Gemälden fließen quasi industrielle Methoden ein. Die Hochkunst wird trivialisiert, Banales zur Hochkunst stilisiert. Selbst Kitsch und Pornographie können auf dem Weg ironischer Anverwandlung in den Kanon der Künste Eingang finden, dessen Grenzen gleichzeitig in unabsehbare Ferne rücken. Aus heutiger Sicht erscheinen die grundlegenden Fragestellungen, mit denen die Concept Art in den 1970er Jahren an die Institution herantritt, wie ein letztes Aufbäumen gegenüber der durchschlagenden Nivellierung künstlerischer Wertbegriffe im Zeichen globaler Popkultur.

Alles ist möglich geworden, sofern sich nur eine Verbindung zwischen den Eskapaden des Künstlers und einem auf Spekulation erpichten Publikum knüpfen läßt. Doch bei aller Freizügigkeit und allem Tabubruch bedarf die Trias von Kunstmarkt, Kunstkritik und Museum freilich nach wie vor des Werturteils, und sei es auf ruinösen Fundamenten gebaut. Auch wenn die kollektive Amnesie gegenüber den Errungenschaften der Kunst beträchtlich ist: Um als Künstler ein anhaltendes Interesse zu erzeugen, genügt es nicht, sich bloß spektakulär zu gebärden. Das Instrumentarium zur Erzeugung öffentlicher Aufmerksamkeit muß schon eine gewisse intellektuelle Reichweite besitzen, um nachhaltige Wirkung zu zeitigen.

tachisme, the white canvas, the torn canvas, the burnt canvas ... But the moment arrives when the avant-garde (i.e. Modernism) can go no further, because in the meantime it has produced a metalanguage to talk about its impossible texts ... The post-modern answer to Modernism consists in the insight that the past – now that it suddenly can no longer be destroyed – must be contemplated in a different manner: with irony, and without innocence."[1] Pop Art stood out as the strongest and most enduring force amidst the babble of metalinguistic voices. It quite nonchalantly embraced those transgressions that Duchamp and Dada had performed in their day with seditious purpose. Pop Art was cool, yet nevertheless toppled just about every parameter that had been applied to the art context over the decades.[2] Not only have the topics and the means of representation been affected, but even the means of production. While in the 1950s the gestural brushstroke was celebrated as an outpouring of artistic subjectivity, it is now frozen and projected as a comic character onto the large canvas. Little short of industrial methods have come to be involved in the production of paintings. High art has been trivialised, and the banal stylised as high art. Even kitsch and pornography have enjoyed an ironic adaptation that has allowed them to enter the canon of the arts, whose boundaries have simultaneously disappeared into uncharted realms. Viewed from the present perspective, the fundamental questions that Concept Art posed to the institution in the 1970s seem like a last act of rebellion against the irrefutable levelling of artistic values under a global pop culture.

Anything has become possible, just as long as a connection can be created between the artist's escapades and the audience's thirst for speculation. Yet for all the liberality and taboo breaking, the triad of art market, art critic and museum continues to require value judgements, even when these are built on crumbling foundations. And regardless of the considerable collective amnesia that exists about past achievements in art: it is not enough for an artist who wishes to generate lasting interest merely to distinguish him- or herself by spectacular behaviour. The apparatus for creating public attention must also have a certain intellectual "clout" if it is to yield lasting effects.

Arabeske und Dreipaß: die Lehren von Matisse

Nicht von ungefähr finden wir Anton Hennings frühe Malereien von Objekten und Fotografien umringt, so als wollten diese uns sagen: „Das, was ihr dort gemalt

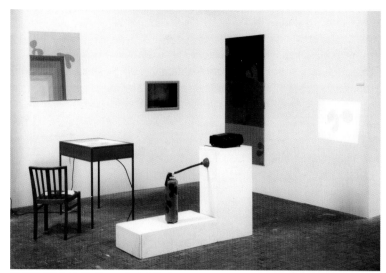

[1] MᴇʀʀY Mᴀᴛɪssᴇ Gᴏ Rᴏᴜɴᴅ (Installation), 1994

Arabesque and trefoil: the lessons of Matisse

It is no accident that Anton Henning's early paintings are encircled by objects and photographs, as if the latter wanted to say: "What you see painted there is actually something else, don't be deceived!" [1]. And conversely, the paintings themselves seem to call to us: "This is not simply some post-dada prank, just take a look – immaculate oil paintings!" In that way one ensures bemusement and straight away creates a repertoire that remains open to various sides, and avoids pigeonhole thinking. In other words: a metalanguage. Especially when Henning systematically permutates his own image as an artist in his photographic self-portraits – as a bourgeois in his Sunday best with a bow tie, as a poor painter-poet in his garret, and as bohemian with a musical touch[3] – he evokes an ironic distance that also seems to fit when we study his other works. A look at two early pieces should demonstrate as much. I am talking now of the paintings Jᴜɴɢᴇ Kᴜʜ ᴀᴜF ᴍᴏᴅᴇʀɴᴇʀ Zᴇɪᴄʜɴᴜɴɢ (= Young Cow on a Modern Drawing, 1996) and Nᴏ. 1 ᴀᴜs ᴅᴇʀ Sᴇʀɪᴇ ᴅᴇʀ ᴇʟᴇɢᴀɴᴛᴇɴ Wᴏʜɴᴢɪᴍᴍᴇʀʙɪʟᴅᴇʀ (= No. 1 from the Series of Elegant Living Room Paintings, 1998) [2, 3]. The first of the two shows a cow painted in verist style, using a palette restricted to a few modulated shades ranging from pale ochre to dark brown. The animal is set against a pink background, which for its part is covered by a sweeping graphic arabesque in red. Numerous dots set among the confusion of curves allow one to imagine any number of female breasts, so that amusingly the animal portrait is lent a soupçon of erotic charm.

Decisive here is that Henning is working with two seemingly incompatible painterly paradigms: the illusionistic presence of the cow remains unreconciled with the quasi abstract tracery of lines. It is sim-

seht, ist eigentlich etwas anderes, täuscht euch nicht!" [1]. Und umgekehrt scheint die Malerei uns zuzurufen: „Das sind nicht bloß post-dadaistische Spielereien, seht her – saubere Ölmalerei!"

So sorgt man für Irritation und schafft sich in eins ein Repertoire, das nach verschiedenen Seiten offen bleibt und sich dem Schubladendenken entzieht. Mit anderen Worten: eine Metasprache. Insbesondere, wenn Henning im fotografischen Selbstporträt sein eigenes Künstlerimage als Bourgeois mit Sonntagsanzug und Fliege, als armer Malerpoet in Spitzwegscher Verkleidung und als musikalisch angehauchter Bohemien durchdekliniert,[3] evoziert er jene Art ironischer Distanz, die auch bei der Anschauung seiner übrigen Werke angemessen erscheint. Die Betrachtung zweier früher Werke soll das erweisen. Ich rede von den Gemälden Jᴜɴɢᴇ Kᴜʜ ᴀᴜF ᴍᴏᴅᴇʀɴᴇʀ Zᴇɪᴄʜɴᴜɴɢ (1996) und Nᴏ. 1 ᴀᴜs ᴅᴇʀ Sᴇʀɪᴇ ᴅᴇʀ ᴇʟᴇɢᴀɴᴛᴇɴ Wᴏʜɴᴢɪᴍᴍᴇʀʙɪʟᴅᴇʀ (1998) [2, 3]. Das erstgenannte Bild zeigt eine veristisch gemalte Kuh, deren Farbigkeit sich auf Tonmodulationen beschränkt, welche von Hellocker bis Dunkelbraun reichen. Sie ist auf einem rosafarbenen Fond plaziert, der wiederum mit einer ausladenden zeichnerischen Arabeske in Rot bedeckt ist. Zahlreiche Punkte lassen in dem Gewirr der Kurvaturen zuweilen weibliche Brüste imaginieren. So gewinnt das Tierporträt witzigerweise einen Hauch erotischer Attraktivität.

Entscheidend ist, daß Henning mit zwei scheinbar unvereinbaren malerischen Paradigmen operiert: Die illusionistische Präsenz der Kuh steht unversöhnt gegen das quasi abstrakte Liniengeflecht. Nur die warme Tonigkeit des Tieres (vielleicht eine Anspielung auf Gerhard Richters Kᴜʜ von 1964) bewahrt davor, daß das Bild vollends in zwei Teile zerfällt. Andererseits – und hier zeigt sich Hennings intellektuelle Reichweite – paraphrasiert die zweigeteilte

Malweise genau jene Ambivalenz, die sich durch das Hauptwerk von Henri Matisse zieht: nämlich die von gegenständlich-perspektivischer und abstrakt-dekorativer Darstellungsform.[4] Doch während Matisse immer wieder zwischen den gegensätzlichen Polen zu vermitteln sucht, spitzt Henning die Gegensätzlichkeit zu.

Mit Blick auf Matisses dekoratives Universum entwickelt Henning eine Reihe seiner frühen Arbeiten. Dazu zählt auch No. 1 AUS DER SERIE DER ELEGANTEN WOHNZIMMERBILDER. Ohne weiteres können wir hier die Akanthusformen wiederentdecken, die Matisse gleichermaßen in seiner Malerei wie in seinen späten *Gouaches découpées* einsetzt. Henning weist ihnen gar die oberste und vorderste Bildschicht zu, um in den Zwischenräumen den Ausblick in eine unbestimmte Tiefe zu eröffnen – also fast eine Umkehrung des Verhältnisses von Figur und Grund im Vergleich zur ,jungen Kuh'. Der Bildtitel geizt nicht mit Anspielungen: Zum einen besagt die ausdrückliche Numerierung, daß wir es noch mit einer Vielzahl ähnlicher Produkte zu tun bekommen werden; und in der Tat haben sich inzwischen etliche Werke mit vorwiegend ornamentaler Struktur unter dem erweiterten Sammeltitel ,Interieurs' in Hennings Œuvre etabliert. Zum anderen deutet die Vokabel ,elegantes Wohnzimmerbild' erneut auf eine ironische Distanzierung des Künstlers zum eigenen Werk. In der Ironie verbirgt sich ebenso das Eingeständnis, den Standort nicht beeinflussen zu können, sobald das Gemälde den Handelsplatz Galerie verlassen hat (selbstverständlich ist auch für Henning das Museum die *ultima ratio* möglicher Standorte), wie das Eingeständnis, womöglich ohne jenen utopischen Mehrwert auskommen zu müssen, der einmal die Moderne befeuert hat. Schließlich impliziert der Titel – sozusagen in einer inneren Kehrtwende dazu – eine ziemlich

ply the warm tonality of the animal (alluding perhaps to Gerhard Richter's Cow of 1964) that saves the painting from falling into two parts. Against this – and here Henning demonstrates his intellectual trajectory – the twofold painting style paraphrases precisely the ambivalence that runs through the chief works of Henri Matisse: between representational-perspectival and abstract-decorative modes of depiction.[4] Yet whereas Matisse forever attempted to mediate between the two opposing poles, Henning brings the contrast to a head.

Henning developed a number of his early works with Matisse's decorative universe in mind. These include No. 1 AUS DER SERIE DER ELEGANTEN WOHNZIMMERBILDER. We have no difficulty whatsoever in recognising here the acanthus forms that Matisse used, both in his paintings as well as in his late *Gouaches découpées*. Henning assigns them in fact to the uppermost, foremost level of the painting in order to open up a glimpse in the interstices into an indeterminate depth – creating an almost total inversion of the figure-ground relationship found in the 'young cow'. The title is also not short of allusions: on the one hand the

[2] JUNGE KUH AUF MODERNER ZEICHNUNG, 1996

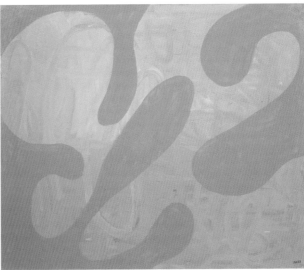

[3] NO. 1 AUS DER SERIE DER ELEGANTEN WOHNZIMMERBILDER, 1998

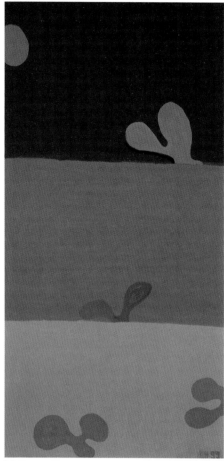

[4] Minimal Matisse, 1993

explicit numbering tells us that we shall soon be dealing with any number of similar products. And as it turns out, meanwhile a substantial number of works with a primarily ornamental structure have entered Henning's œuvre under the broad collective title 'Interiors'. On the other hand, the wording 'elegant living room painting' points yet again to the ironic distance the artist adopts to his own work. This irony not only contains the admission of being unable to influence the painting's location once it has left the point of sale, the gallery (it goes without saying that for Henning, too, the museum is the ultimate of all possible locations). It also admits that we may have to forsake that added utopian bonus that once fired Modernism. Finally, the title implies – in a to all intents and purposes inner U-turn – a fairly open sales strategy that once again must be seen as ironic.

Matisse's acanthus ornamentation also provided the basis for Henning's trefoil – what he termed the 'Hennling' and from then on turned into his personal trademark. Its origins in Matisse are most apparent in the painting Minimal Matisse (1993) [4]. Enough has been written on all the mutations the trefoil has undergone throughout Henning's work – as a tattoo, rubber stamp, comic figure, logo, object, décor, wallpaper, monument, and so on. Ralf Christofori rightly points out that it is "never [defined] in its own terms ... but always simply by an external designation. As an ornament it represents an abstract form that operates prior to all levels of meaning, as a Matisse quote it takes up a painterly legacy, and as a tattoo it becomes the emblem of a corporate identity. Finally, in the comic strip it becomes the hero of a short picture story whose storyline lives from a tongue-in-cheek look at recent art history."[5] Whilst the humour of the comic figure proves somewhat short-winded, Henning has arrived at some of his most beautiful visual creations through the various metamorphoses he performs on his logo – as for instance in Schlossplatz Berlin-Mitte (1997) [5]. Transformed into a gigantic sculpture, the logo dominates the urban (parking) place in a totally self-evident way. The sculpture is reflected to the left in the windows of the former Palace of the Republic, while to the right a street lamp (also a leftover from the GDR) gives it a nod, and in the background

offene und somit abermals ironisch zu verstehende Verkaufsstrategie.

Aus Matisses Akanthusornamenten extrahiert Henning auch die Dreipaßform – den sog. ‚Hennling', den er fortan zu seinem Markenzeichen stilisiert. Am deutlichsten ist die Herkunft von Matisse in dem Gemälde Minimal Matisse (1993) [4] ablesbar. Es ist hinreichend beschrieben worden, wie der Dreipaß im weiteren Verlauf der Arbeit allerlei Mutationen erfährt, als Tattoo, Stempel, Comicfigur, Logo, Objekt, Dekor, Tapete, Denkmal usf. Mit Recht weist Ralf Christofori darauf hin, daß er sich „nie durch sich selbst" definiert, „sondern immer nur über eine Zuschreibung von außen. Als Ornament steht er für eine abstrakte Form, die vor jeder Bedeutungsebene operiert, als Matisse-Zitat bemüht er ein malerisches Erbe, als Tattoo wird er zum Emblem einer Corporate Identity. Im Comicstrip schließlich ist er der Held einer kurzen Bildergeschichte, deren Pointe ihrerseits vom augenzwinkernden Blick auf die jüngere Kunstgeschichte lebt."[5] Während der Witz der Comicfigur eher kurzatmig ausfällt, gewinnt Henning aus den diversen Metamorphosen seines Logos einige seiner schönsten Bildschöpfungen – so etwa Schlossplatz Berlin-Mitte (1997) [5]. Dort beherrscht der Dreipaß, zur gigantischen Skulptur verwandelt, ganz selbstverständlich den städtischen (Park-)Platz. Auf der linken Seite spiegelt sich die Skulptur im ehemaligen Palast der

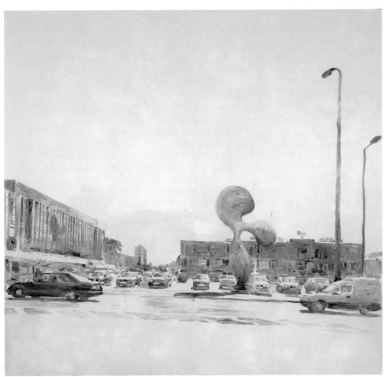

[5] SCHLOSSPLATZ BERLIN-MITTE, 1997

we find its two-dimensional pendant in a cultural logo on the roof of the former GDR police station. I know of no painting that has captured the signs of the political turn in 1989 with such subtlety, which comes precisely from the way the composition slurs fiction and reality to the point where the two are indistinguishable. In the meantime, the work has become part of the overall complex FRANKFURTER SALON (2005).

Henning did well to employ his trademark more sparingly once he had put it into circulation – well knowing that weariness may result if something is too often recognised. But his work contains a further vehicle, which has an openness that promises far greater possibilities. I mean the arabesque that we already found in JUNGE KUH AUF MODERNER ZEICHNUNG. Its origins can likewise be traced back to Matisse, even if a figural version already appeared in Picasso's middle period [6, 7]. In Henning's work we see it fully unfurled, embracing the entire canvas and in correspondence with that trefoil, as in INTERIEUR No. 1 (= Interior no. 1, 1995) [8], and

Republik, auf der rechten nickt ihr eine Peitschenlampe (gleichfalls aus DDR-Beständen) zu, im Hintergrund finden wir ein zweidimensionales Pendant als Kulturlogo auf dem Dach des Polizeireviers aus DDR-Zeiten wieder. Ich kenne kein Bild, das die Zeichen der Wende nach 1989 subtiler dargestellt hätte, und zwar gerade deshalb, weil die Komposition Fiktion und Realität bis zur Unkenntlichkeit verschleift. Inzwischen gehört es zum Gesamtkomplex FRANKFURTER SALON (2005).

Henning hat gut daran getan, sein Markenzeichen, nachdem es einmal im Umlauf war, zusehends spärlicher zu verwenden – wohlwissend, daß Überdosen an Wiedererkennbarkeit in der Kunst leicht Überdruß auslösen können. Es gibt aber in seinem Werk ein weiteres Vehikel, das wegen seiner Offenheit ungleich größere Einsatzmöglichkeiten verspricht. Ich meine jene Arabeskenlinie, die wir schon in der Arbeit JUNGE KUH AUF MODERNER ZEICHNUNG vorfanden. Ihre Herkunft läßt sich ebenfalls auf Matisse zurückführen, auch wenn eine figürliche Version bereits im mittleren Werk von Picasso auftaucht [6, 7]. Bei Henning sehen wir sie, bildübergreifend aufgefaltet und in Korrespondenz mit jenem Dreipaß,

[6] Picasso, ARLEQUIN À LA BATTEDANSANT, 1918

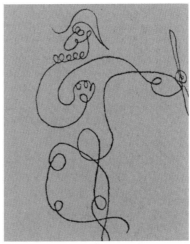

[7] Matisse, SANS TITRE (ARABESQUE), 1944–47

45

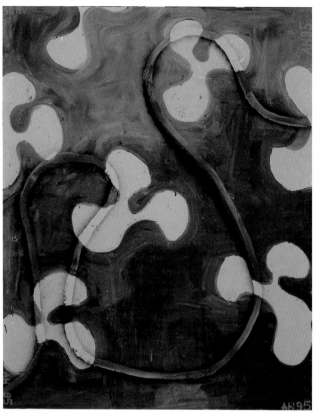

[8] Interieur No. 1, 1995

as a kind of "Boredom Loop" (as Sigmar Polke entitled his somewhat limper version) in front of a quasi empty ground in the painting Luxus (= Luxury, 1997)[6]. It further appears as a form filled with rich colours in his Picasso adaptation Picasso, 1976, No. 1 (1998) [9]; in a daring tightrope act wavering between representation and pattern in Interieur No. 15 (= Interior no. 15, 1998) [10]; and as a pirouette performed about a pedestal in Blumenstilleben No. 74 (= Flower Piece no. 74, 2001)[7]. All of these mutations represent for their part mere stations within a field of numerous variants that extends up to the very present. Such as for instance a sculptural variation in pure white has been included in the installation 31 Apotheotische Antiphrasen in Museum Haus Esters, Krefeld (2005). The arabesque has evidently proved extremely fruitful, not least in terms of sheer numbers. It not only casts a light on Henning's constant drive to metamorphosis, but also says a lot about his abounding lust to paint. And no less apparent in all of these variations is that, despite all the citations and borrowings, Henning's art should on no account be confused with Appropriation Art. Although art history provides Henning equally with support and targets for his heretical travesties, once he has left this port of call he sets out blithely into the open seas of painterly desire, not knowing what insights and inspiration may come his way during his journey.

The 'white cube' and the living room

In his lucid and still eminently readable essay *Inside the White Cube*, Brian O'Doherty describes the development of the gallery space step by step, from the 19th century salons to the white cube of the 20th century: "The pedestal melted away, leaving the spectator waist-deep in wall-to-wall space. As the frame dropped off, space slid across the wall, cre-

etwa in Interieur No. 1 (1995) [8], als eine Art „Langeweileschleife" (wie die etwas schlaffere Version von Sigmar Polke heißt) vor quasi leerem Grund in dem Gemälde Luxus (1997)[6], mit üppigen Farben zur gefüllten Form ausgestaltet in der Picasso-Adaption Picasso, 1976, No. 1 (1998) [9], in einem gewagten Balanceakt zwischen Abbild und Muster changierend im Interieur No. 15 (1998) [10], als Pirouette um einen Sockel kreisend im Blumenstilleben No. 74 (2001)[7]. Alle genannten Mutationen bilden wiederum nur Stationen innerhalb eines Feldes zahlreicher Varianten, die bis in die unmittelbare Gegenwart reichen. So gehört z. B. eine plastische Variante in purem Weiß zur Installation 31 Apotheotische Antiphrasen im Museum Haus Esters, Krefeld (2005). Die Arabeskenlinie erweist sich also als eine äußerst erfolgreiche Formfindung, allein numerisch betrachtet. Sie wirft nicht nur ein Licht auf Hennings durchgängigen Impetus zur Metamorphose, sondern sagt auch viel über seine überbordende Lust zu malen. Nicht minder zeigt sich an all diesen Variationen, daß man Hennings Kunst, bei allen Rückgriffen und Zitaten, keineswegs mit Appropriation Art verwechseln darf. Die Kunstgeschichte bietet Henning zwar gleichermaßen Rückhalt wie Angriffsfläche für ketzerische Travestien, doch hat er einmal diesen Hafen verlassen, dann steuert er unbekümmert in die offene See der Malerlust, was immer ihm auf der Reise an Erkenntnissen und Eingebungen auch zufallen mag.

Die ‚weiße Zelle' und das Wohnzimmer

In seinem luziden und immer noch lesenswerten Essay „In der weißen Zelle" zeichnet Brian O'Doherty Schritt um Schritt die Entwicklung des Galerieraumes vom Salon des 19. Jahrhunderts bis zum White Cube des 20. Jahrhunderts auf: „Der Sockel schmolz dahin und ließ den Betrachter hüfttief im Raum stehen. Der Rahmen wurde abgeschafft, und der Raum begann entlang der Wand wegzufließen, es kam zu Turbulenzen in den Ecken. Die Collage fiel aus dem Bild heraus und ließ sich auf dem Boden nieder wie ein Lumpensammler. Der neue Gott, der extensive und homogene Raum, breitete sich in der ganzen Galerie aus. Alle Hindernisse wurden zugunsten der ‚Kunst' entfernt. ... Die weiße Zelle wurde Kunst in Potenz, der umschlossene Raum ein alchemistisches Medium."[8] Anläßlich seiner Ausstellung im Kasseler Kunstverein (1998) richtet Anton Henning zum ersten Mal einen kompletten Raum ein, indem er Wände und Boden gleichermaßen in Beschlag nimmt. Noch bleibt die Wandgestaltung einfarbig, und die dichte Aneinanderreihung der Gemälde erinnert ein wenig an die alte Salonhängung. Er bestückt das Ambiente mit Sesseln, Stehlampen und Schnittblumen, auf dem schachbrettartig gemusterten Teppich läuft ein eigenes Video im Fernsehmonitor. Solchermaßen infiziert er die ‚weiße Zelle' mit der Atmosphäre eines spießigen Wohnzimmers aus den frühen 1960er Jahren. Umgekehrt trifft dieser Stimulus auch die ausgestellte Malerei. Insbesondere die Picasso-

ating turbulences in the corners. Collage flopped out of the picture and settled on the floor as easily as a bag lady. The new god, extensive, homogeneous space, flowed easily into every part of the gallery. All impediments except 'art' were removed. ... The white cube became art-in-potency, its enclosed space an alchemical medium."[8]

For his exhibition at the Kasseler Kunstverein (1998), Anton Henning fitted out an entire room for the first time by drawing in not only the walls but also the floor. At this point in his development the walls remained monotone, and the compact hanging of the rows of paintings was somewhat reminiscent of the salons of old. He furnished the environment with armchairs, standard lamps and cut flowers, and placed a television on a chequered carpet to show a video he had filmed. In this way he infected the white cube with the atmosphere of a staid, middle-class living room from the early sixties. And a very similar impetus was behind the paintings he exhibited. In particular his Picasso adaptations looked in this setting like those nasty copies that betoken mediocre taste: the daredevil consequence of an ironic gesture!

Anyone who subsequently visited THE MANKER MELODY MAKERS LOUNGE in Leipzig, a bare twelve months later, was no less bewildered. The likewise temporary but useable space now radiated the coolness of the Hiphop generation: the walls were painted in colourful stripes, and the paintings were casually arranged about the walls at different levels. Even the ceiling was incorporated into this work, and the furniture consisted of a mixture of designer pieces and Henning's own creations.

While Henning had restricted himself until then to responding to given spaces, for his exhibition at the Städtische Ausstellungshalle am Hawerkamp, Münster 2001, [11] he created his own separate space: the white cube was duplicated and transformed into a modern living room, in which all of the paintings and furnishings bore the artist's

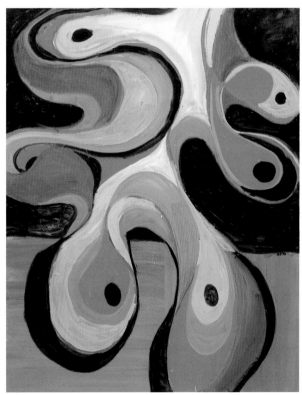

[9] PICASSO, 1976, NO. 1, 1998

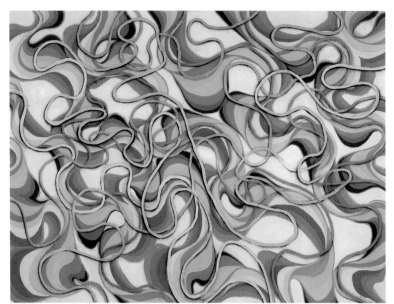

[10] Interieur No. 15, 1998

signature. In order to mark the boundary between preset and newly-fashioned space, he placed the latter quite logically on a plinth. How is one to judge this act? Henning created a space in which paintings and interior are mutually explanatory; perhaps an ideal space for the undisturbed contemplation of his art, which simultaneously thwarts the ideology of the white cube by amalgamating the purified space with its opposite, the middle-class living room. As such, it seems only fitting when totally heterogeneous contexts intersect inside: the wall design reveals echoes of Hard Edge painting, while the surfaces of the circular central-leg table are adorned with those arabesques we have already encountered as paintings in their own right. Henning has also returned to the idea of a spatially separated total installation for his Oktogon für Herford (2005). Unfortunately, all that I have of this at the time of writing are some rough sketches.

A further setting – staged with considerably more sophisticated means than in Münster – can currently be seen under the title Frankfurter Salon (2005) at the Museum für Moderne Kunst in Frankfurt. Here, however, Henning was compelled to return to using an existing space – the former Reading Room Sacco & Vanzetti by Siah Armajani. The coloured division of the walls accords with Constructivist principles that he similarly used in a number of earlier paintings, and that spread here even to the surfaces of the couch table: interlocking fields of asymmetrically arranged colour. But their muted pastels only distantly recall Mondrian, van Doesburg or Lissitzky, particularly since each colour compartment is divided from its neighbour by a white line. In addition, a diversity of paintings has been introduced into this complex, some of which illuminated by cubic lamps of Henning's own design. With this,

Adaptionen wirken in diesem Umfeld wie Abziehbilder eines mediokren Geschmacks: halsbrecherische Konsequenz einer ironischen Geste!

Wer daraufhin die Leipziger The Manker Melody Makers Lounge besucht, die nur etwa ein Jahr später entsteht, ist nicht weniger irritiert. Der gleichfalls temporäre und benutzbare Raum strahlt nunmehr die Coolness der Hiphop-Generation aus: Die Wände sind mit farbigen Streifen bemalt, die Bilder locker auf verschiedene Ebenen der Wände verteilt. Auch die Decke des Raumes ist jetzt in die Gestaltung einbezogen. Das Mobiliar besteht aus einer Mischung aus Designerstücken und eigenen Kreationen.

Ist Henning bis dahin gehalten, auf vorgegebene Räume zu reagieren, so kreiert er anläßlich seiner Ausstellung in der Städtischen Ausstellungshalle am Hawerkamp, Münster 2001, [11] einen isolierten eigenen Raum: Die ‚weiße Zelle' wird verdoppelt und in ein modernes Wohnzimmer verwandelt, Bilder und Mobiliar tragen nunmehr allesamt die Handschrift des Künstlers. Um die Grenze zwischen gegebenem und gestaltetem Raum zu markieren, sockelt er den Raum folgerichtig auf. Wie darf man diesen Akt bewerten? Henning schafft einen Raum, in welchem sich Gemälde und Interieur gegenseitig erläutern; womöglich einen Idealraum für die störungsfreie Wahrnehmung seiner Kunst, der indessen die Ideologie des White Cube konterkariert, indem er den bereinigten Raum mit seinem Gegenteil, dem bürgerlichen Wohnzimmer, amalgamiert. Insofern erscheint es nur stimmig, wenn sich darin durchaus heterogene Kontexte kreuzen: So finden wir in der Wandgestaltung Anklänge an die Hard Edge-Malerei, die Oberflächen der

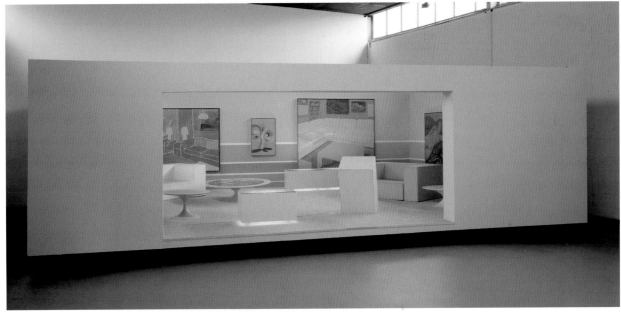

[11] Installation Städtische Ausstellungshalle am Hawerkamp, Münster, 2001

the artist manages to almost completely dissolve the physical walls. Through the apparent jumping back and forth of the colour zones, in which the representational paintings act like views of the outside world while the abstract works consolidate the structures of the wall design, the space opens up as it were both inwards and outwards to form liaisons with the furniture. Has Henning reached the point where the idea of the 'elegant living room painting' has passed seamlessly into an overall installation? Indeed, the FRANKFURTER SALON radiates an elegance that we only otherwise know from the exhibits at "Better Living" fairs.

Impure painting in pure surroundings

It is useful to look back at this point at one of the earliest interior designs of Modernism, to Mondrian's SALON DE MADAME B[IENERT] (1926) [12], a piece that was only first realized posthumously in 1970, on a 1:1 scale at the Pace Gallery in New York. Mondrian likewise based his plans in the Twenties on an already existing space. Yet instead of underlining the room's structure, his colour scheme glossed it over: "The panels are so adjusted that they advance and recede within a narrow compass. The room breathes, as it were, through the walls. This is enhanced by its perspective, producing the obliques Mondrian formally proscribed. The room is not so much anthropomorphic as *psyche-morphic*."[9] And all the more so because Mondrian permitted no further elements – apart from a bed, table and lamp – although he was forced to accept the view out of the window. Everything was informed by that ideal of purity that dominated Mondrian's work as a whole, and which extended to his vision of

kreisrunden Ein-Fuß-Tische zieren jene Arabesken, die wir schon als solitäre Gemälde kennengelernt haben. Den Gedanken einer räumlich separierten Totalinstallation wird Henning im OKTOGON FÜR HERFORD (2005) wieder aufgreifen. Zum Zeitpunkt, als dieser Text entsteht, liegen mir dazu jedoch nur grobe Skizzen vor.

Ein weiteres Ambiente – im Verhältnis zu Münster mit erheblich verfeinerten Mitteln inszeniert – liegt inzwischen unter dem Titel FRANKFURTER SALON (2005) im Museum für Moderne Kunst, Frankfurt, vor. Allerdings mußte sich Henning hier wieder weitgehend auf den vorhandenen Raum – den vormaligen READING ROOM SACCO & VANZETTI von Siah Armajani – einlassen. Die farbige Aufteilung der Wände folgt konstruktivistischen Prinzipien, die zuvor in ähnlicher Form in zahlreichen Gemälden verwendet wurden und nun auch von den Oberflächen der Couchtische Besitz ergreifen: ineinander verschachtelte, asymmetrisch angeordnete Farbfelder. Deren pastellartige Tonigkeit läßt indes nur entfernt an Mondrian, van Doesburg

an art that would lead to a new social order: "Painting and sculpture will not manifest themselves as separate objects, nor as 'mural art' which destroys architecture itself, nor as 'applied art', but being purely constructive will aid the creation of a surrounding not merely utilitarian or rational but also pure and complete in its beauty."[10]

We cannot say what Mondrian really envisaged by these words. But have they perhaps found concrete form in Henning's FRANKFURTER SALON? Certainly a number of things would speak in favour of this – were it not for his "fairly beautiful"[11], fairly impure and not totally perfect paintings. Alongside that vision of the square in Berlin from 1997, we find a number of beach scenes in which the artist in person, a surrealist sculpture, and a number of naked beauties from the stock of images of the "Bund für Leibeszucht"[12] all make their appearance. Nor are his *Pin-ups* lacking here. Henning has set aside a special category within his overall œuvre for this particular group of works, which can be traced back in art history terms to Picabia's kitschy nudes from the 1940s. The FRANKFURTER SALON even presents the frankly pornographic view of a woman's spread-eagled sex [13], whose prototype is to be found in Gustave Courbet's long concealed painting L'ORIGINE DU MONDE (1866). No doubt the most elegant painting in the *Salon* – and here we see Henning's double strategy in a nutshell – is also the most provocative: a purely ornamental work whose materials are chiefly the product of the artist's digestive system on one particular day: KOMPOSITION MIT KÖNIGSBERGER KLOPSEN, SENFGURKEN, ROTE BEETE, KARTOFFELN, WASSERMELONE UND ZITRONENSAFT, RHEINGAURIESLING UND GROSSEM BROWNIE (= Composition with Konigsberg meatballs, gherkin in piccalilli, beetroot, potatoes, water melon and lemon juice, Rheingau Riesling, and large brownie, 1995) [14].

Seen in this light, although the environment might be regarded as "perfect", it is anything but "pure", and certainly the pictures are not to be classified as 'salon painting', as suggested by the title 'Salon'. Rather, the seal of elegance has been used to bring together heterogeneous modalities of art, which together span a wide range of highs and lows. And it is above all the painting itself – its intellectual virility – that gen-

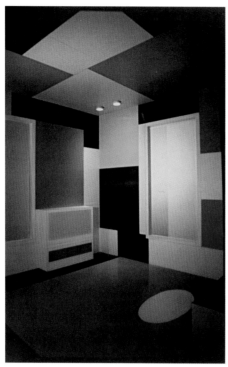

[12] Mondrian, STUDIERZIMMER / SALON IDA BIENERT, 1926
Courtesy Pace Gallery, New York

oder Lissitzky denken, zumal jedes farbige Kompartiment durch eine weiße Linie vom benachbarten Feld abgegrenzt bleibt. In dieses komplexe Gebilde sind diverse Gemälde eingelassen, die teilweise von eigens gestalteten, kubischen Lampen beleuchtet werden. So gelingt es Henning, die realen Wände fast vollständig aufzulösen. Im Vor- und Zurückspringen der Farbzonen, in denen die gegenständlichen Bilder wie Ausblicke funktionieren, während die ungegenständlichen die Strukturen der Wandgestaltung verdichten, öffnet sich der Raum gleichermaßen nach innen wie nach außen und geht mit dem Mobiliar Liaisons ein. Hat Henning den Punkt erreicht, an dem die Idee des ‚eleganten Wohnzimmerbildes' bruchlos in der Gesamtinstallation aufgeht? In der Tat strahlt der FRANKFURTER SALON eine Eleganz aus, die wir sonst nur in den exponierten Beispielen einer Schöner-Wohnen-Kultur finden.

Unreine Malerei im reinen Ambiente

Hilfreich ist es, aus diesem Anlaß auf eine der frühesten Raumgestaltungen der Moderne zurückzublicken, nämlich auf Mondrians STUDIERZIMMER VON IDA BIENERT (1926) [12], eine Arbeit, die allerdings erst posthum 1970 in der New Yorker Pace Gallery 1:1 realisiert wurde. Auch Mondrian bezog die Planung seinerzeit auf einen vorgegebenen Raum. Seine Farbgestaltung unterstreicht nicht die bauliche Struktur, sondern überspielt sie: „Die Felder sind so angeord-

net, daß sie innerhalb einer engen Marge nach vorne kommen und zurückweichen. Der Raum atmet mit seinen Wänden. Dies wird durch die Perspektive verstärkt, welche die von Mondrian verpönten Schrägen ins Spiel bringt. Der Raum ist weniger anthropomorph, als *psychomorph*."[9] Und er ist es um so mehr, als Mondrian keine weiteren Elemente – bis auf Bett, Tisch und Lampe – zuließ; den Fensterausblick mußte er notgedrungen hinnehmen. Alles war von jenem Ideal der Reinheit getragen, das Mondrians Werk insgesamt dominiert und bis in seine Vorstellung, von der Kunst könne eine neue Gesellschaftsordnung ausgehen, hineinreicht: „Malerei und Skulptur werden sich nicht in getrennten Objekten realisieren, weder als Wandkunst noch als ‚angewandte Kunst'; sie werden ganz und gar konstruktiv sein und so ein Ambiente erschaffen, das nicht nur zweckmäßig und rational, sondern auch rein und vollkommen in seiner Schönheit ist."[10]

Wir wissen nicht, was sich Mondrian bei dieser Diktion konkret vorstellte. Aber hat sie womöglich in Hennings FRANKFURTER SALON Gestalt angenommen? Einiges spricht sicherlich dafür – wären da nicht jene „ziemlich schönen"[11], ziemlich unreinen und nicht ganz vollkommenen Malereien. Neben jener Berliner Platzvision von 1997 finden wir eine Reihe von Strandszenen vor, in denen der Künstler selbst, eine surrealistische Skulptur und einige nackte Schönheiten aus dem Bilderreservoir des ehemaligen „Bundes für Leibeszucht"[12] auftreten. Auch an *Pin-ups* fehlt es nicht. Innerhalb der Kategorisierung seiner eigenen Werke hat Henning dieser Gruppe, die wir kunstgeschichtlich auf Picabias kitschige Akte aus den 1940er Jahren zurückführen können, eine eigene Rubrik gewährt. Der FRANKFURTER SALON

erates the resistance that is needed to break with the apparent slickness of the *Salon*. The furniture can change, become more sophisticated: but without the cunning ambiguity of the paintings it would be all too possible to misconstrue this as a kind of post-modern Biedermeier.

This was one of the reasons why Henning decided against creating another environment when he planned his exhibition 31 APOTHEOTISCHE ANTIPHRASEN (2005) for Haus Esters in Krefeld. The sole chair in this space will be placed on a plinth, and thus is not something to be sat on. In one respect the installation can even be seen as a Homage to Bauhaus master Mies van der Rohe, the architect of Haus Esters: Taking as his starting point the way the wall sections inside the Villa are framed – somewhat like paintings – by visually striking skirting boards and door frames, Henning has taken the step of double framing the paintings in the exhibition. And while in his FRANKFURTER SALON he provided special illumination for individual works, in Krefeld he has elevated this idea to a principle: each individual painting has its own light source integrated into its frame. Here again, this is a reference to the building itself, which can dispense during the exhibition with typical museum lighting.

In terms of the white cell ideology, this is yet another innovation: after the walls, floor, ceilings and gallery as a whole had been expropriated and placed the disposal of an all-embracing art, with the expropriation of the light sources the last remainder of the customary gallery has also been absorbed. But then – although this can only be completely verified *in situ* – something strange occurs: when twilight falls, the individual works lit by their own sources will gradually stand out from the space and the white walls, producing a light situation not totally unlike the one we

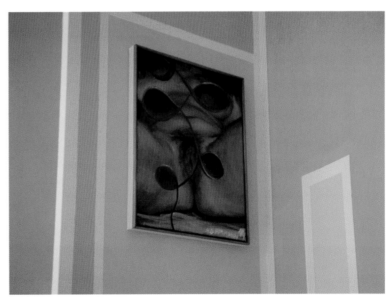

[13] BLUMENSTILLEBEN NR. 223, 2004

[14] Komposition mit Königsberger Klopsen, Senfgurken, Rote Beete, Kartoffeln, Wassermelone und Zitronensaft, Rheingauriesling und grossem Brownie, 1995

know from old museums, where the painted masterpieces are set apart from their profane surroundings ... So whereas Henning's installations to date have produced a crossover of paintings, furnishings and coloured walls, exactly the opposite will occur in Krefeld – a turnabout through which the artist once again eludes any prospective categorisation or prognosis of his work.

Twixt Irony and Idyll

At the same time an œuvre has built up over the years that permits at least a few assumptions. What in fact distinguishes this œuvre? When we click to Henning's homepage we find five categories under the heading 'Painting': *Interiors, Flower Pieces, Pin-ups, Portraits, Other Paintings* – categories we would expect more from a mail-order catalogue than from an artist at the dawn of the 21st century with a serious reputation. Yet it is precisely here that part of his provocative strength lies: beckoning with kitsch and then catching us out by serving up art. But it is not enough to know how to tap both the broad field of art history as well as the world of trivial imagery – enough artists of repute have already done and continue to do that. Henning, however, does so with such an open-heartedness and cheerful lack of scruples that some commentators are left speechless. And they are no less shocked that he regards his own œuvre in much the same way, as a quarry and permanent construction site. The *Interiors* for instance have currently topped the 300 mark, the *Pin-ups* lie at around 100, and his *Flower Pieces* are approaching 200 in number. When we take a close look at his publications, we stumble time and again on variations of the one and the same basic motif. Are we dealing here with the dictum that the pressure to

bietet gar die un(verblümt) pornographische Ansicht eines geöffneten Frauenschoßes [13], deren Urbild wiederum in Gustave Courbets lange versteckt gehaltenem Gemälde L'Origine du monde (1866) zu suchen ist. Das wohl eleganteste Gemälde des *Salons* – und hier zeigt sich Hennings Doppelstrategie *in nuce* – ist zugleich das provozierendste: ein rein ornamentales Bild, dessen Materialien sich in erster Linie dem persönlichen Verdauungsprozeß des Künstlers an einem ganz bestimmten Datum verdanken: Komposition mit Königsberger Klopsen, Senfgurken, Rote Beete, Kartoffeln, Wassermelone und Zitronensaft, Rheingauriesling und grossem Brownie (1995) [14].

So gesehen mag man das Ambiente vielleicht als „vollkommen" ansehen, „rein" ist es ganz gewiß nicht, und ebensowenig ist als ‚Salonmalerei' zu klassifizieren, was unter dem Titel ‚Salon' daherkommt. Vielmehr haben sich unter dem Siegel der Eleganz heterogene Modalitäten von Kunst versammelt, die zusammengesehen eine beträchtliche Fallhöhe abgeben. Es ist vor allem die Malerei selbst – ihre intellektuelle Potenz –, die es vermag, jenen Widerstand zu erzeugen, der unabdingbar ist, um mit der vermeintlichen Glätte des *Salons* zu brechen. Das Mobiliar mag wechseln, sich weiter verfeinern: Ohne die Doppelbödigkeit der Bilder wäre in der Tat das Mißverständnis, hier handele es sich womöglich um ein postmodernes Biedermeier, durchaus gegeben.

Nicht zuletzt aus diesem Grund hat Henning im Hinblick auf seine Installation 31 Apotheotische Antiphrasen (2005) in dem von Mies van der Rohe erbauten Haus Esters in Krefeld die Entscheidung getroffen, kein weiteres

Ambiente zu kreieren: der einzige Sessel wird hier auf einem Sockel plaziert, dient also nicht als Sitzgelegenheit. In einem Punkt darf man die Installation gar als Hommage an den Bauhaus-Meister betrachten: Ausgehend davon, daß die Wandkompartimente der Villa durch den Einsatz von visuell dominanten Bodenleisten bzw. Türrahmen bildmäßig gefaßt sind, geht Henning nunmehr dazu über, die Gemälde der Ausstellung mit aufgedoppelten Rahmen zu versehen. Und hat er schon im FRANKFURTER SALON einzelne Werke eigens beleuchtet, so macht er diese Idee in Krefeld zum Prinzip: Die einzelnen Gemälde erhalten ihr eigenes, in den Rahmen integriertes Licht – auch dies eine Referenz an die Architektur, die während der Ausstellung auf museale Leuchtmittel verzichten kann.

Im Hinblick auf die Ideologie der ‚weißen Zelle' ist dies eine weitere Neuerung: Nachdem Wände, Böden, Decken der Galerie enteignet und in den Besitz einer alles umgreifenden Kunst übergegangen sind, scheint mit der Enteignung der Beleuchtung auch das letzte Residuum des herkömmlichen Galerieraums absorbiert. Doch dann – und das wird sich erst vor Ort vollends verifizieren – geschieht etwas Seltsames: Wenn sich in der Dämmerung des Tages die einzelnen Werke unter ihrem eigenen Licht zusehends vom Raum und von den weißen Wänden abheben, entsteht eine Lichtsituation, die nicht wenig an jene erinnert, welche wir in den alten Museen vorfinden, wo die Meisterwerke der Malerei von der profanen Umgebung abgesondert werden … Während also die bisherigen Installationen von Henning ein *Crossover* von Bildern, Möbeln und farbigen Wänden erzeugten, geschieht in Krefeld das genaue Gegenteil – eine Kehrtwende, mit der sich der Künstler abermals jeder weitergehenden Zuordnung und Prognose über seine Arbeit entzieht.

succeed leads to the compulsion to repeat? The matter gets all the more complicated inasmuch as some pieces which, for instance, go under the heading *Flower Pieces* could also be categorised as *Pin-ups*; and what is called a portrait can often be seen as an abstract. In this way, Henning's categorisations turn out to be a witty, wicked trap for the kindly-disposed purchaser. Evidently everything in Henning's globe of images is linked with everything else, one simply has to give it the right spin.

The artist himself gives us a clue as to how we should view these metamorphoses in his motifs and subjects: "To me, all of those paintings relate to each other. They're about me, and I'm simply not one-dimensional. My work is an autopoietic system."[13] Anton Henning names here the critical mass in his system, for sooner or later an autopoietic system runs the danger of cutting off the outside air it needs in order to work. It should be said, however, that for Henning, theory and practice do not necessarily have to be in harmony the whole time – fortunately. We have shown quite sufficiently that he is capable of exploiting just about every conceivable source. The fact that the rural landscape (complete with fauna) in his immediate surroundings also serves as such a source remains at the same time a scandalous matter which his colleagues – as far as I can tell – wisely choose to avoid. Which brings me back to ABENDLIED (= Evening Song) (numerous versions since 2001), which I mentioned at the beginning: the painting of a bird perched on a branch above the roof at home, warbling its sweet song before a rosy sunset. Such an unscrupulous defiance of every suspicion of kitsch is bound to make his more timorous artist colleagues blanch in envy. Not that such motifs are absolutely taboo: after all, Picabia and Polke have already paved the way for processing kitsch into art. But the big question is always *how* one does it. Following on from Polke and quite oblivious to the so-called "Tuymans effect"[14], Henning persists in using a strongly impasto style of painting that draws in the entire surface, and which in its representational moments deftly summons up Courbet, before flowing on without more ado into abstract motifs, as and when the artist wishes. Henning could perhaps be taken to task for showing a lack of reflection on the means at his disposal; but it is precisely the

Zwischen Ironie und Idylle

Andererseits hat sich mit den Jahren ein Œuvre angesammelt, das zumindest zu Vermutungen Anlaß gibt. Was macht dieses Œuvre eigentlich aus? Wenn wir Hennings eigene Homepage öffnen, so finden wir unter dem Stichwort Malerei fünf Kategorien: *Interieurs, Blumenstilleben, Pin-ups, Portraits, Andere Malereien* – Kategorien, die wir eher im Angebot eines Versandhauskatalogs vermuten als bei einem ernstzunehmenden Künstler des angehenden 21. Jahrhunderts. Doch gerade darin liegt eine seiner provokanten Stärken: mit Kitsch zu winken und dann doch mit Kunst zu überraschen. Dazu

gehört nicht allein, daß er sich im weiten Feld der Kunstgeschichte ebenso wie in der trivialen Bilderwelt zu bedienen weiß – das haben auch andere Künstler von Rang getan und tun es noch. Aber Henning tut dies mit einer offenherzigen und fröhlichen Skrupellosigkeit, daß es manchem Rezipienten die Sprache verschlägt. Nicht weniger schockiert, daß er auch sein eigenes Œuvre dergestalt als Steinbruch und Dauerbaustelle ansieht. Die *Interieurs* z. B. haben gegenwärtig bereits die Anzahl von 300 überschritten, die *Pin-ups* liegen bei knapp 100, während die *Blumenstilleben* auf die 200 Werke zugehen. Bei genauer Sichtung der Publikationen stoßen wir wieder und wieder auf Varianten ein und desselben Grundmotivs. Gilt hier das Diktum: Erfolgszwang führt zum Wiederholungszwang? Die Angelegenheit verkompliziert sich insofern, als manches, was z. B. unter *Blumenstilleben* firmiert, ebenso *Pin-up* heißen könnte; was unter Porträt firmiert auch abstrakte Komposition sein kann. Solchermaßen entpuppt sich die Kategorienbildung als witzig-böse Falle für den geneigten Käufer. Offensichtlich hängt in Hennings Bilderglobus alles mit jedem zusammen, man muß ihn nur entsprechend zu drehen wissen.

Der Künstler selbst gibt uns einen Fingerzeig, wie wir die Metamorphosen seiner Motive und Sujets betrachten dürfen: „Für mich beziehen sich all diese Malereien aufeinander. Sie handeln von mir, und

way he sticks to these trivial and kitschy subjects that unleashes his artistic provocation. Twittering birds, sunsets and other idylls in the painterly wraps of a Courbet, all done without visible irony – that's almost a bit much, when one thinks of the countless artists trying to wrest one more signature style from the paint and brush that has not yet entered the annals of Western painting. Seen in this light, his courage to pursue his subversive course within that field of tension twixt irony and idyll deserves our every respect. After all, it is this tension which the artist lives in his own self, both in Manker and in the world.
August 2005

1 Umberto Eco, Postille al nome della rosa, 1983, German: Nachschrift zum 'Namen der Rose'. Munich & Vienna, 1984, p. 77
2 It would seem that this step has established itself as permanent. Beat Wyss, for instance, speaks of "a pop culture that is extending across the globe, and which has synchronised the art scene just as it has all of our lifestyles." Beat Wyss, Die Welt als T-Shirt. Zur Ästhetik und Geschichte der Medien, Cologne, 1997, p. 109
3 Ill. in cat. Anton Henning: Too much of a good thing ..., Kasseler Kunstverein and Kunstverein Heilbronn, pp. 43 – 45
4 Cf. Pierre Schneider, "The Figure in the Carpet: Matisse und das Dekorative", in cat. Henri Matisse, Kunsthaus Zürich, Kunsthalle Düsseldorf, 1983, p. 16 f.
5 Ralf Christofori, "Der Hennling", in cat. Colour Me Blind!: Malerei in Zeiten von Computergame und Comicstrip, Württembergischer Kunstverein Stuttgart, Städtische Ausstellungshalle am Hawerkamp, Münster, Verlag der Buchhandlung Walther König, Cologne, 1999, p. 52
6 Ill. cat. Anton Henning: Too much of a good thing ..., cf. Footnote 3, p. 56
7 Ill. ibid, p. 23
8 Brian O'Doherty, Inside the White Cube: The Ideology of the Gallery Space, [1976] Expanded Edition, University of California Press, 2000, p. 87
9 Brian O'Doherty, op cit., p. 83 (italics in the original)
10 Cited in Brian O'Doherty, ibid., p. 85
11 Ziemlich schöne Malereien (= Fairly Beautiful Paintings) is the title of a

ich bin einfach nicht eindimensional. Mein Werk ist ein autopoietisches System."[13] Damit ist zugleich die kritische Masse im System Anton Henning benannt: Denn ein autopoietisches System setzt sich früher oder später der Gefahr aus, die Außenluft, die es zum Funktionieren braucht, abzuschnüren. Allerdings gilt auch für Henning, daß Theorie und Praxis nicht unbedingt jederzeit im Einklang stehen – glücklicherweise. Wir haben hinreichend zeigen können, daß er in der Lage ist, aus allen nur denkbaren Quellen zu schöpfen. Daß auch die Landschaft (samt Tierwelt) seiner unmittelbaren ländlichen Umgebung dazugehört, bleibt unterdessen ein Skandalon, das – soweit ich sehe – von allen seinen Zeitgenossen wohlweislich umschifft wird. Hier komme ich auf das eingangs erwähnte Abendlied (seit 2001 mehrere Fassungen) zurück: das Bild eines Vogels, der, vor rötlichem Abendhimmel auf einem Ast über dem heimischen Dach sitzend, sein Lied trällert. Sich derart skrupellos über den Kitschverdacht hinwegzusetzen, dürfte manch zaghafteres Künstlergemüt neidvoll erblassen lassen. Nicht daß solche Sujets ganz und gar tabu wären:

Immerhin haben Picabia und Polke den Boden für die Kitschverarbeitung von Kunst geebnet. Aber es kommt immer noch auf das *Wie* an. Henning beharrt auch nach Polke, und unbenommen des sogenannten Tuymans-Effekts[14], auf einer pastos aufgetragenen, vollflächigen Malweise, die, wo sie sich gegenständlich gebärdet, an Courbet erinnern mag, um dann ohne Umschweife in abstrakte Sujets einzufließen, wenn es der Künstler so will. Man mag ihm das als mangelnde Reflexion der Darstellungsmittel ankreiden; doch im Hinblick auf seine trivialen und kitschigen Sujets kulminiert in diesem Beharren geradezu die künstlerische Provokation. Vogelgezwitscher, Sonnenuntergänge und andere Idyllen im malerischen Gewand eines Courbet – ohne sichtbare Ironie vorgeführt – das ist schon ein starkes Stück, gemessen an den zahllosen Versuchen, dem Duktus des Pinsels womöglich eine letzte Spur abzugewinnen, die in der Geschichte abendländischer Malerei noch nirgends aufgehoben ist. So gesehen gebührt seinem Mut, in der Spannung zwischen Ironie und Idylle subversiv Kurs zu halten, aller Respekt. Nicht zuletzt ist es diese Spannung, die der Künstler selbst lebt, in Manker und in der Welt.　　　　　*August 2005*

catalogue by Anton Henning, Kunstmuseum Luzern, 2003.

12 The Naturism championed by the "Bund für Leibeszucht" (1934–45) strictly excluded non-Aryans. Consequently its photographic self-presentations featured solely nudists who exemplified the Aryan ideal of blonde, pristine beauty.

13 Cited in Dominic van den Boogerd, Mercedes by the Sea, in: cat. ANTON HENNING: SURPASSING SURPLUS, cf. Footnote 7, p. 54.

14 See Jordan Kantor, "The Tuymans Effect", in ARTFORUM, November 2004, p. 164. As such, a painting by Henning that still reveals white primer is simply one that has not yet finished.

1 Umberto Eco, NACHSCHRIFT ZUM ‚NAMEN DER ROSE‘. München-Wien 1984, S. 77

2 Es hat nicht wenig den Anschein, als sei dieser Schritt endgültig. Beat Wyss etwa spricht von „einer weltweit sich ausdehnenden Popkultur, die die Kunstszenen ebenso synchronisiert hat wie unser aller Lebensstil". Beat Wyss, DIE WELT ALS T-SHIRT. ZUR ÄSTHETIK UND GESCHICHTE DER MEDIEN, Köln 1997, S. 109

3 Abb. in Kat. ANTON HENNING: TOO MUCH OF A GOOD THING …, Kasseler Kunstverein und Kunstverein Heilbronn, S. 43–45

4 Vgl. Pierre Schneider, The Figure in the Carpet: Matisse und das Dekorative, in Kat. HENRI MATISSE, Kunsthaus Zürich, Kunsthalle Düsseldorf 1983, S. 16 f.

5 Ralf Christofori, Der Hennling, in: Kat. COLOUR ME BLIND!: MALEREI IN ZEITEN VON COMPUTERGAME UND COMICSTRIP, Württembergischer Kunstverein Stuttgart, Städtische Ausstellungshalle am Hawerkamp, Münster, Verlag der Buchhandlung Walther König, Köln 1999, S. 52

6 Abb. Kat. ANTON HENNING: TOO MUCH OF A GOOD THING …, a. a. O., S. 56

7 Abb. ebenda, S. 23

8 Brian O'Doherty, INSIDE THE WHITE CUBE: THE IDEOLOGY OF THE GALLERY SPACE. The Lapis Press, Santa Monica, San Francisco 1986; zit. nach der dtsch. Ausgabe, hrsg. von Wolfgang Kemp, Merve Verlag Berlin 1996, S. 99

9 Brian O'Doherty, a. a. O., S. 95 (Hervorhebung im Originaltext)

10 Zit. nach Brian O'Doherty, a. a. O., S. 97

11 ZIEMLICH SCHÖNE MALEREIEN ist der Titel eines Katalogs von Anton Henning, Kunstmuseum Luzern 2003

12 Die Freikörperkultur des „Bundes für Leibeszucht" (1934–45) zeichnete sich dadurch aus, daß sie Nicht-Ariern verboten war. Insofern verkörperten die fotografischen Nacktdarstellungen das arische Ideal blonder, makellos-natürlicher Schönheit.

13 Zit. Dominic van den Boogerd, Mercedes by the Sea, in: Kat. ANTON HENNING: SURPASSING SURPLUS, a. a. O., S. 54, rückübersetzt aus dem Englischen

14 Vgl. Jordan Kantor, The Tuymans Effect, in: ARTFORUM, November 2004, S. 164ff. Insofern ist bei Henning ein Gemälde, das noch weißen Malgrund zeigt, eben nicht fertig.

31 Apotheotische Antiphrasen für Haus Esters

Museum Haus Esters, Krefeld

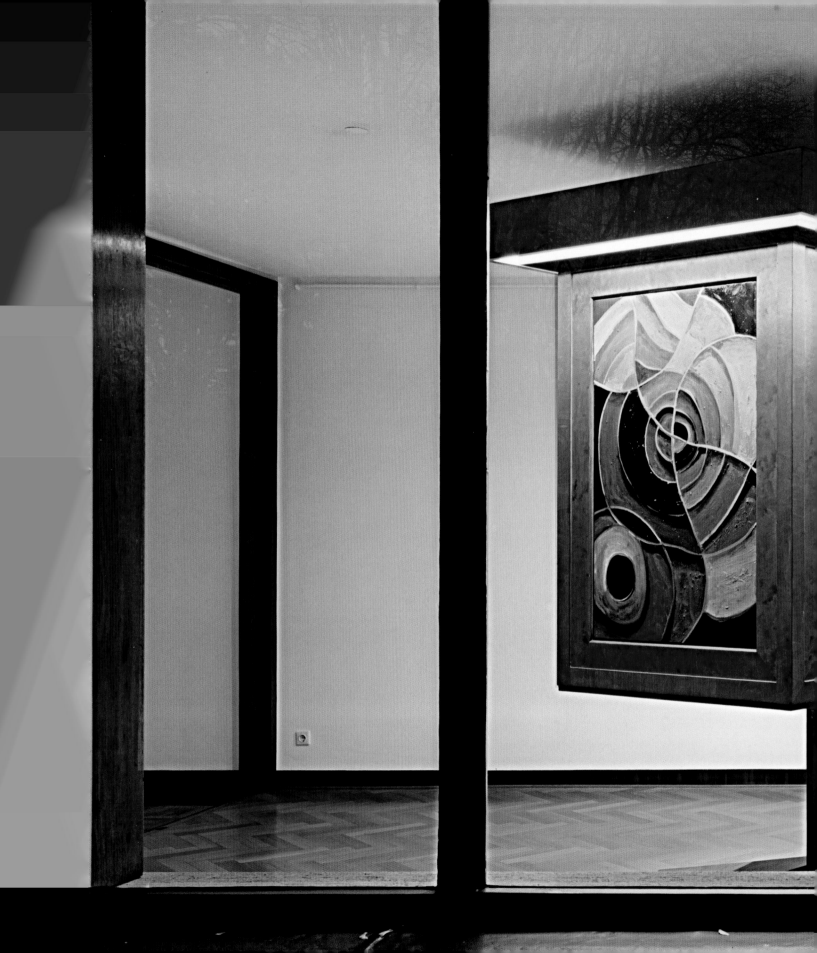

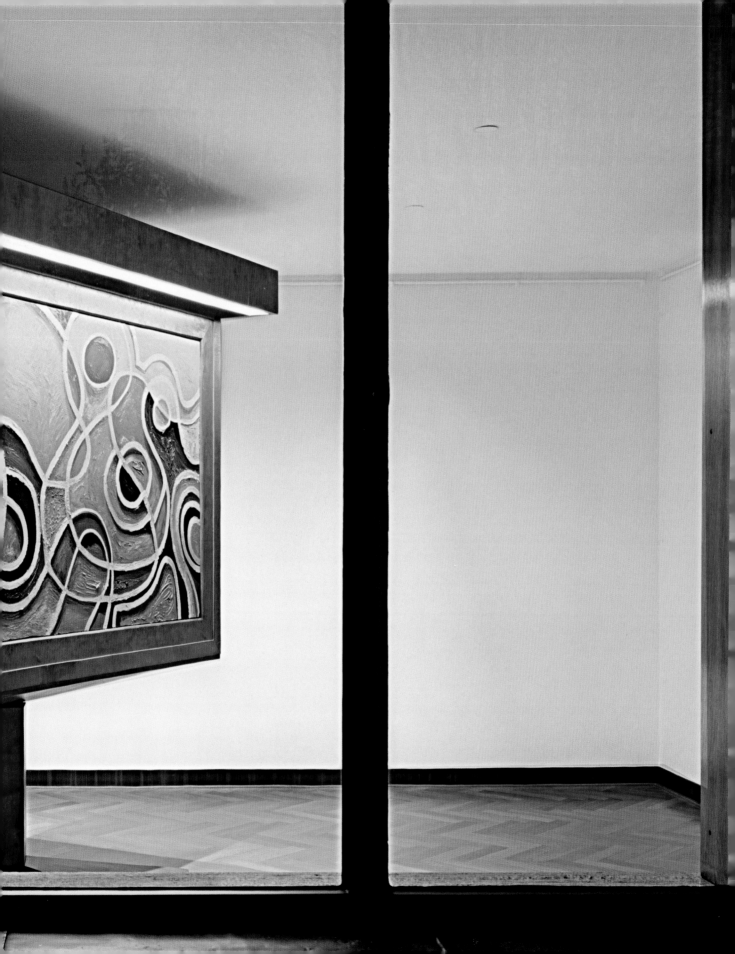

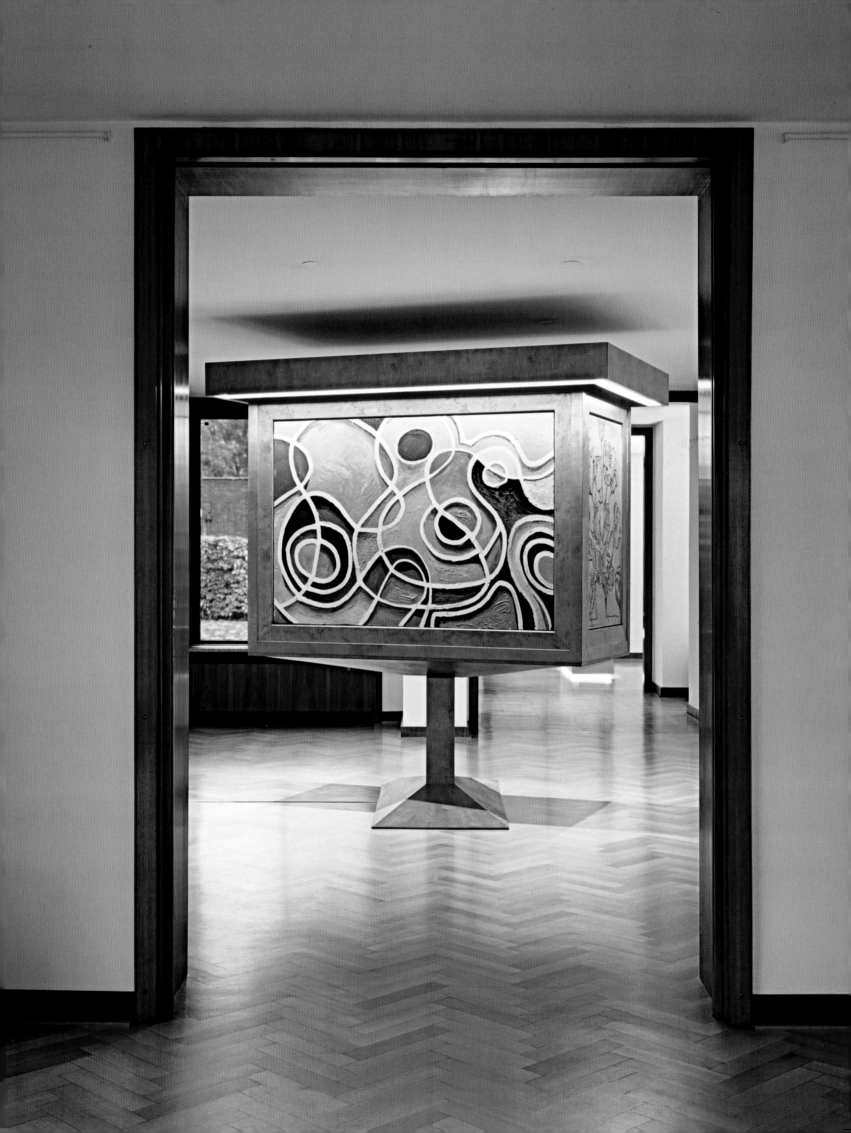

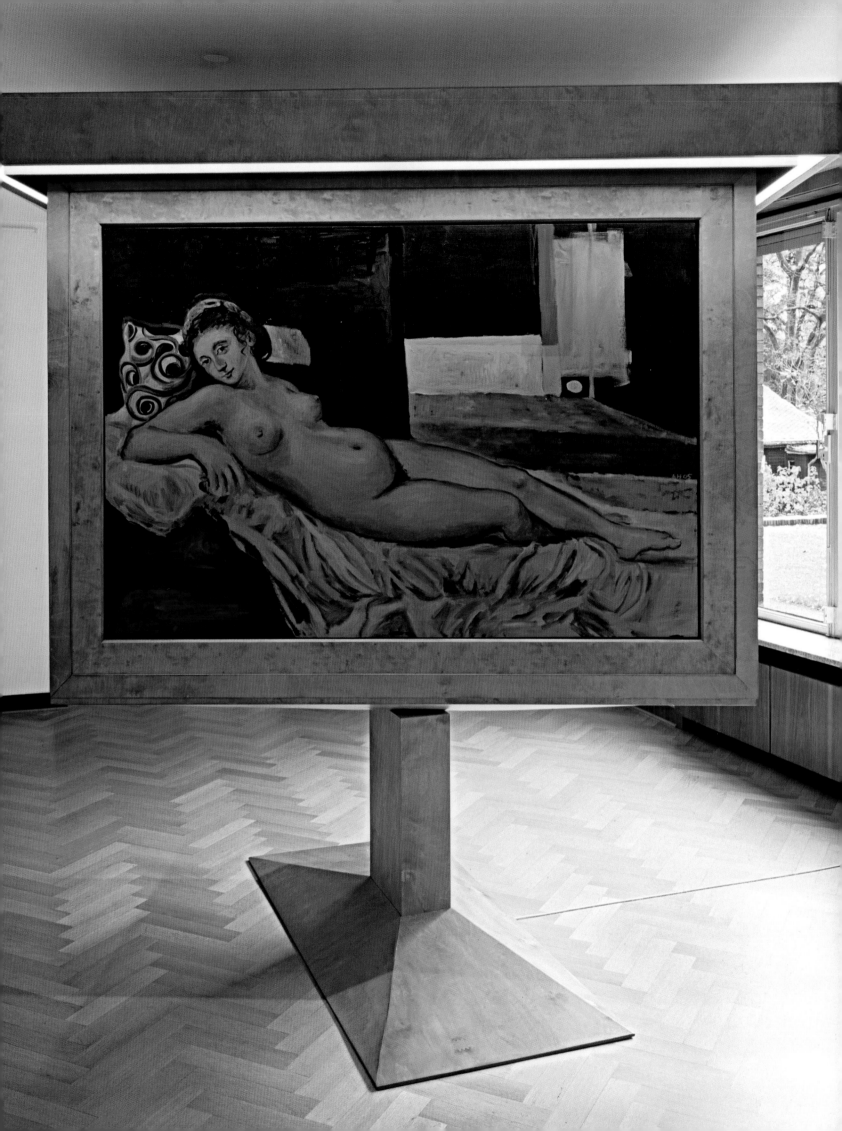

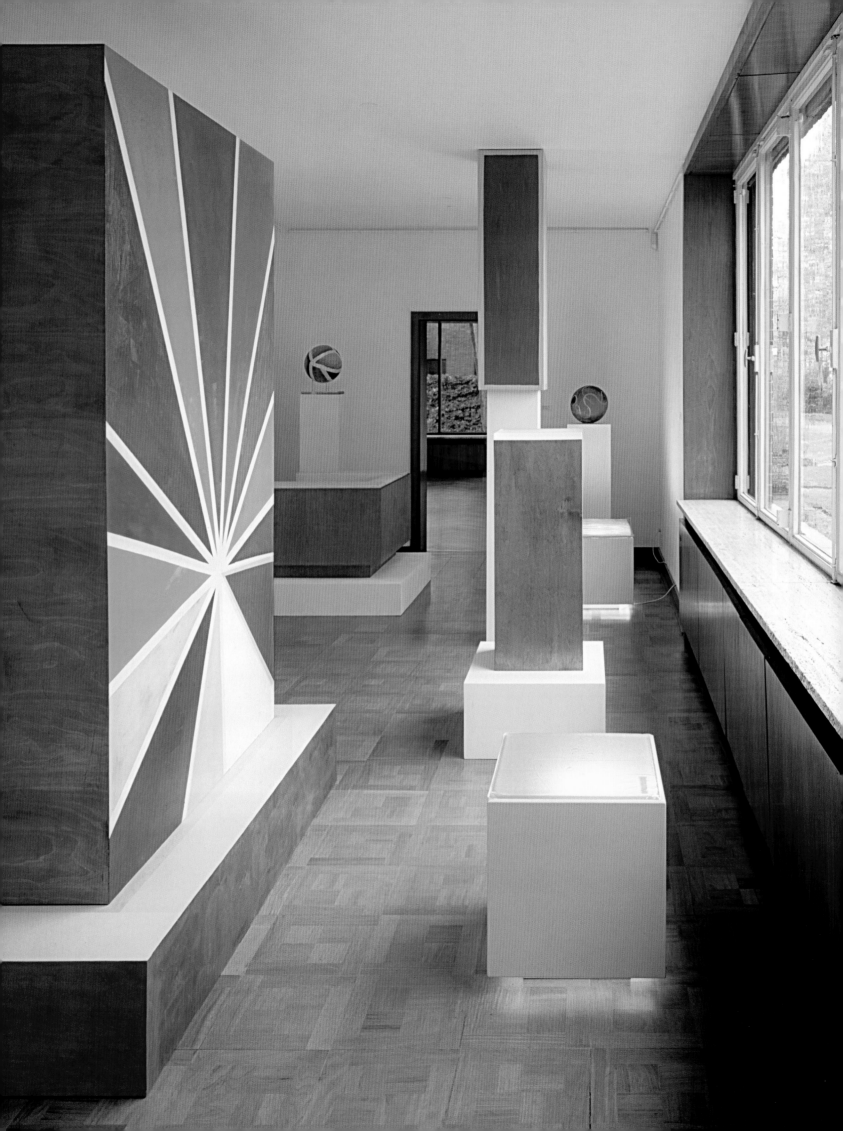

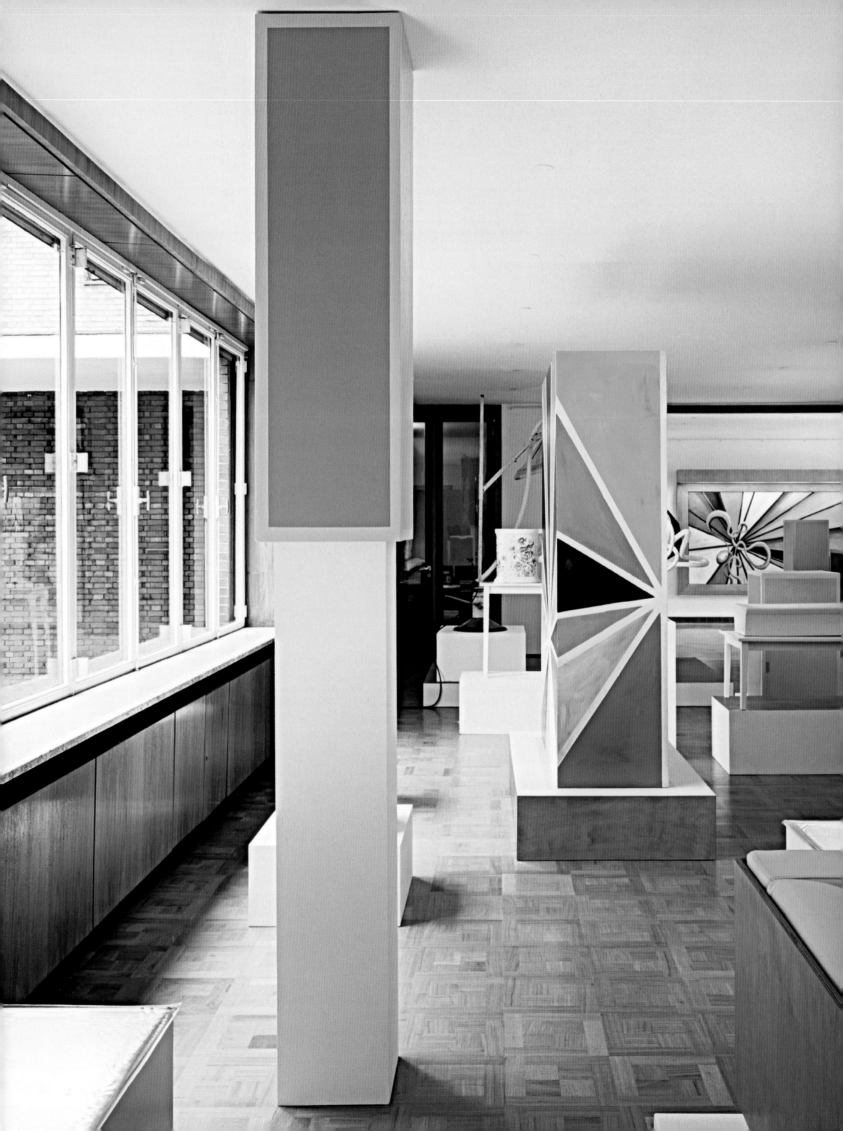

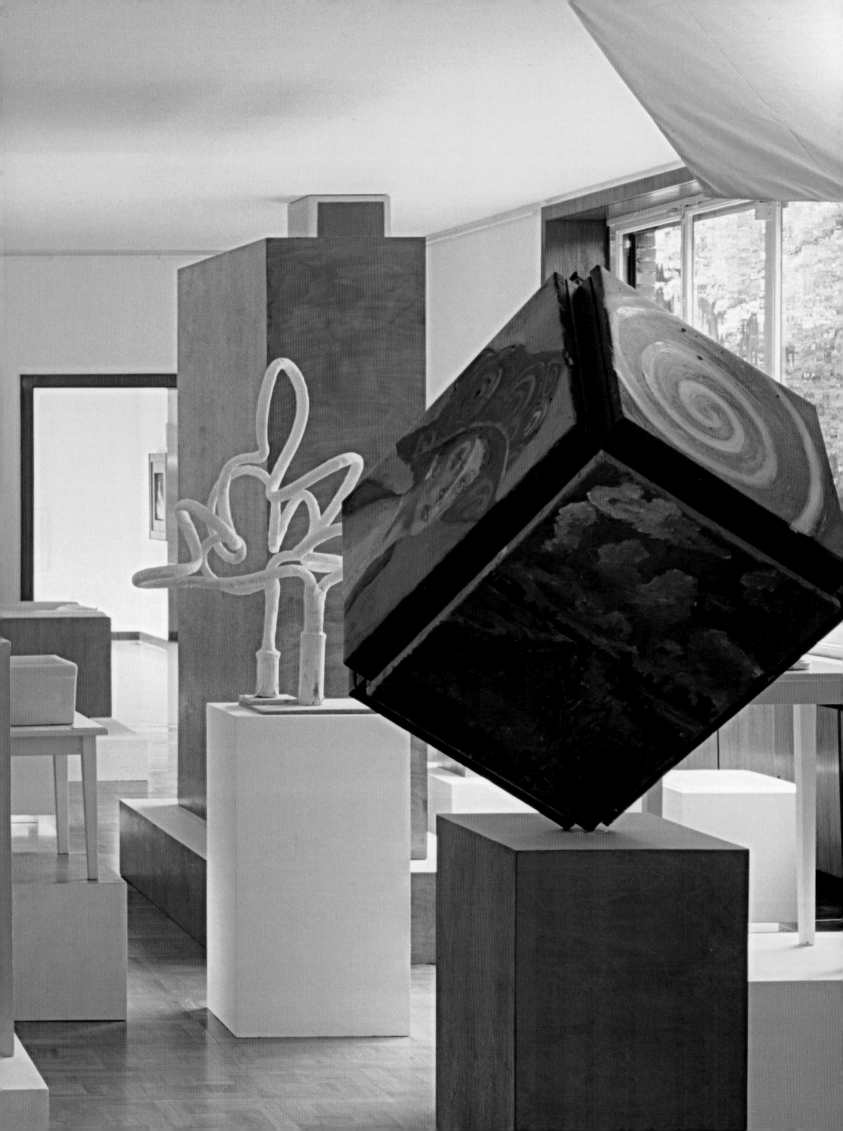

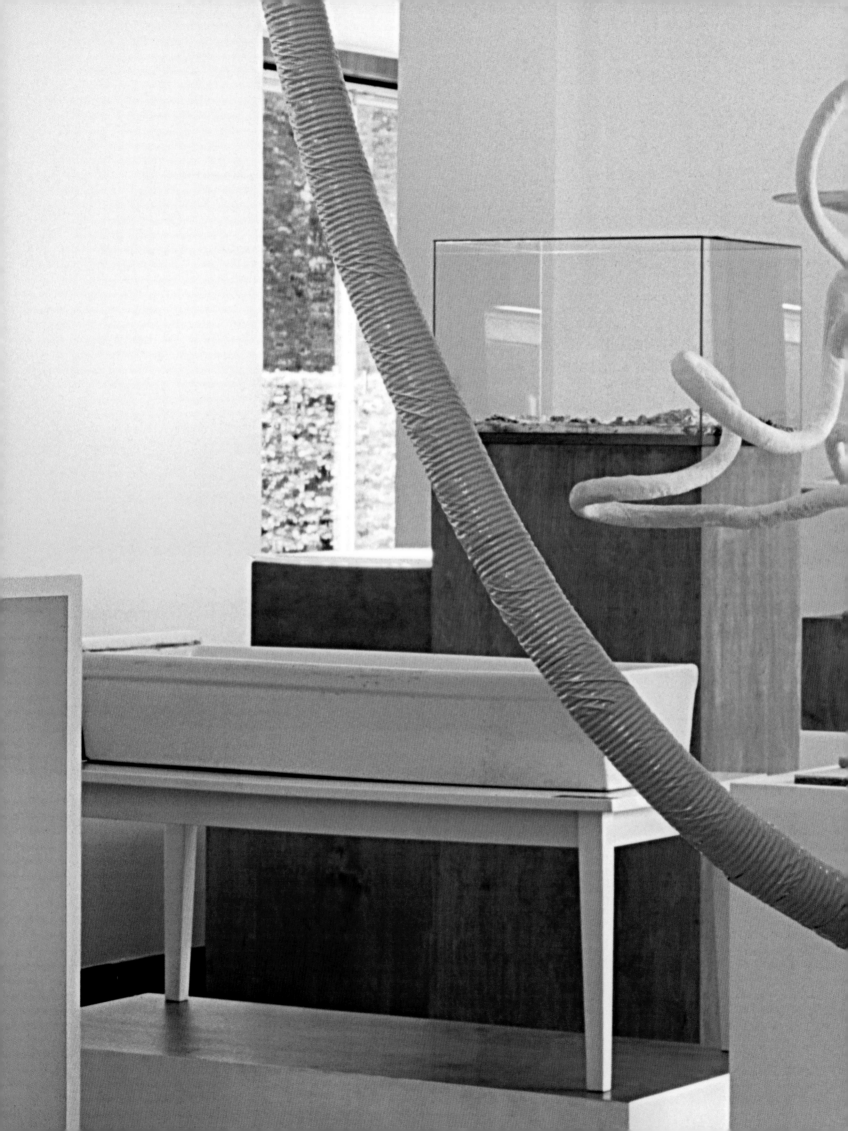

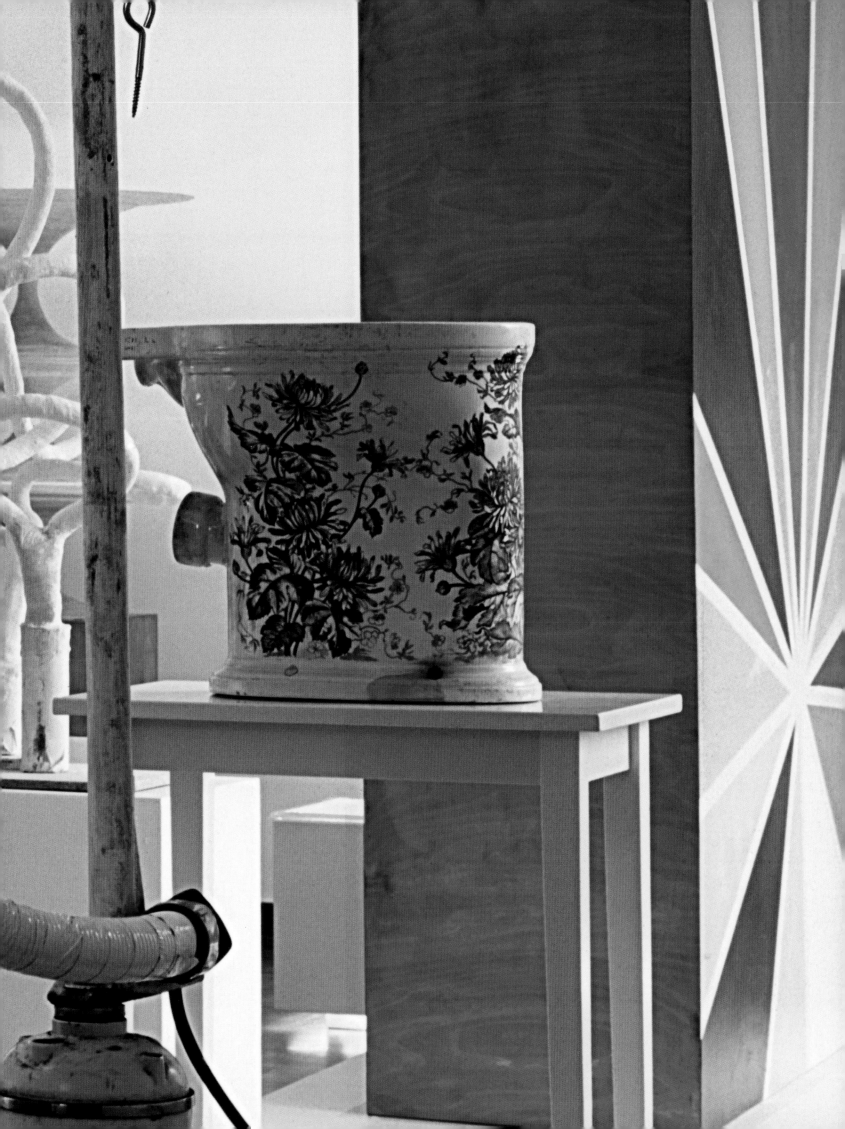

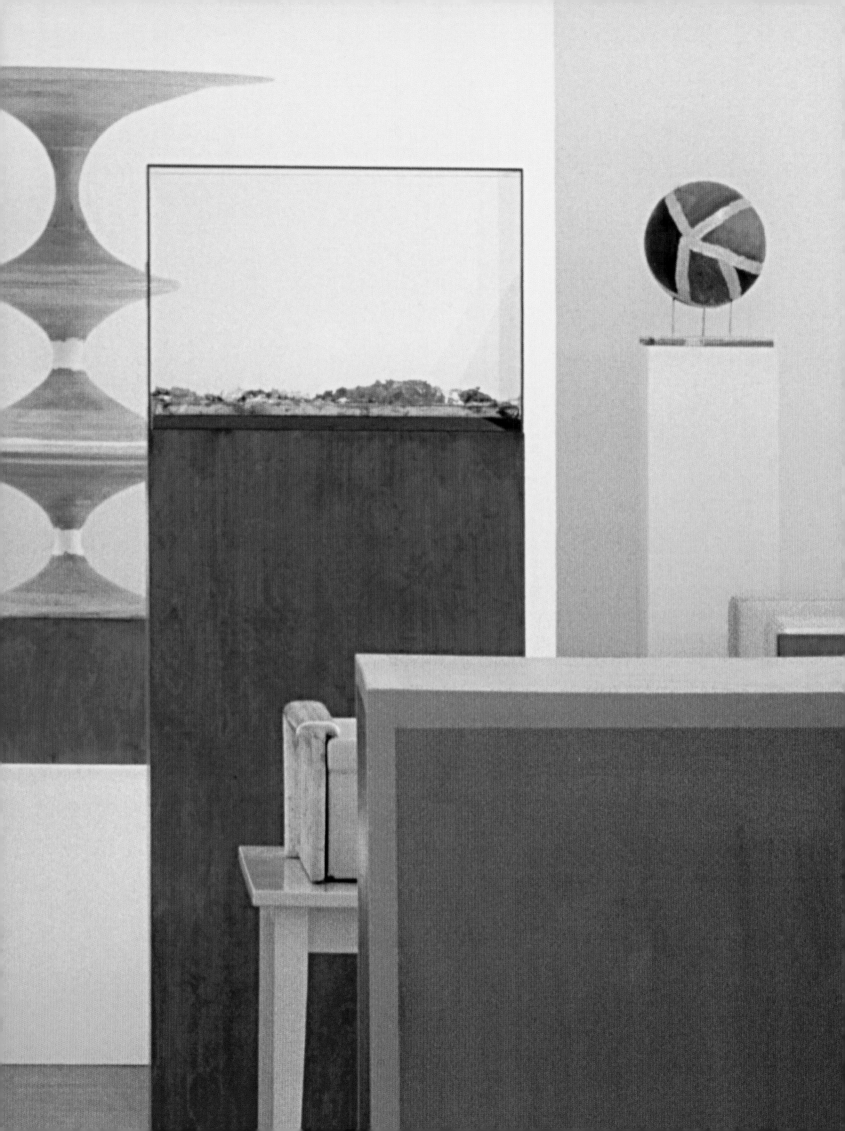

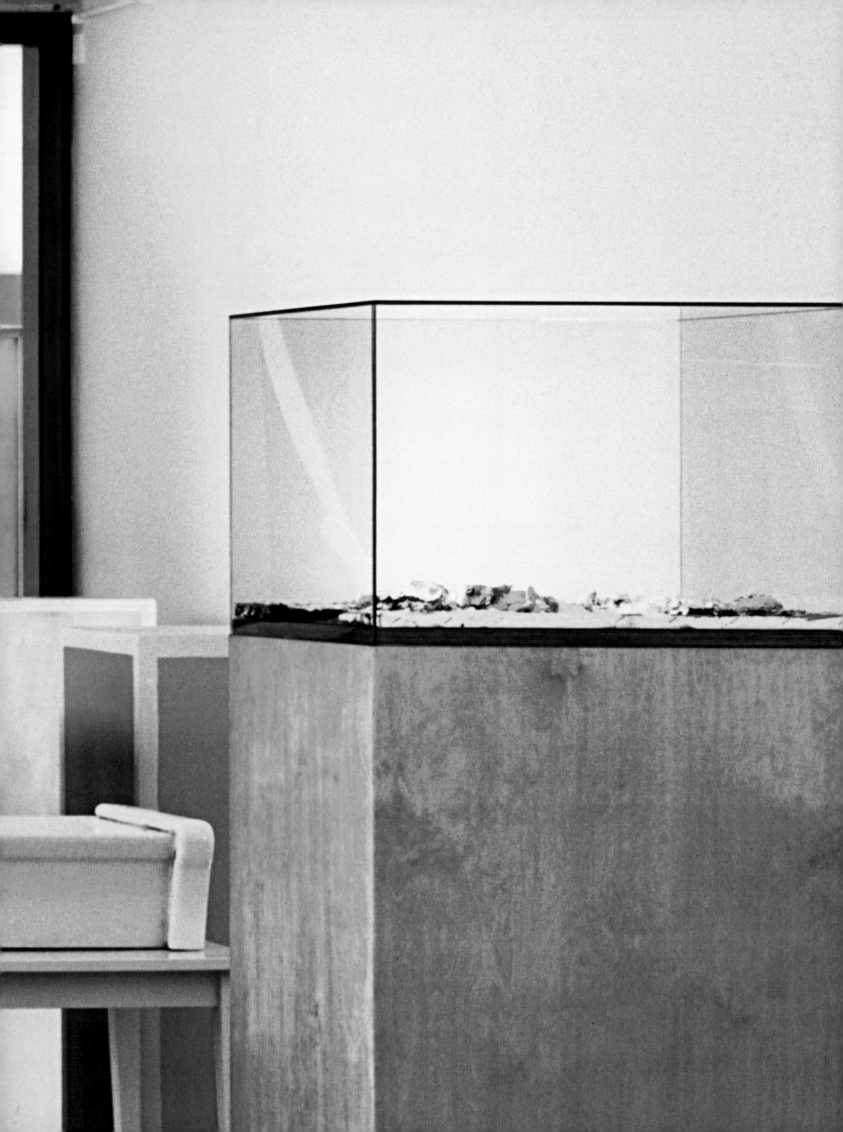

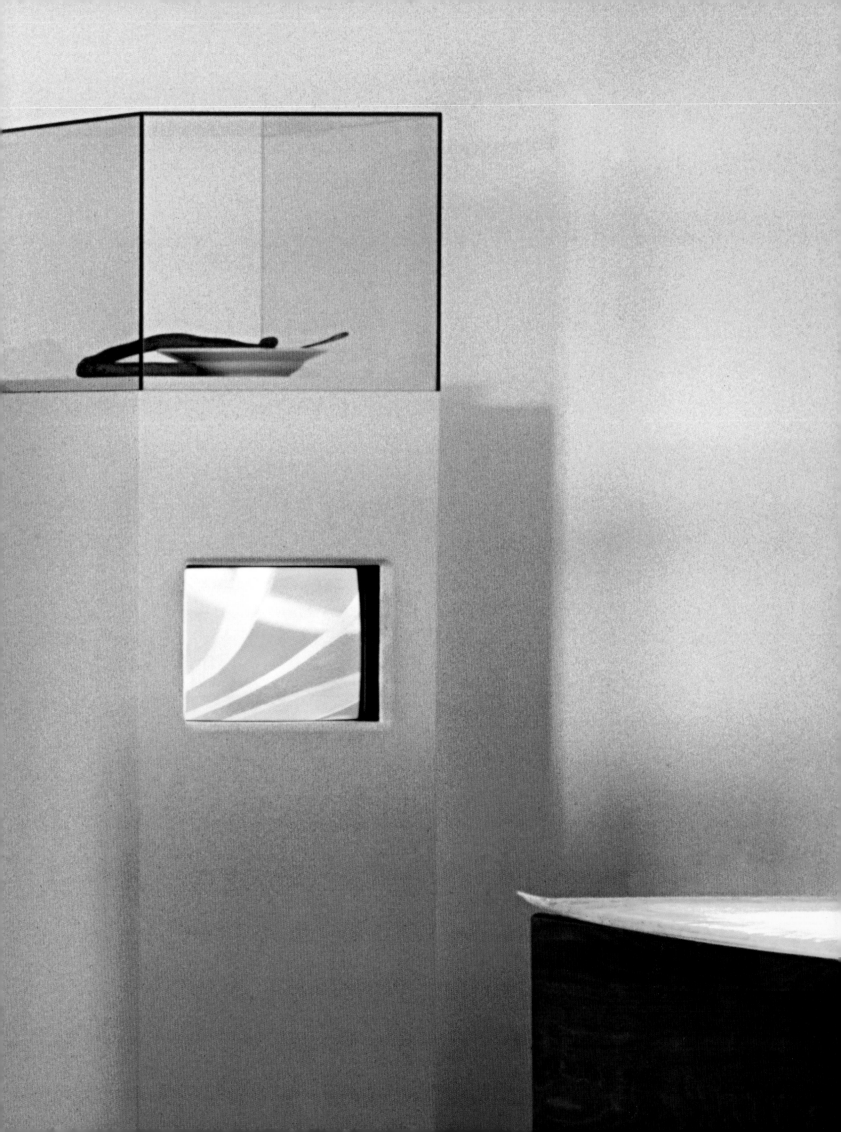

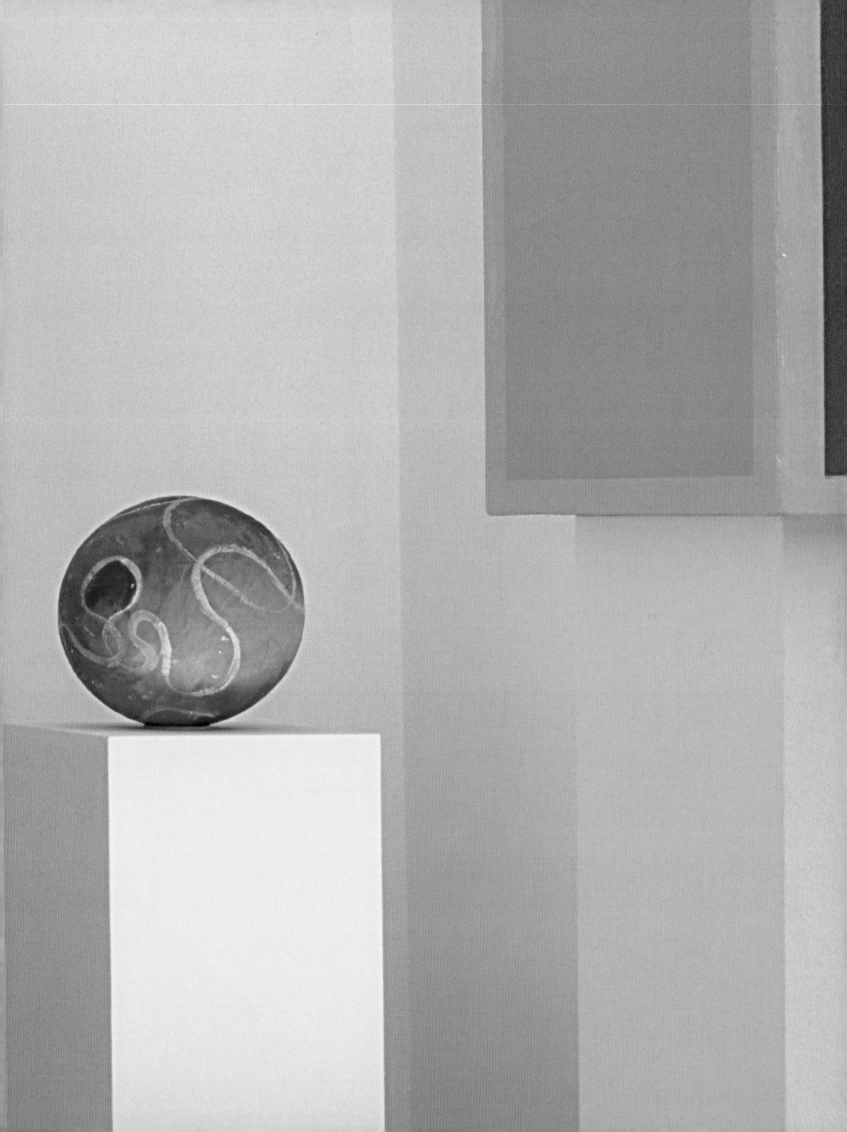

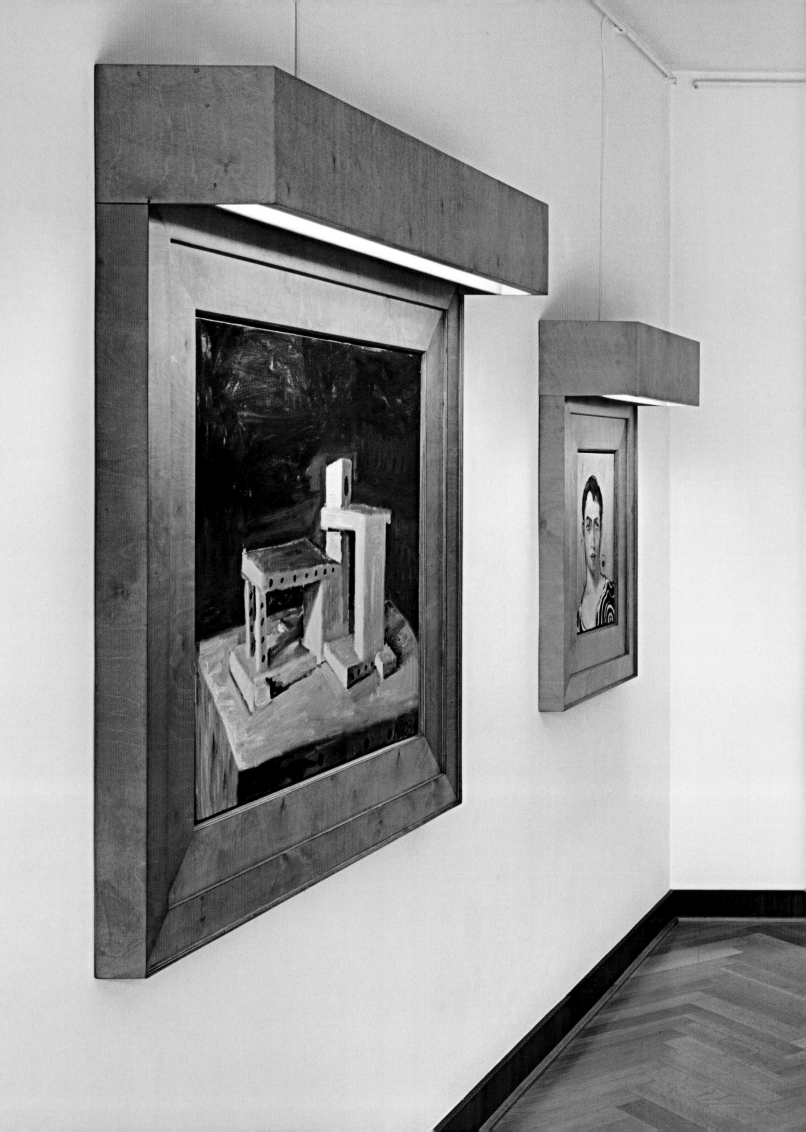

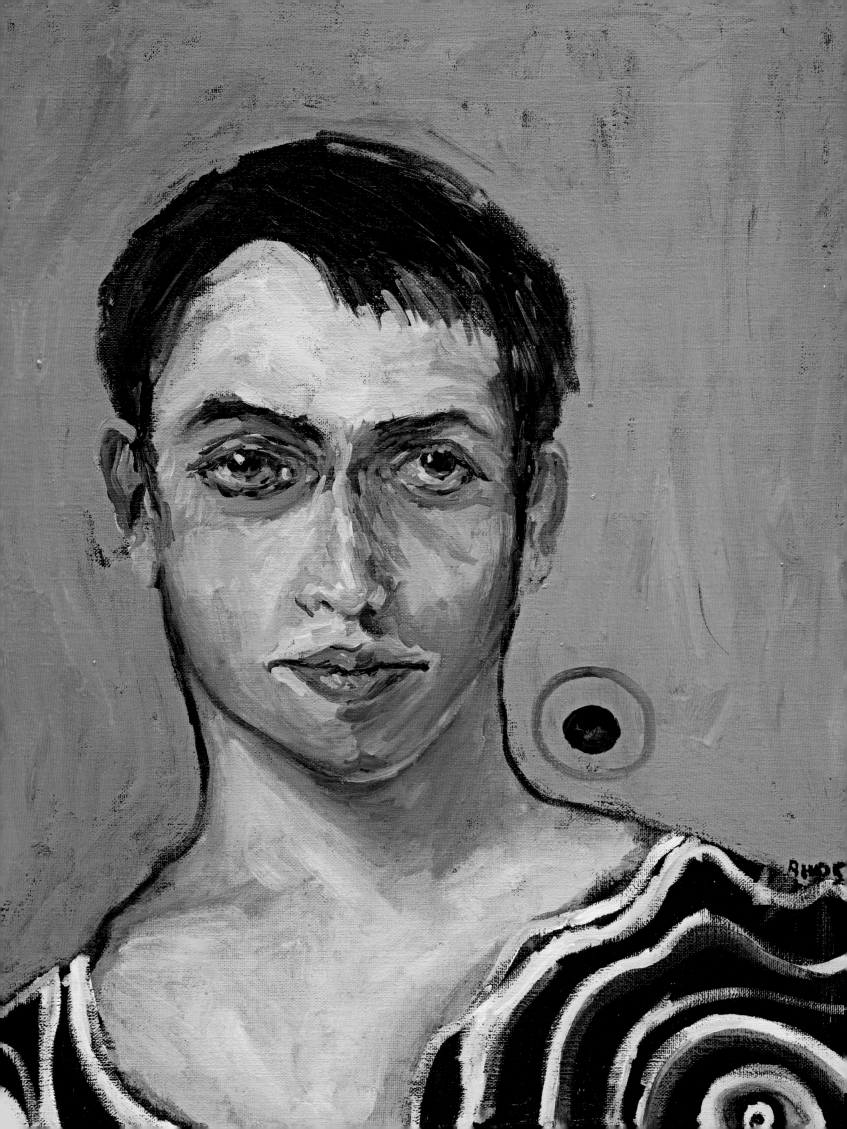

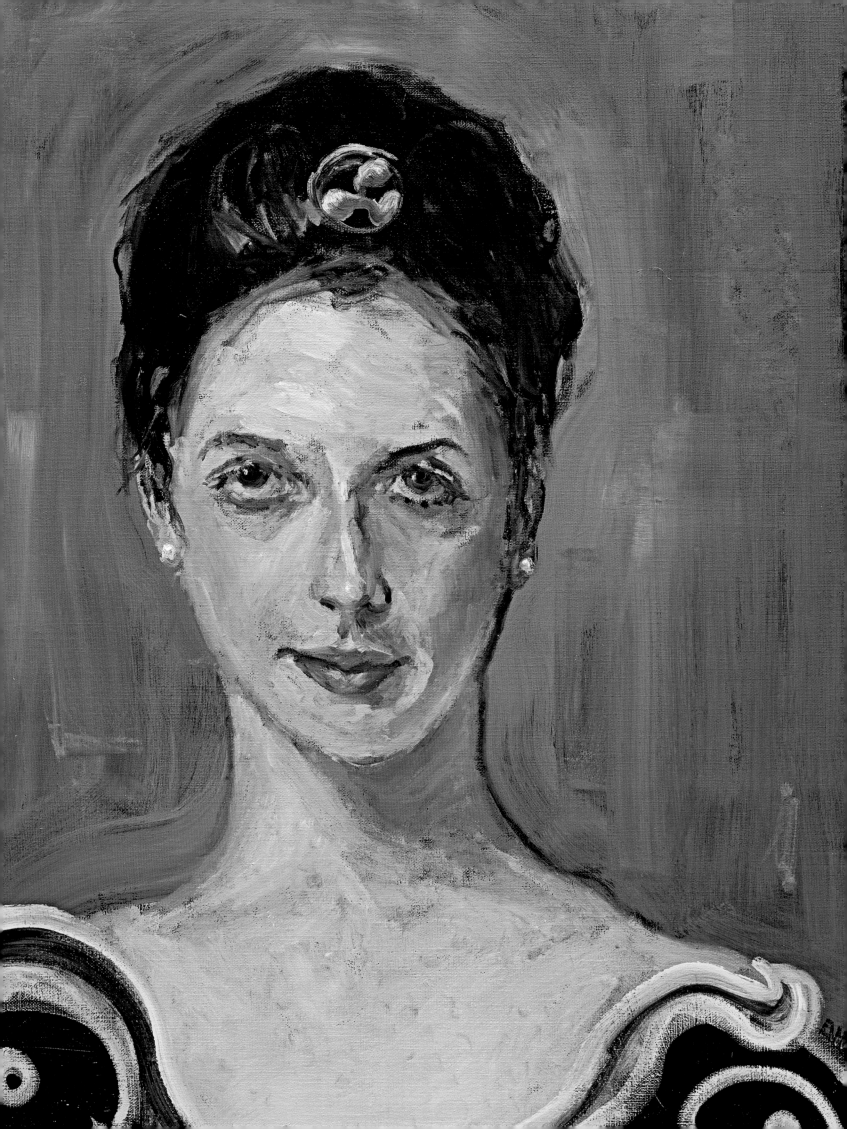

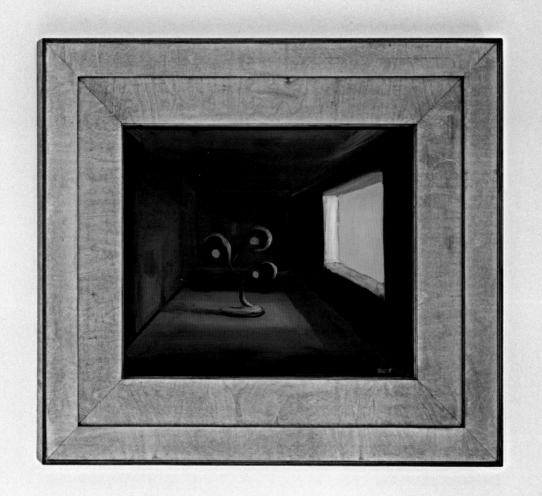

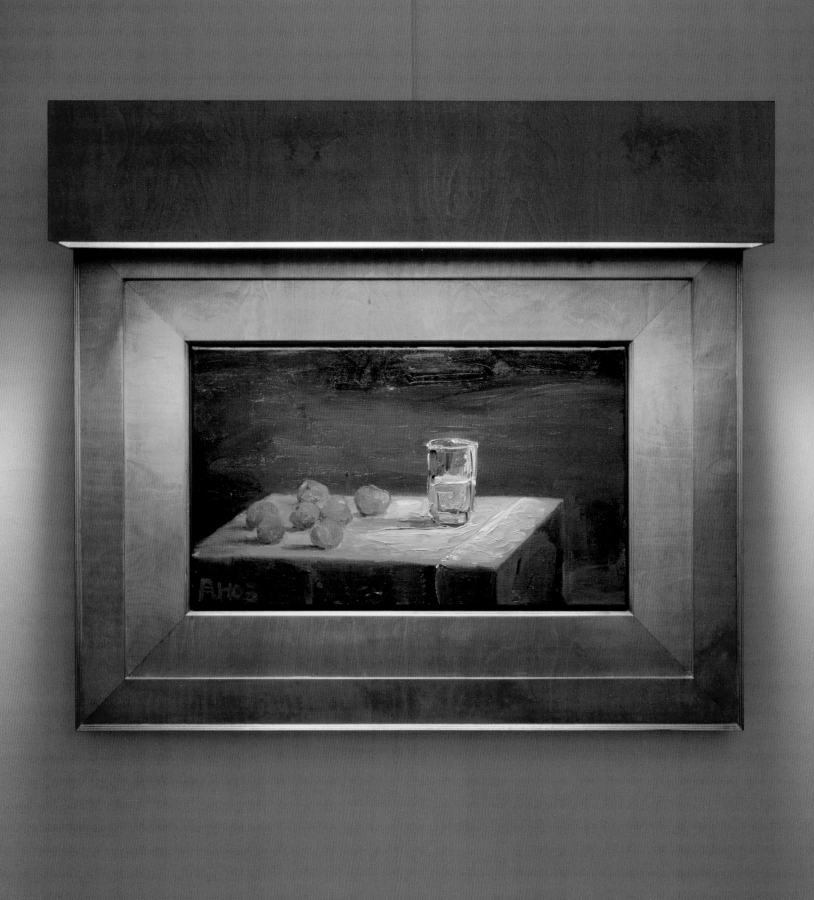

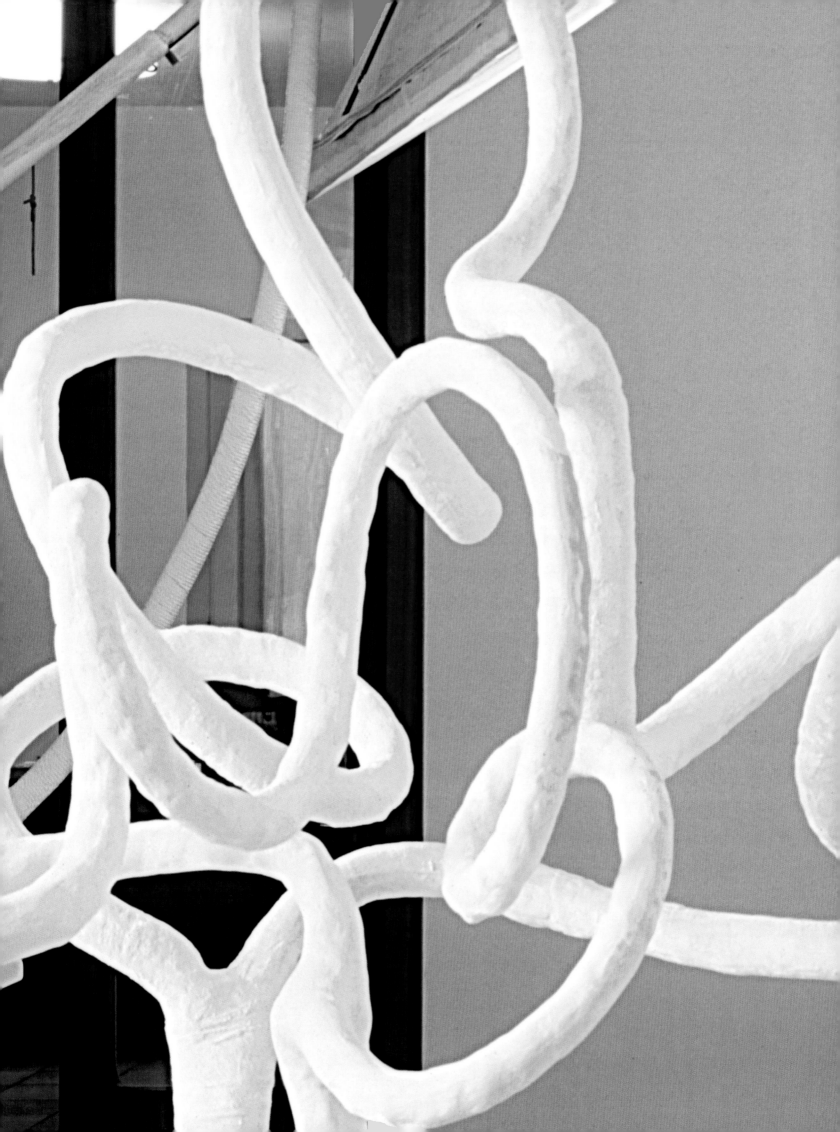

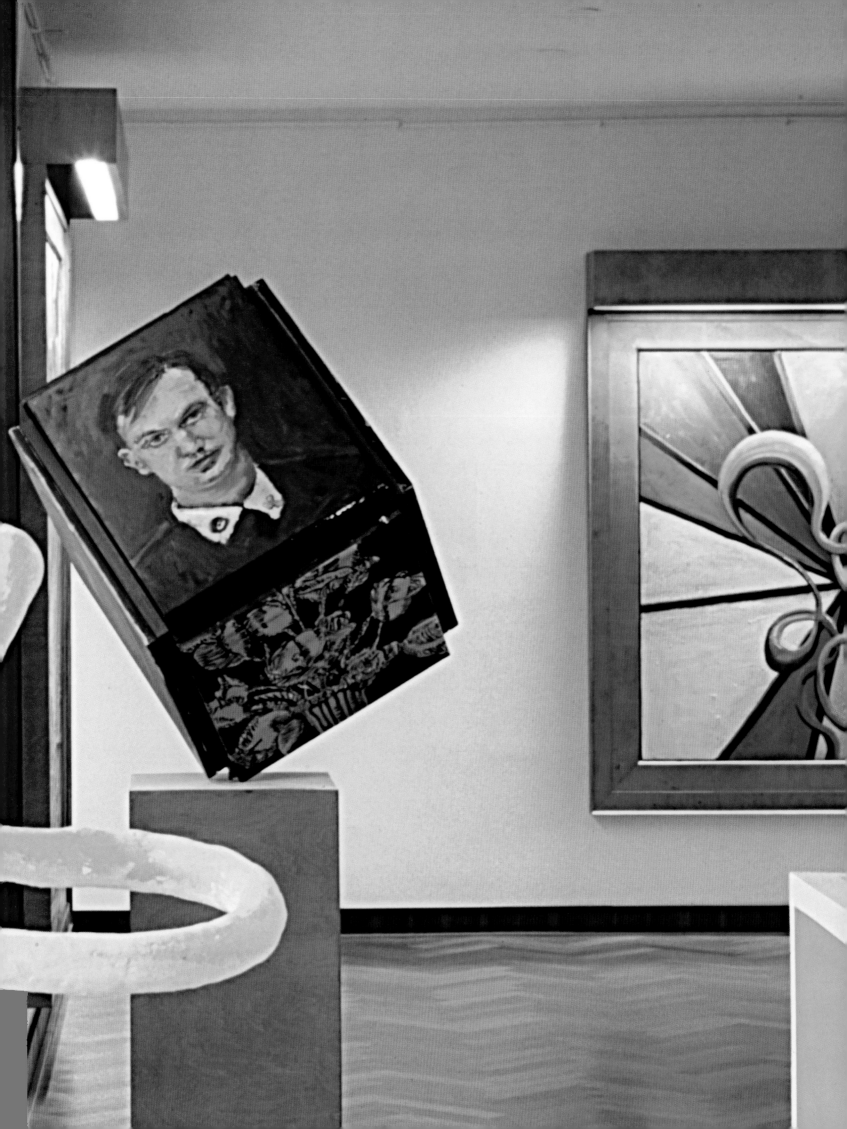

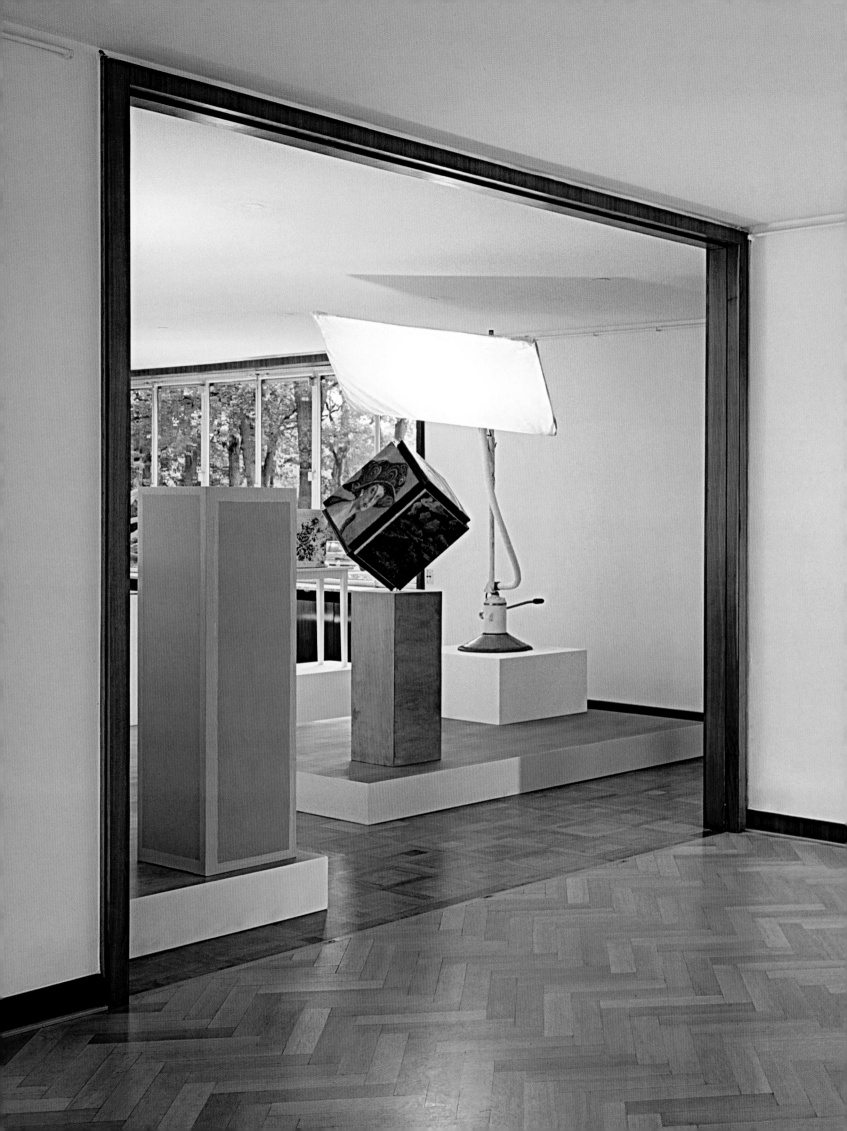

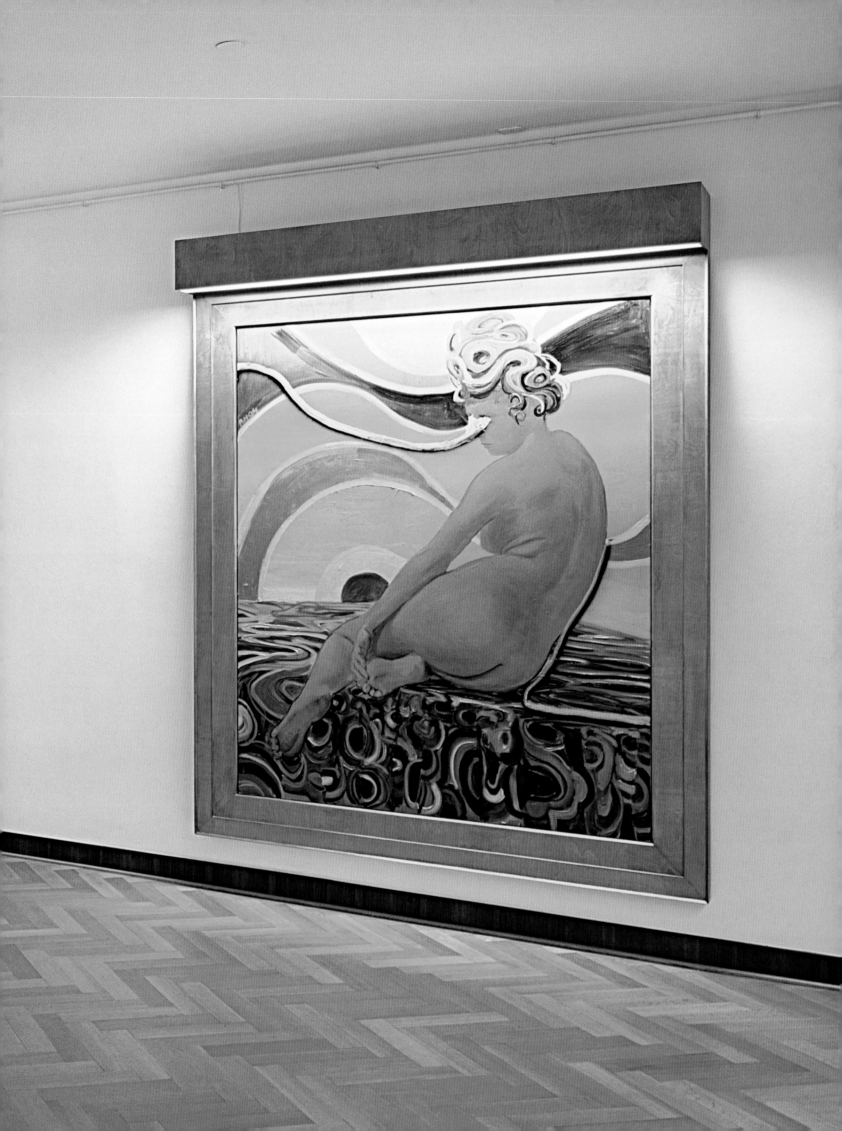

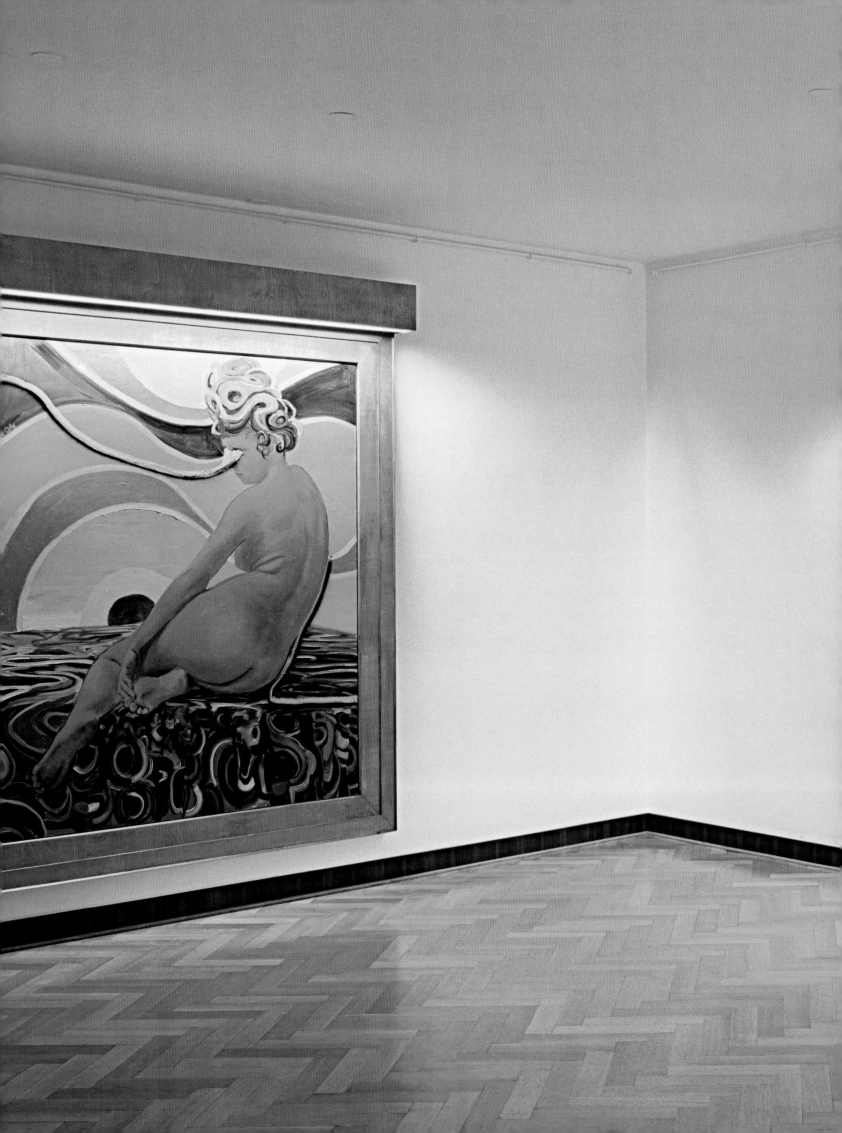

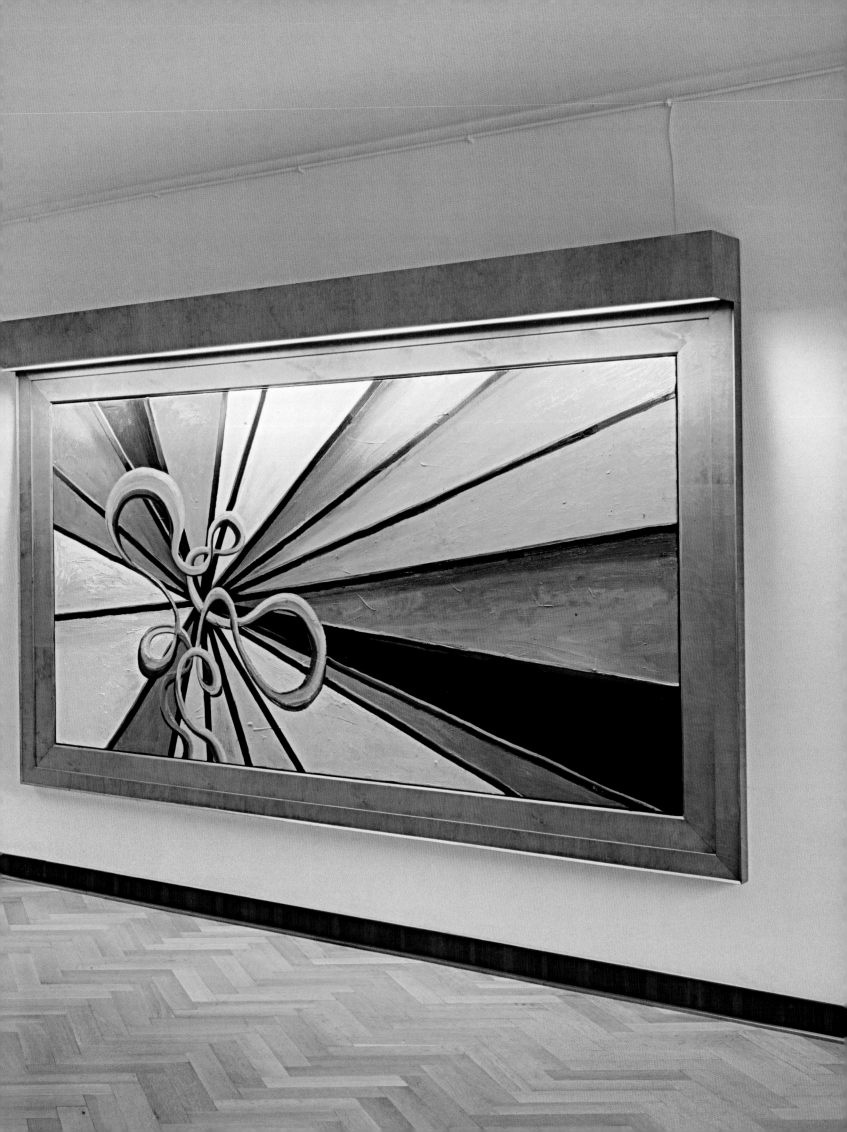

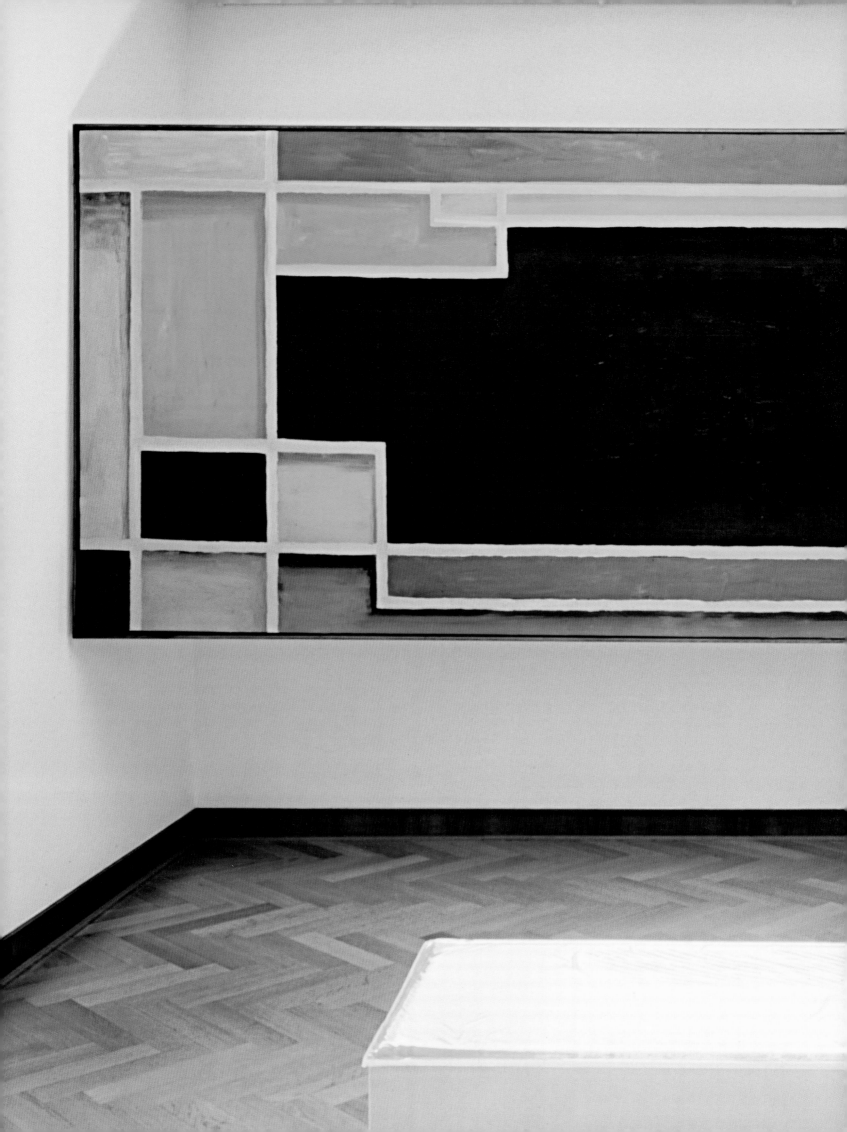

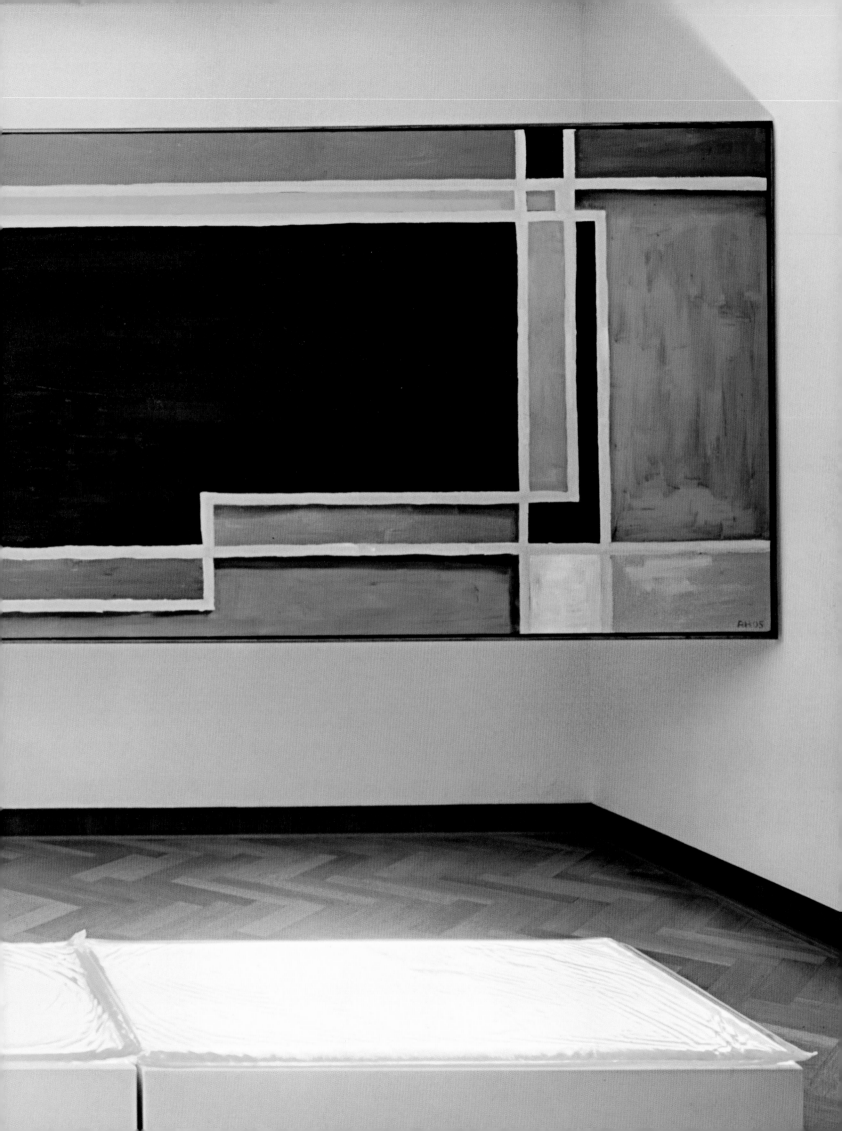

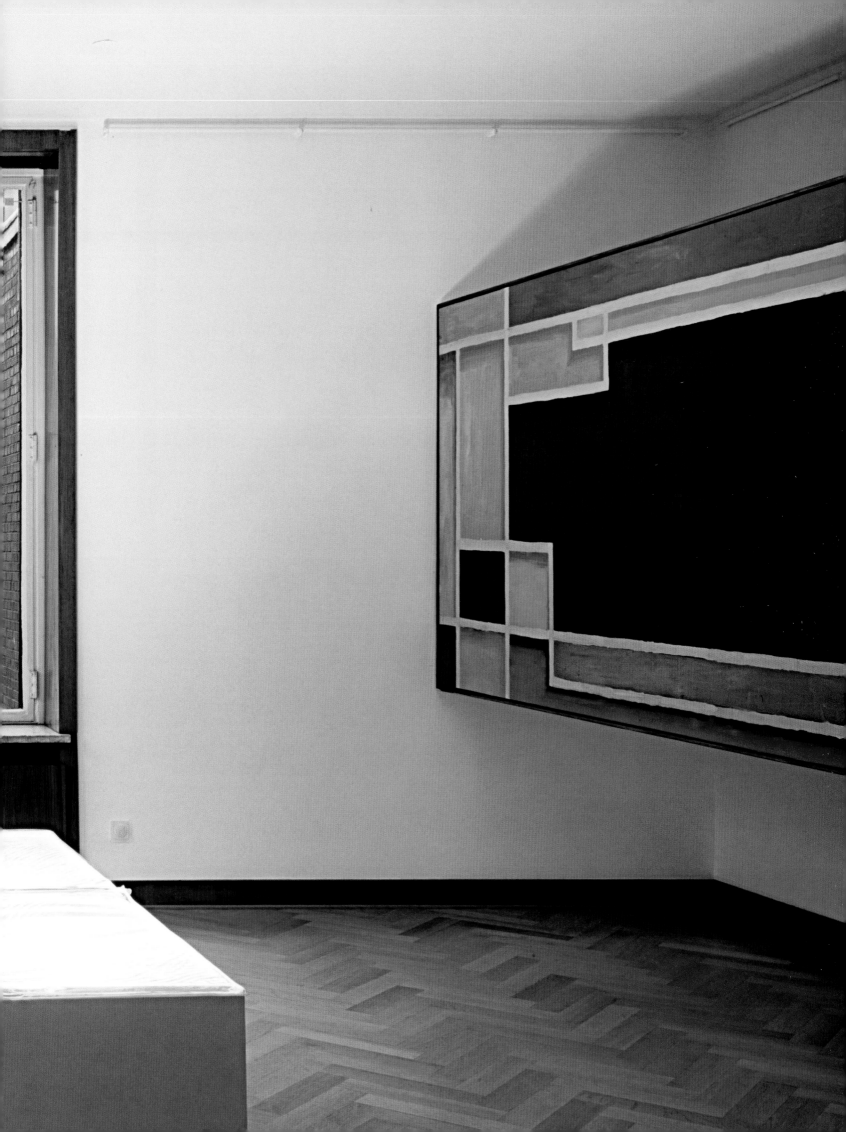

Oktogon für Herford

MARTa Herford

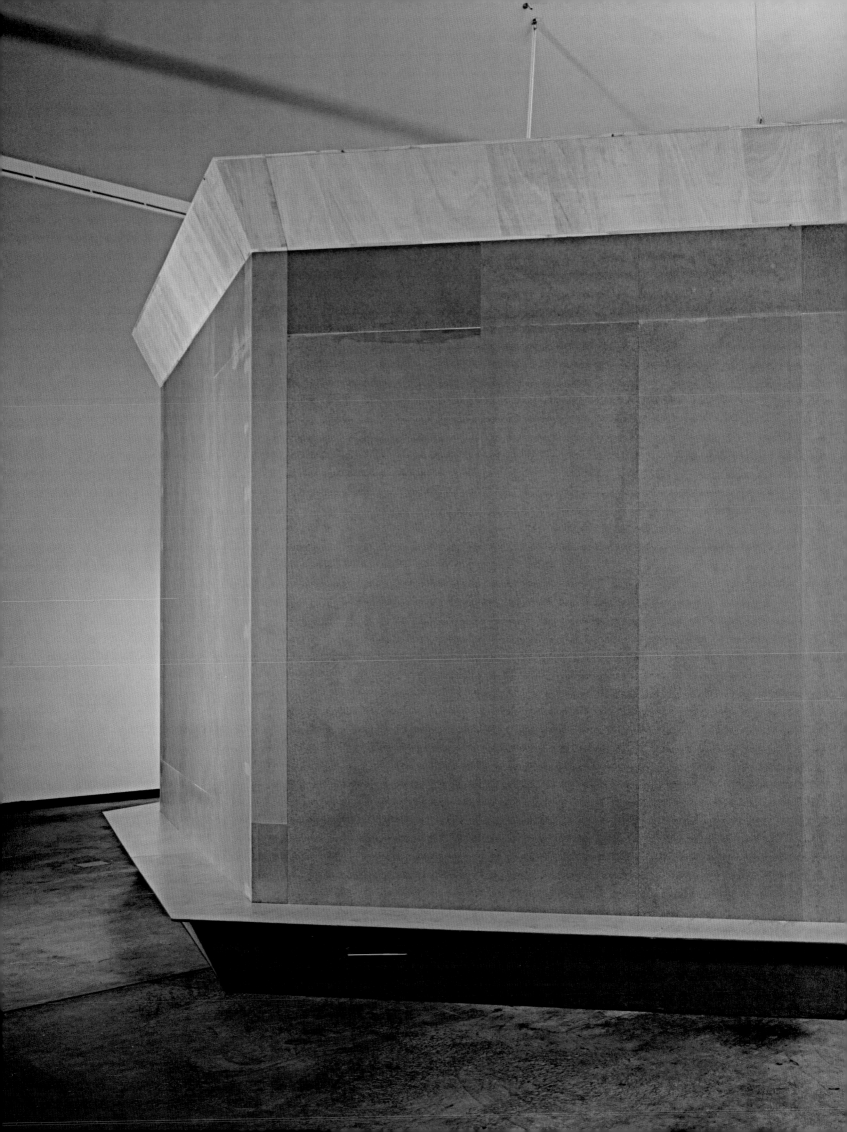

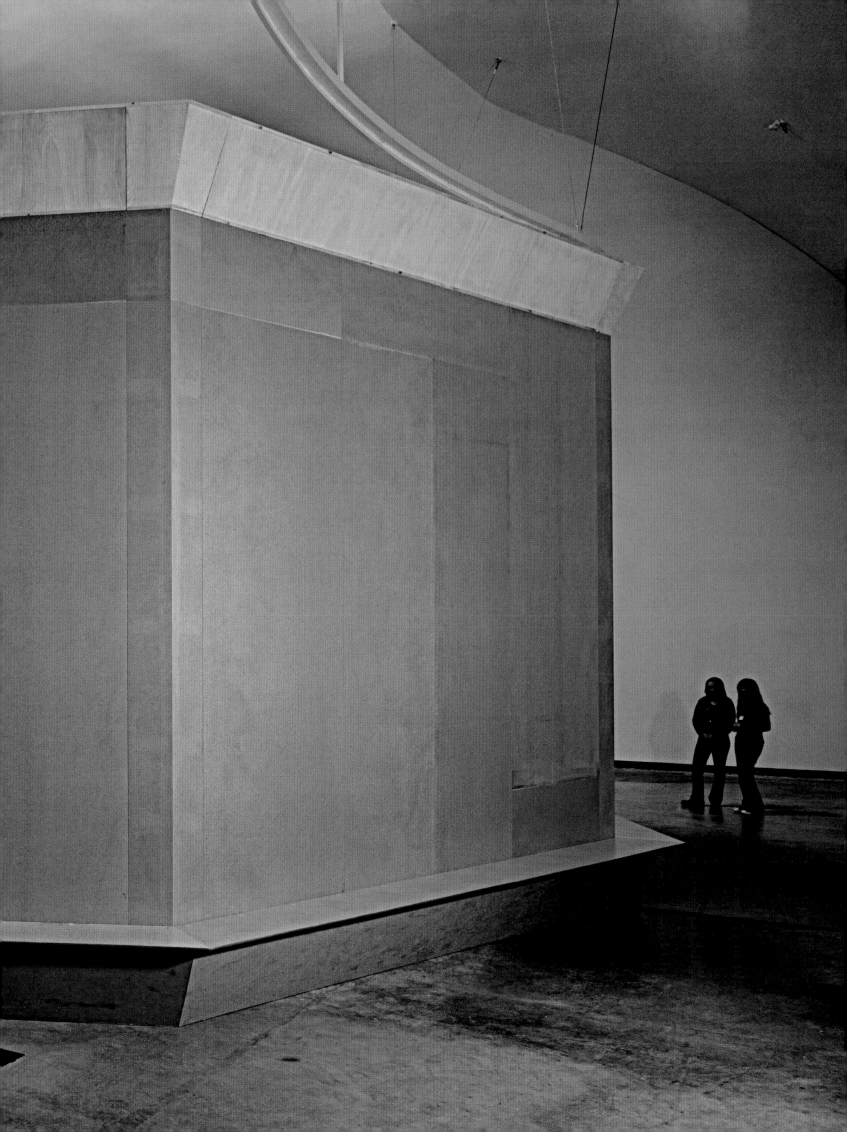

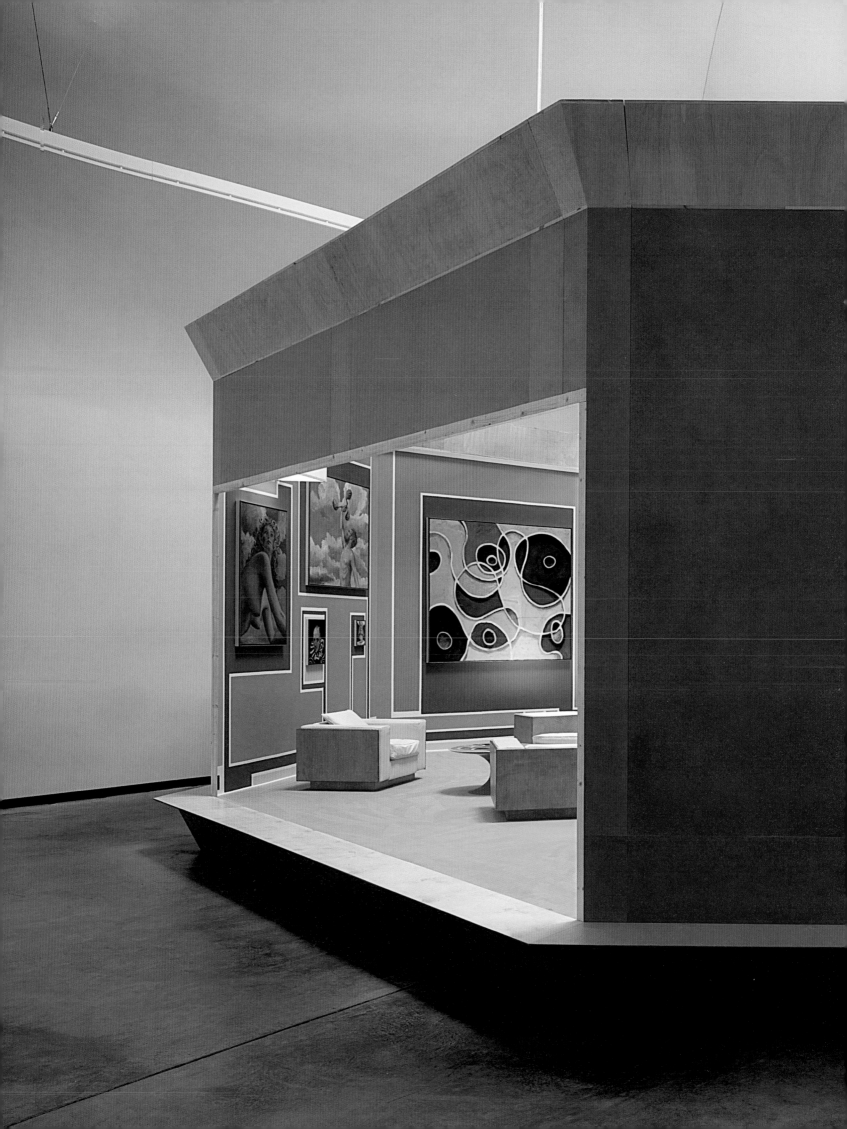

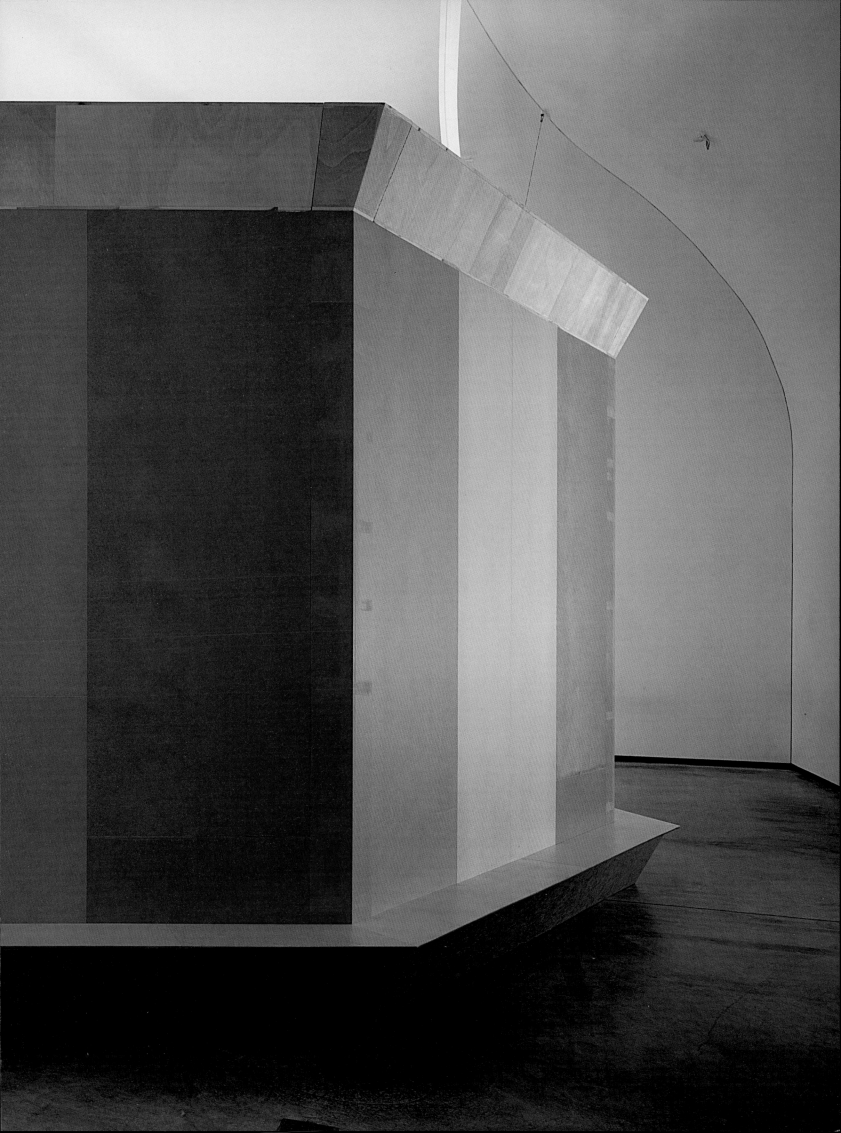

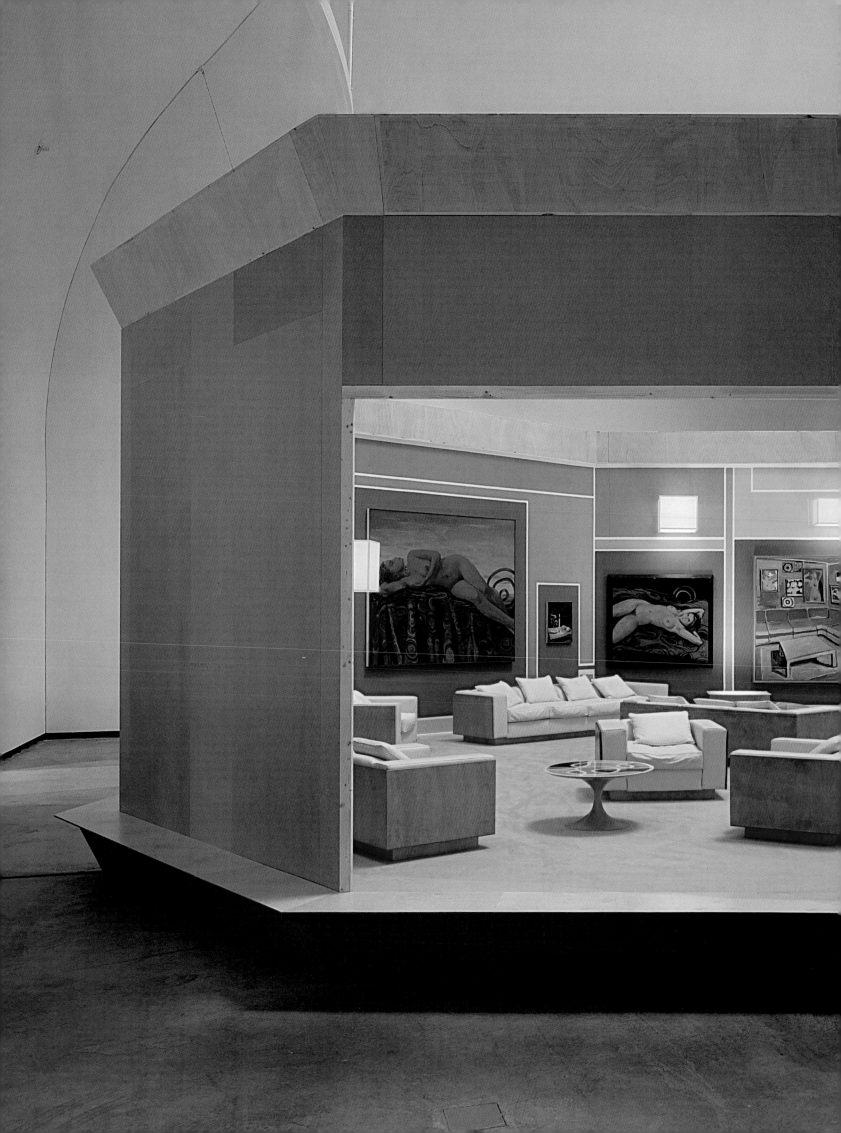

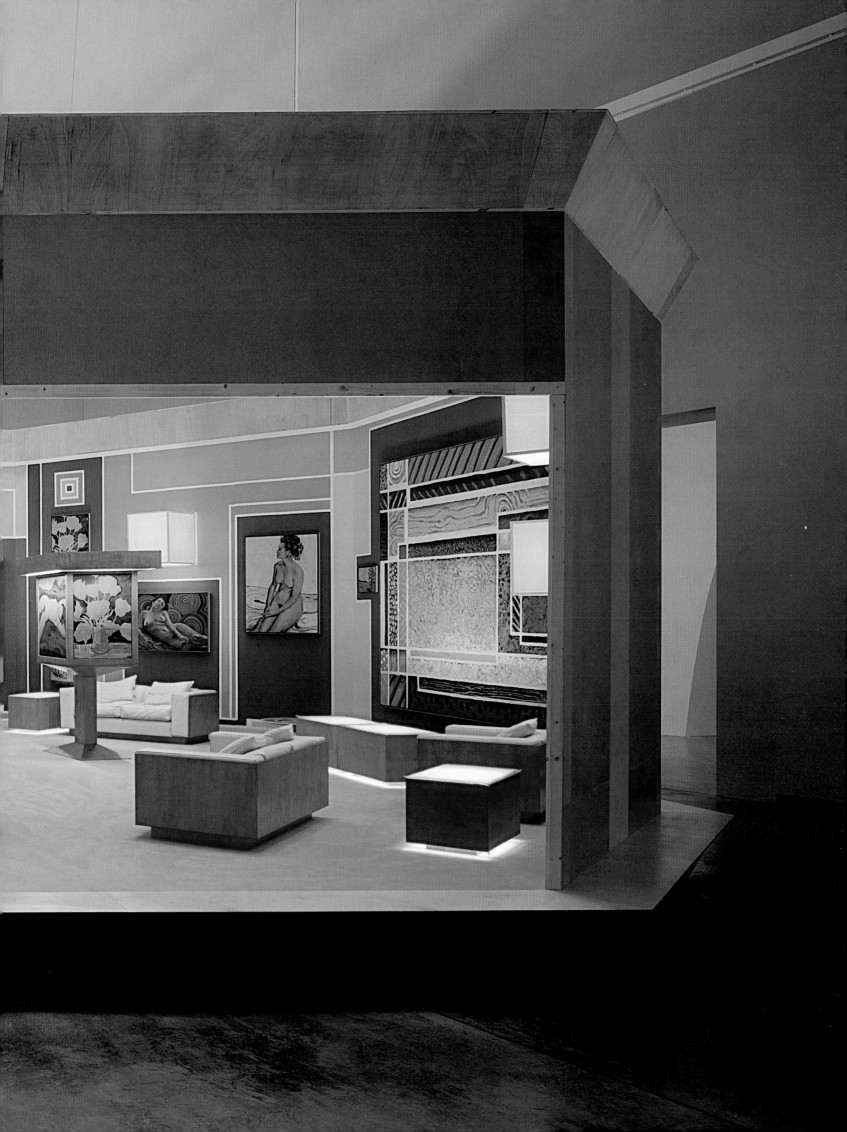

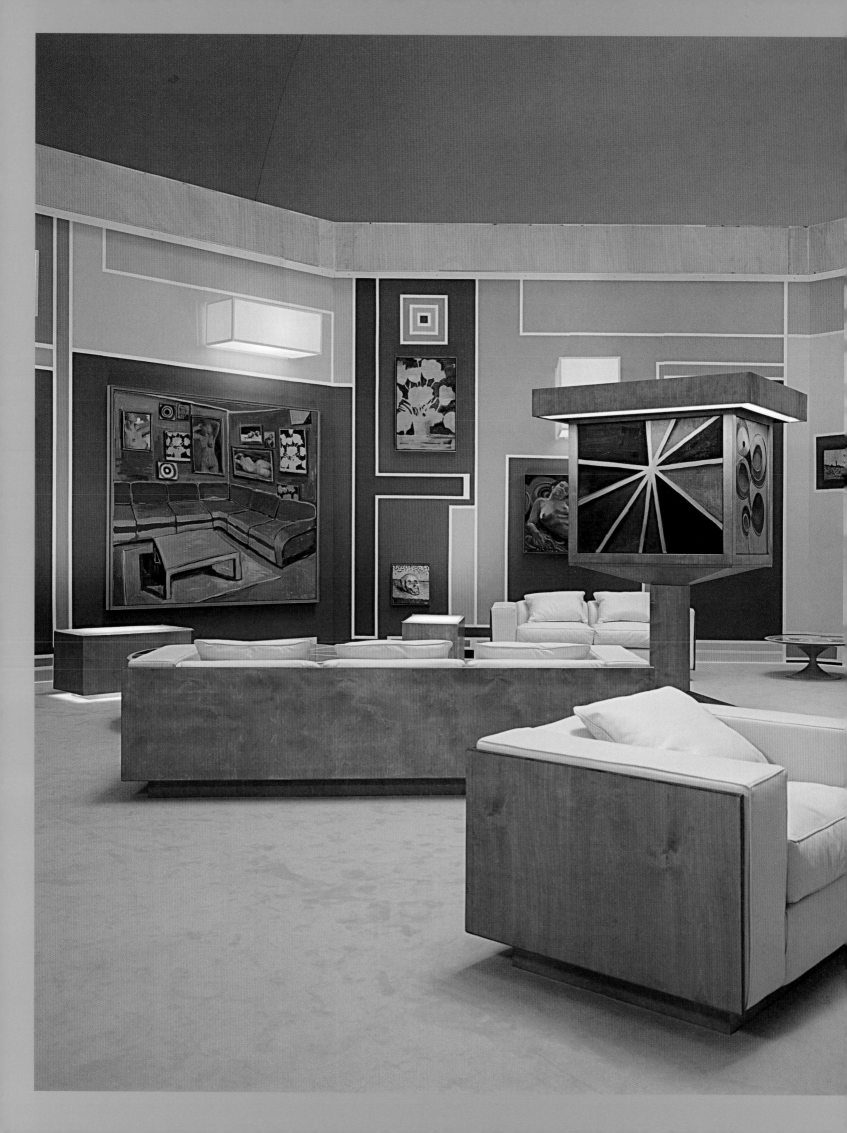

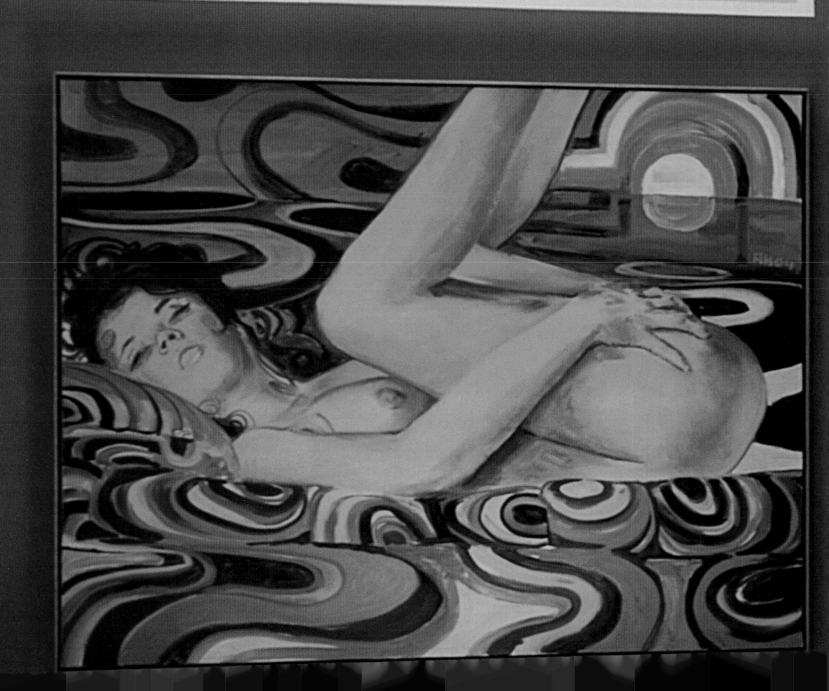

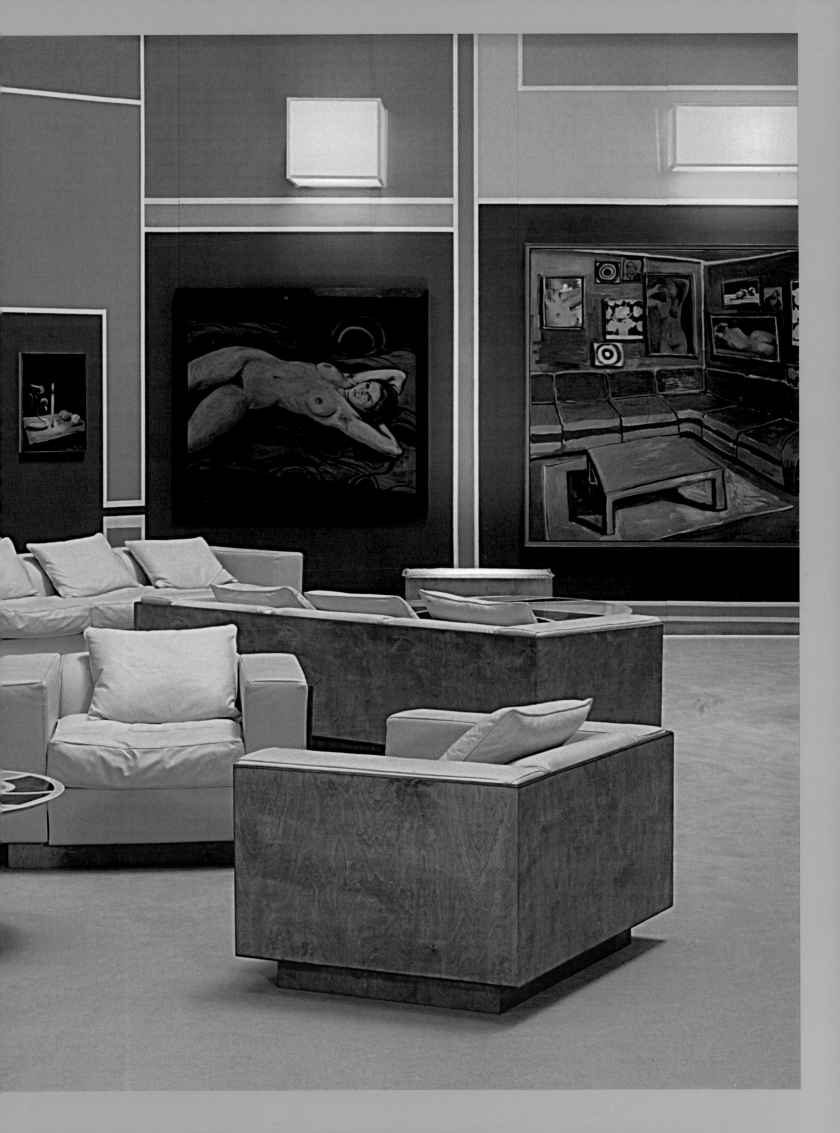

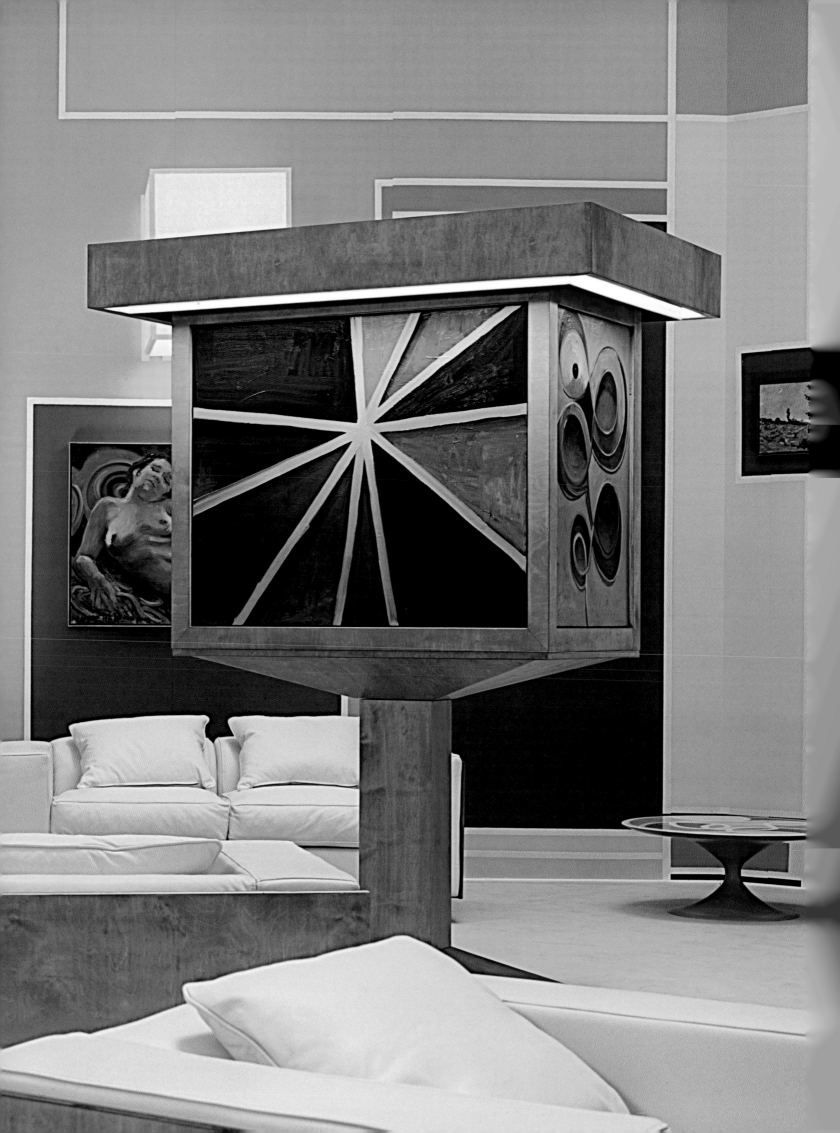

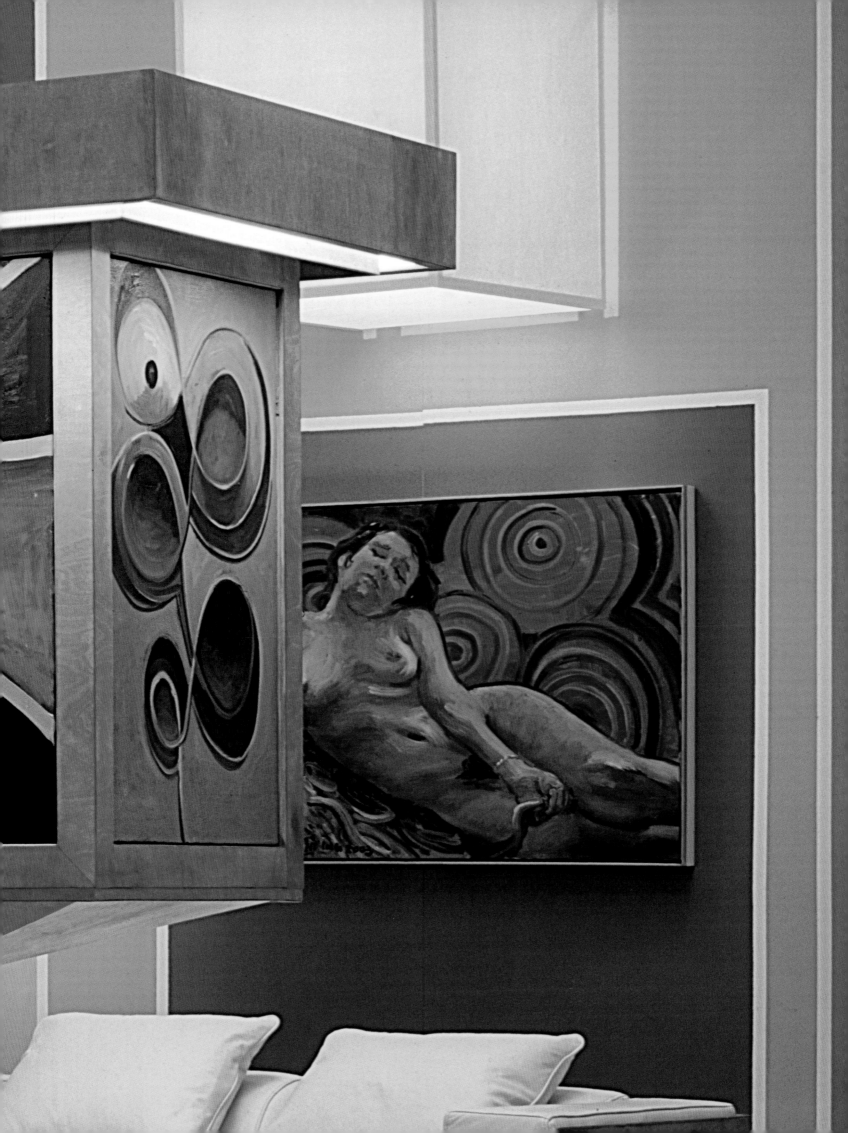

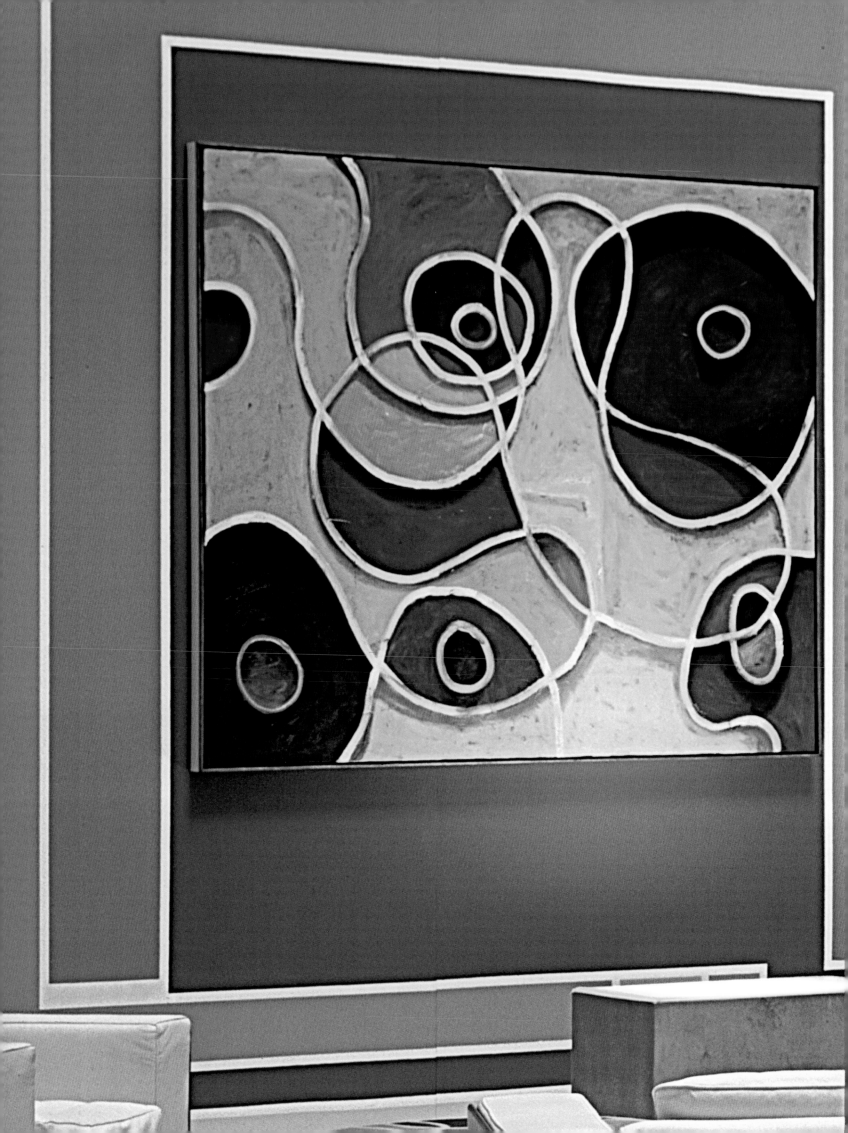

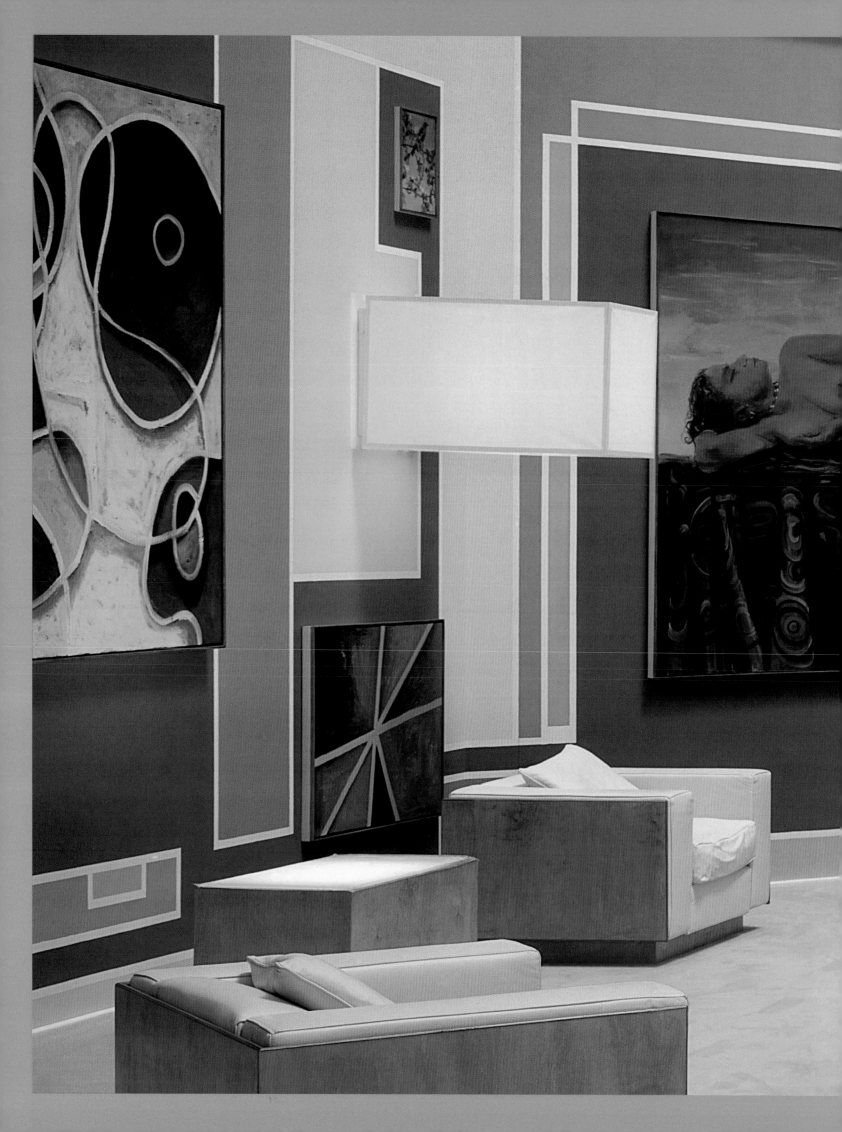

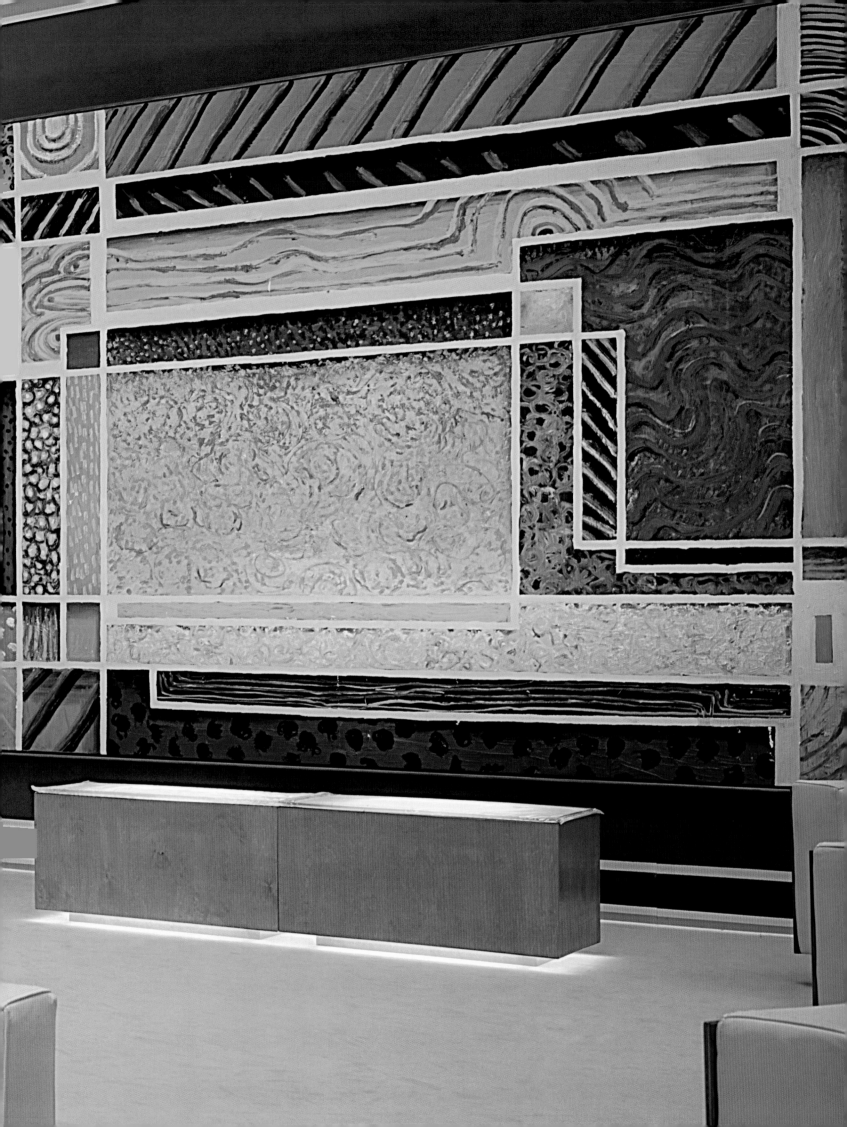

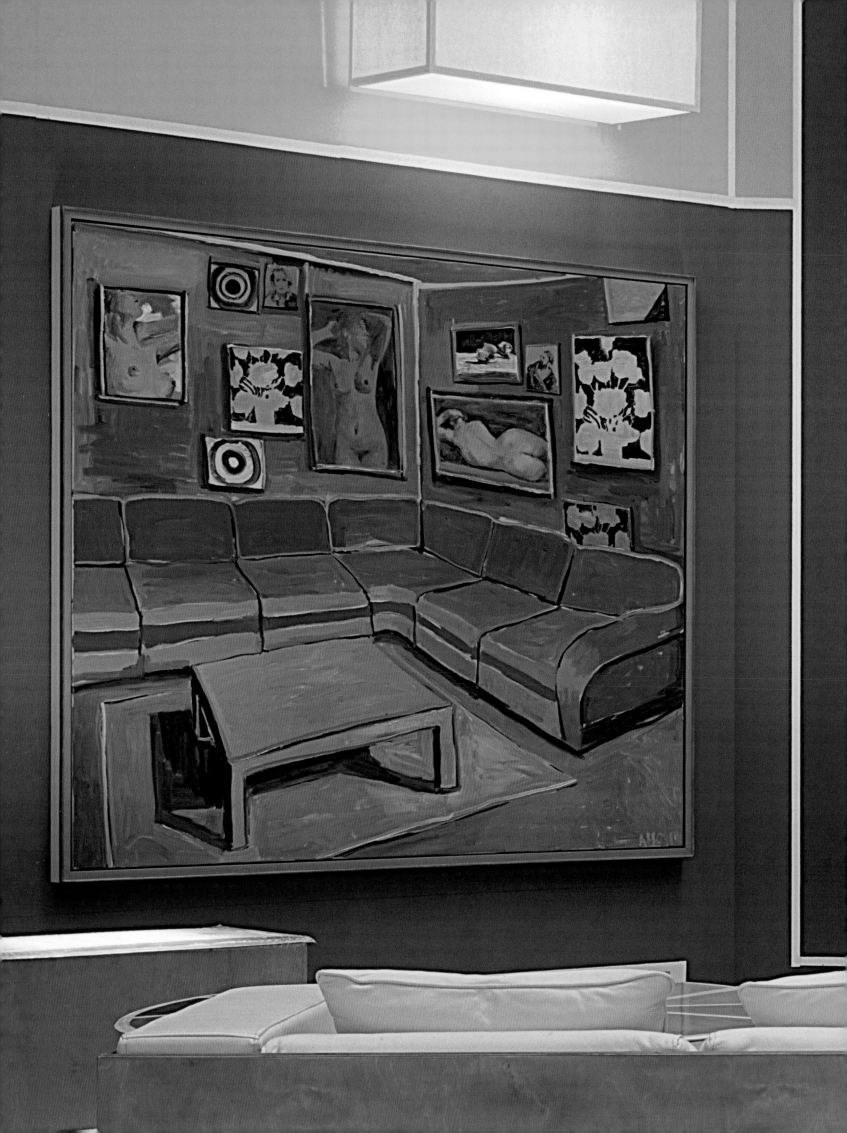

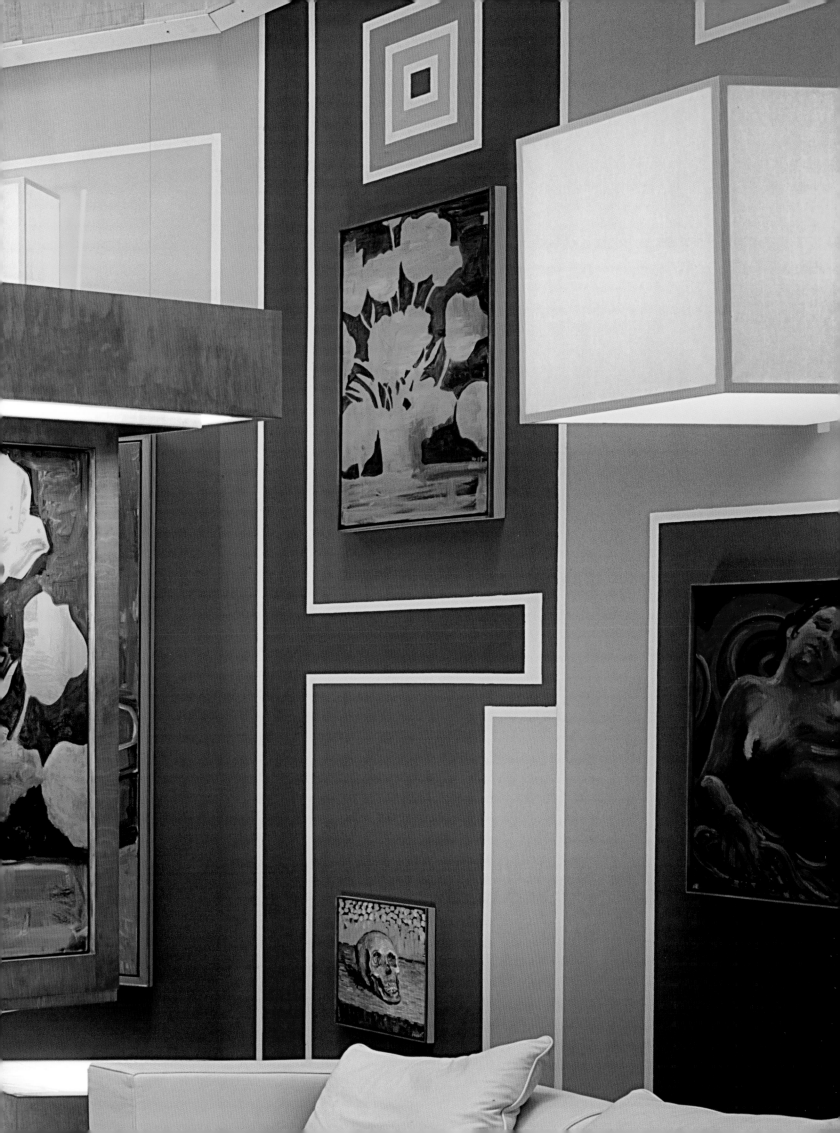

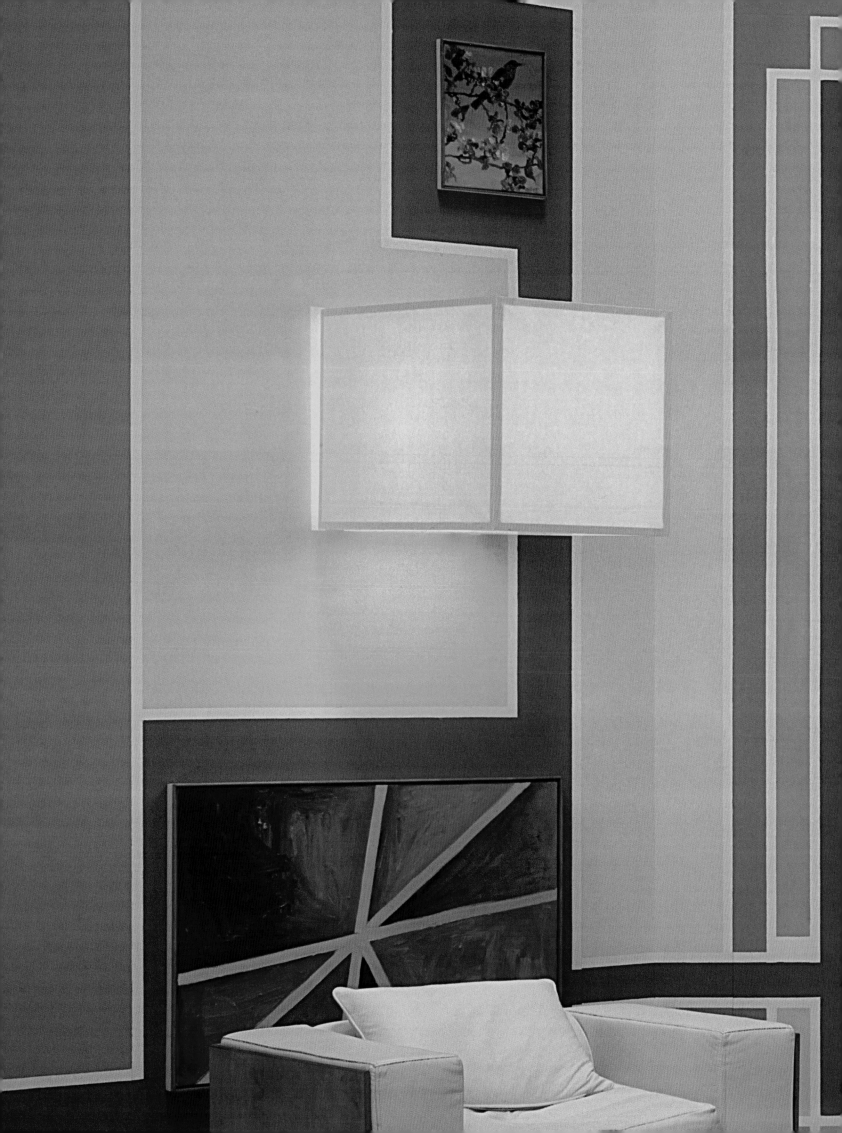

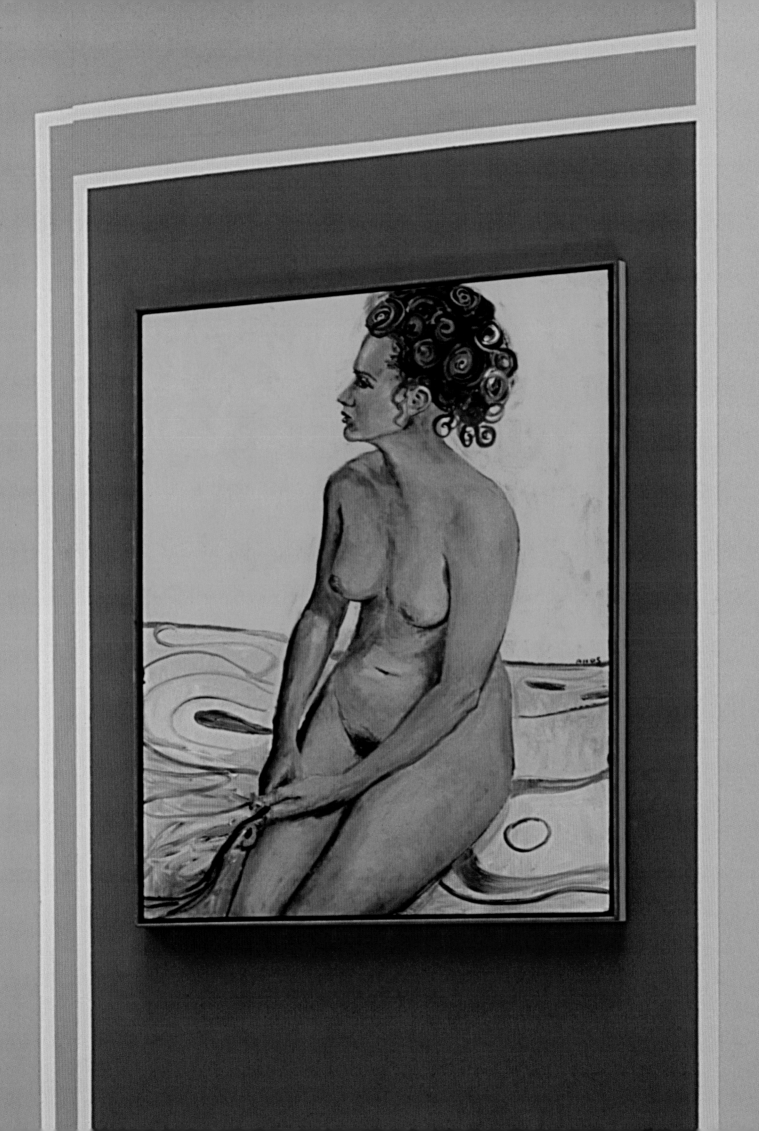

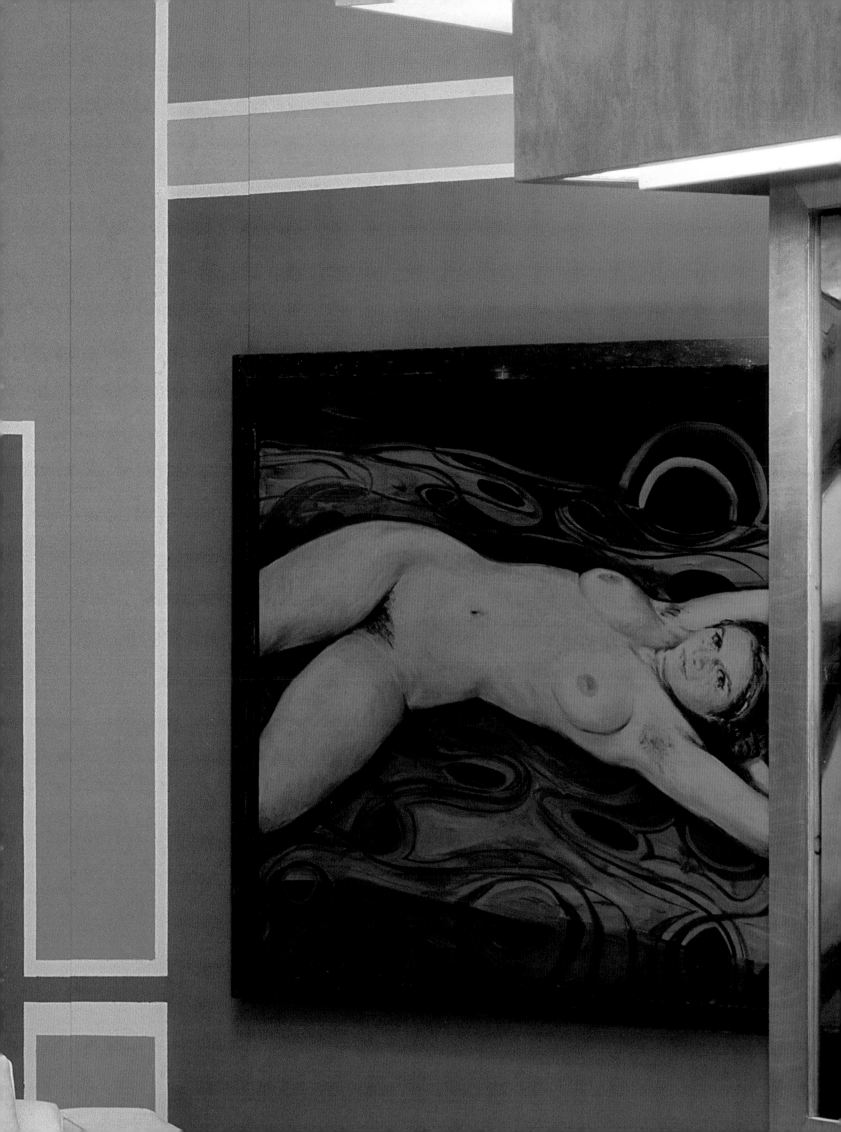

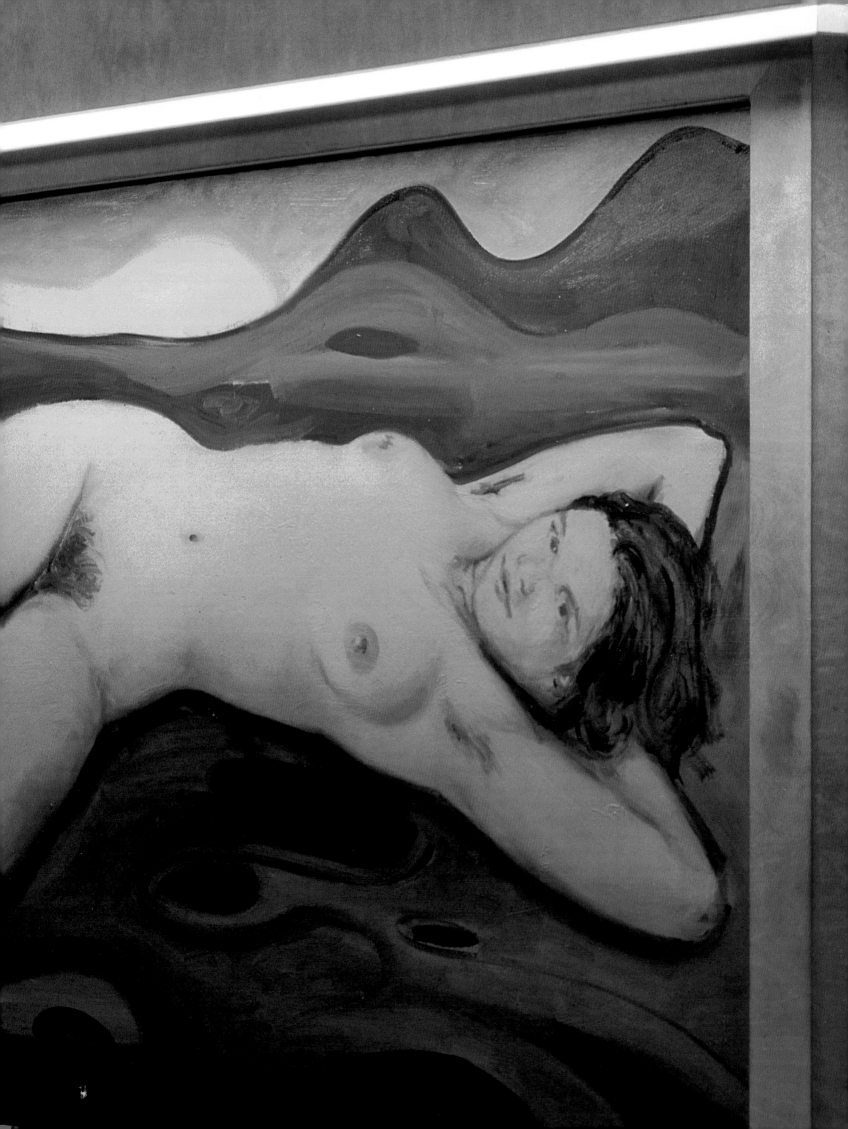

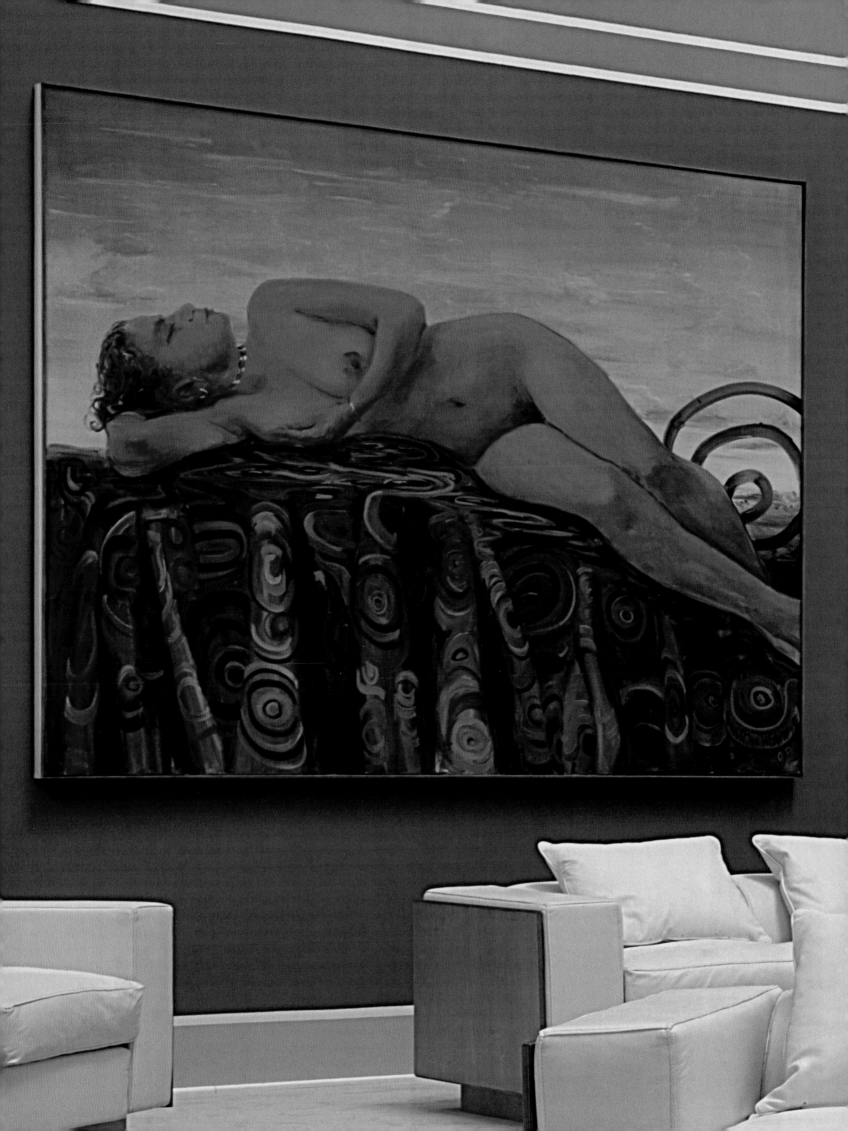

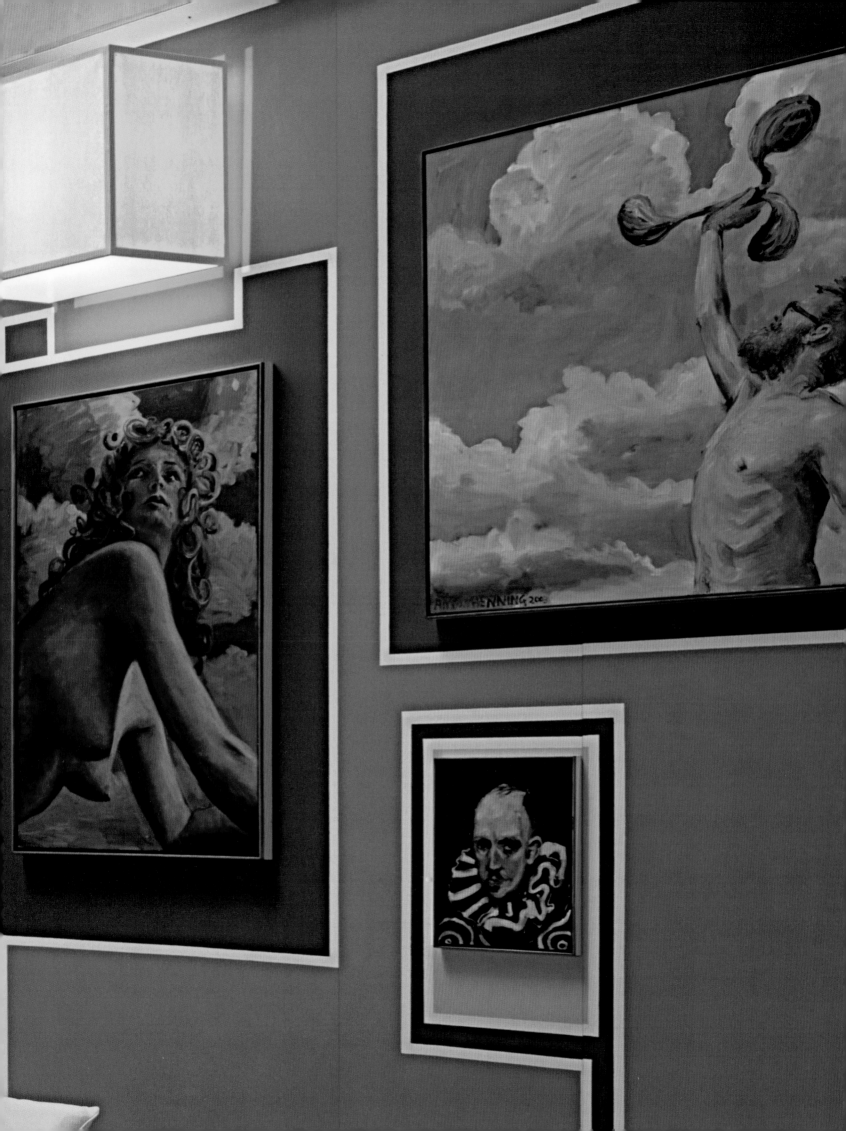

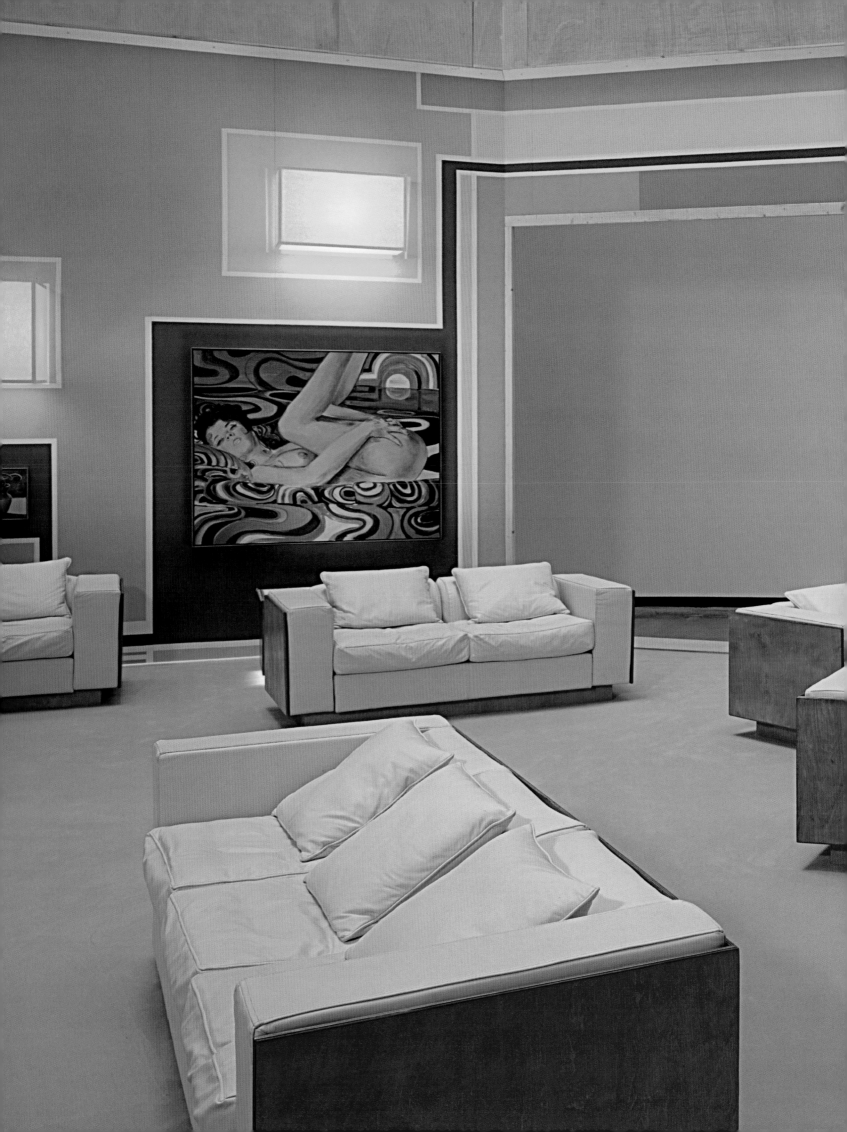

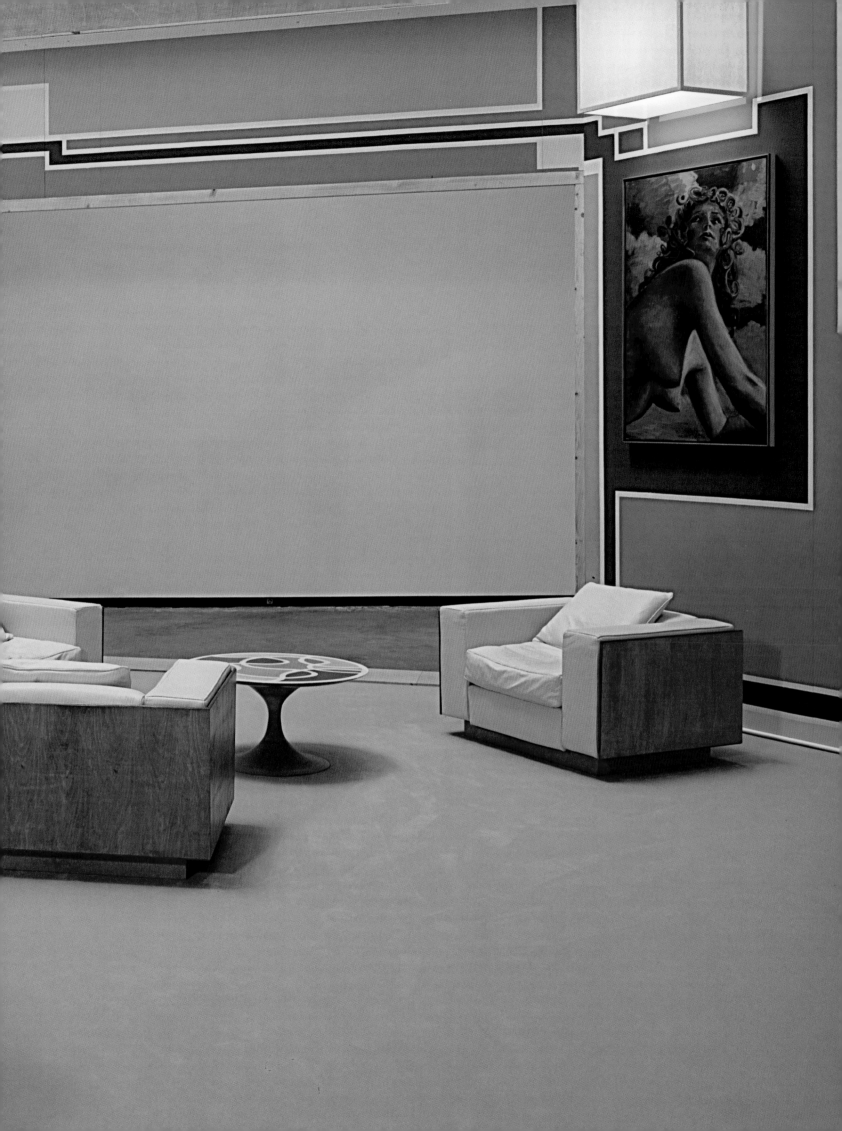

Verzeichnis der Werke List of Works

Frankfurter Salon, 2005

Raumspezifische Installation site-specific installation
Wandmalerei, Sitz- und Leuchtmöbel, Tische, Wand- und Deckenlampen, Bibliotheken
mural painting, chairs, lighting furniture, tables, wall lights, ceiling lights, libraries
Installationsmaß variabel dimensions of the installation variable
Museum für Moderne Kunst, Frankfurt am Main
Realisiert mit großzügiger Unterstützung der Dornbracht Installation Projects®
realized with generous grant by Dornbracht Installation Projects®

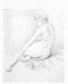
1 Pin-up No. 85, 2004
Bleistift auf Papier auf Leinwand
pencil on paper on canvas
203,5 x 172,4 cm
Museum für Moderne Kunst, Frankfurt
am Main
Erworben mit großzügiger Unterstützung
von acquired with generous grant by
Karin und and Michael Thoma, Frankfurt
am Main

Erworben mit Mitteln aus einer Spende
von Karin und Michael Thoma zum
60. Geburtstag von Jean-Christophe
Ammann
acquired with generous grant by Karin
and Michael Thoma on the occasion
of Jean-Christophe Ammann's sixtieth
birthday

2 Moderne Malerei No. 6 (intim)
1997
Öl auf Leinwand oil on canvas
61,1 x 91,2 cm
Museum für Moderne Kunst, Frankfurt
am Main
Schenkung des Künstlers gift from
the artist

5 Interieur No. 274, 2004
Öl auf Leinwand oil on canvas
94,5 x 314,5 cm
Leihgabe des Künstlers
courtesy of the artist

**6 Sonnenbadende mit erotischem
alte Maler Traum**, 2005
Öl auf Leinwand oil on canvas
94,5 x 126,5 cm
Leihgabe des Künstlers courtesy of
the artist

3 Blumenstilleben No. 254, 2004
Öl auf Leinwand oil on canvas
157,5 x 126 cm
Museum für Moderne Kunst, Frankfurt
am Main
Erworben mit großzügiger Unterstützung
von acquired with generous grant by
Karin und and Michael Thoma, Frankfurt
am Main

7 Pin-up No. 78, 2003
Öl auf Leinwand oil on canvas
141 x 94,3 cm
Leihgabe des Künstlers courtesy of
the artist

4 In den Dünen No. 2, 1996
Öl auf Leinwand oil on canvas
214 x 183 cm
Museum für Moderne Kunst, Frankfurt
am Main

**8 Badende im Gegenlicht No. 6
(Strandbad Wannsee)**, 2001
Öl auf Leinwand oil on canvas
161 x 224 cm
Museum für Moderne Kunst, Frankfurt
am Main
Erworben mit Hilfe der NASPA-Stiftung
„Initiative und Leistung" und einer
Privatspende von Cornelia Morgenstern

acquired with generous grant by NASPA-Stiftung „Initiative und Leistung" and donation by Cornelia Morgenstern

 9 ABENDLIED 21.45 UHR, 2005
Öl auf Leinwand oil on canvas
40 x 30 cm
Leihgabe des Künstlers courtesy of
the artist

 10 ELLE, 1996
Öl auf Leinwand oil on canvas
183 x 153 cm
Museum für Moderne Kunst, Frankfurt
am Main
Erworben mit Mitteln aus einer Spende
von Karin und Michael Thoma zum
60. Geburtstag von Jean-Christophe
Ammann
acquired with generous grant by Karin
and Michael Thoma on the occasion
of Jean-Christophe Ammann's sixtieth
birthday

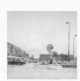 **11 SCHLOSSPLATZ BERLIN-MITTE**, 1997
Öl auf Leinwand oil on canvas
280,4 x 299,8 cm
Museum für Moderne Kunst, Frankfurt
am Main
Schenkung des Künstlers gift from
the artist

 **12 KOMPOSITION MIT KÖNIGSBERGER
KLOPSEN, SENFGURKEN, ROTE BEETE,
KARTOFFELN, WASSERMELONE UND
ZITRONENSAFT, RHEINGAURIESLING UND
GROSSEM BROWNIE**, 1995
Mischtechnik auf Leinwand
mixed media on canvas
184 x 258 cm
Museum für Moderne Kunst, Frankfurt
am Main
Erworben mit Mitteln aus einer Spende
von Karin und Michael Thoma zum
60. Geburtstag von Jean-Christophe
Ammann
acquired with generous grant by Karin
and Michael Thoma on the occasion
of Jean-Christophe Ammann's sixtieth
birthday

 13 BLUMENSTILLEBEN NO. 223, 2004
Öl auf Leinwand oil on canvas
50 x 40 cm
Museum für Moderne Kunst, Frankfurt
am Main
Erworben mit Mitteln der
acquired with generous grant by
Dornbracht Installation Projects®

 14 PIN-UP NO. 73, 2003
Öl auf Leinwand oil on canvas
50 x 90 cm
Leihgabe des Künstlers courtesy of the
artist

 15 STRANDLÄUFER OHNE BART, 2005
Öl auf Leinwand oil on canvas
125,5 x 141,3 cm
Leihgabe des Künstlers courtesy of the
artist

 16 ELLE NO. 2, 1996
Öl auf Leinwand oil on canvas
183 x 152,5 cm
Museum für Moderne Kunst, Frankfurt
am Main
Schenkung des Künstlers gift from
the artist

 17 ABENDLIED 21.05 UHR, 2005
Öl auf Leinwand oil on canvas
40 x 30 cm
Leihgabe des Künstlers courtesy of
the artist

 M1–6 MINTREX, 2004
Holz, Glas, Leuchtelemente, Kunststoff,
Silikon wood, glass, lighting elements,
synthetic material, silicone
92,5 x 52 x 50 cm
Leihgabe des Künstlers courtesy of
the artist

1S1–5 1-SITZER, 2005
Holz, Glas, Leuchtelemente, Kunststoff, Silikon wood, glass, lighting elements, synthetic material, silicone
64 x 117 x 90 cm
Leihgabe des Künstlers courtesy of the artist

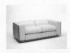

2S1–2 2-SITZER, 2005
Holz, Stahl, Leder, Schaumstoff, Daunenfedern wood, steel, leather, plastic foam, down feathers
64 x 187 x 90 cm
Leihgabe des Künstlers courtesy of the artist

3S1 3-SITZER, 2005
Holz, Stahl, Leder, Schaumstoff, Daunenfedern wood, steel, leather, plastic foam, down feathers
64 x 257 x 90 cm
Leihgabe des Künstlers courtesy of the artist

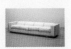

4S1 4-SITZER, 2005
Holz, Stahl, Leder, Schaumstoff, Daunenfedern
wood, steel, leather, plastic foam, down feathers
64 x 327 x 90 cm
Leihgabe des Künstlers courtesy of the artist

T1 OHNE TITEL UNTITLED (TISCH TABLE)
2005
Bootslack, Öl und Holz boat lacquer, oil and wood
180 x 75 x 50 cm
Leihgabe des Künstlers courtesy of the artist

T2 OHNE TITEL UNTITLED (TISCH TABLE), 2005
Bootslack, Öl und Holz boat lacquer, oil and wood
180 x 75 x 50 cm
Leihgabe des Künstlers courtesy of the artist

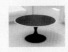

T3 OHNE TITEL UNTITLED (TISCH TABLE)
2005
Bootslack, Öl und Holz boat lacquer, oil and wood
Höhe height 46 cm, Durchmesser diameter 90 cm
Leihgabe des Künstlers courtesy of the artist

B1 OHNE TITEL UNTITLED (BIBLIOTHEK LIBRARY), 2005
Holz, Leuchtstoffröhren wood, fluorescent tubes
220 x 160 x 60 cm
Leihgabe des Künstlers courtesy of the artist

B2 OHNE TITEL UNTITLED (BIBLIOTHEK LIBRARY), 2005
Holz, Leuchtstoffröhren, Lederintarsie wood, fluorescent tubes, leather inlay
115 x 90 x 110 cm
Leihgabe des Künstlers courtesy of the artist

L1–6 KÜNSTLERLAMPE, 2005
Holz, Pergamin, Leuchtelement
wood, glassine, lighting element
50 x 55 x 30 cm; 55 x 70 x 50 cm;
75 x 85 x 30 cm; 50 x 80 x 60 cm;
60 x 80 x 70 cm; 50 x 100 x 60 cm
Leihgabe des Künstlers courtesy of the artist

31 Apotheotische Antiphrasen für Haus Esters

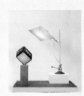

1 L'origine de la sculpture No. 2
2005
6 Gemälde Öl auf Leinwand, Holz,
Metall, Pappe, Leuchtelement
6 paintings oil on canvas, wood, metal,
cardboard, lighting element
280 x 278 x 205 cm
Leihgabe Sammlung Burger, Schweiz
courtesy of Burger Collection, Switzer-
land
Courtesy Arndt & Partner, Berlin

2 Exterieur No. 2, 2005
Acryl auf Holz acrylic on wood
160 x 160 x 90 cm (incl. Sockel pedestal)
Leihgabe des Künstlers
courtesy of the artist und and
Arndt & Partner, Berlin

3 Mintrex, 2005
Gelmatte, Holz, Glas, Leuchtelemente
gelmat, wood, glass, lighting elements
50,3 x 92,5 x 52 cm
Leihgabe Privatsammlung Grimm
courtesy of the Grimm private collection
Courtesy Arndt & Partner, Berlin

4 Haute Couture, 1996
Keramik, Papier, Epoxidharz, Holz
ceramics, paper, epoxy resin, wood
113 x 62 x 38 cm
Leihgabe aus Privatbesitz
courtesy of private collection

5 Blumenstilleben No. 294, 2005
Gips bemalt, Kunststoff, Holz
plaster painted, synthetic material,
wood
102 x 72 x 55 cm
Leihgabe Privatsammlung Grimm
courtesy of the Grimm private collection
Courtesy Arndt & Partner, Berlin

6 Exterieur No. 3, 2005
Acryl auf Holz acrylic on wood
110,5 x 160 x 90 cm (incl. Sockel
pedestal)
Leihgabe des Künstlers
courtesy of the artist und and
Arndt & Partner, Berlin

7 Mintrex, 2000
Holz, Glas, Leuchtelemente, Kunststoff,
Silikon wood, glass, lighting elements,
synthetic material, silicone
50 x 48 x 52 cm
Leihgabe aus Privatbesitz
courtesy of private collection

8 L'origine de la sculpture, 1996
Keramik, Reproduktion, Epoxidharz,
Holz
ceramics, print, epoxy resin, wood
55 x 118 x 62 cm
Leihgabe aus Privatbesitz courtesy of
private collection

9 Exterieur No. 4, 2005
Acryl auf Holz acrylic on wood
209 x 145 x 55 cm
Leihgabe courtesy of Collección Es Arte
Deleitosa, Madrid, Spain
Courtesy Arndt & Partner, Berlin

10 Mintrex, 2000
Holz, Glas, Leuchtelemente, Kunststoff,
Silikon wood, glass, lighting elements,
synthetic material, silicone
50 x 48 x 52 cm
Leihgabe aus Privatbesitz courtesy of
private collection

11 Silicon Plains No. 1, 2005
Holz, Silikon wood, silicone
103 x 40 x 40 cm
Leihgabe des Künstlers
courtesy of the artist und and
Arndt & Partner, Berlin

12 Oel auf Leinwand, 2005
Öl auf Leinwand oil on canvas
179,5 x 62 x 51,5 cm
Leihgabe Privatsammlung courtesy of
private collection Frankfurt am Main
Courtesy Arndt & Partner, Berlin

13 Söhnel, 2005
Glas, Epoxidharz, Insekten, Keramik,
Holz, diverse Materialien
glass, epoxy resin, insects, ceramics,
wood, various materials
180 x 45 x 50 cm
Leihgabe Privatsammlung courtesy
privat collection Guadalajara, Mexico
Courtesy Arndt & Partner, Berlin

14 Mintrex, 2005
Holz, Glas, Leuchtelemente, Kunststoff,
Silikon wood, glass, lighting elements,
synthetic material, silicone
50,3 x 92,5 x 52 cm
Leihgabe des Künstlers
courtesy of the artist und and
Arndt & Partner, Berlin

15 Etcetera No. 1, 2005
Holz wood
Höhe height 115 cm, Durchmesser diameter 90 cm
Leihgabe courtesy of the Beth Rudin
DeWoody collection
Courtesy Arndt & Partner, Berlin

16 Mintrex, 2005
Holz, Glas, Leuchtelemente, Kunststoff,
Silikon wood, glass, lighting elements,
synthetic material, silicone
51,5 x 92,5 x 52 cm
Leihgabe aus Privatbesitz
courtesy of private collection

17 Exterieur No. 1, 2005
Acryl auf Holz acrylic on wood
140,5 x 45 x 50 cm
Leihgabe des Künstlers
courtesy of the artist und and
Arndt & Partner, Berlin

18 Mintrex, 2005
Holz, Glas, Leuchtelemente, Kunststoff,
Silikon wood, glass, lighting elements,
synthetic material, silicone
51,5 x 92,5 x 52 cm
Leihgabe aus Privatbesitz
courtesy of private collection

19 Globale Malerei No. 2, 2005
Wasserfarbe, Gips, Ton, Holz
water color, plaster, clay, wood
Durchmesser diameter 30 cm
Leihgabe Privatsammlung Grimm
courtesy of the Grimm private collection
Courtesy Arndt & Partner, Berlin

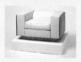

20 Arbiter, 2005
Holz, Stahl, Leder, Schaumstoff,
Daunenfedern wood, steel, leather,
plastic foam, down feathers
64 x 118 x 90 cm
Leihgabe des Künstlers
courtesy of the artist und and
Arndt & Partner, Berlin

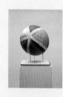

21 Globale Malerei No. 1, 2005
Öl, Gips, Ton, Metall, Holz
oil, plaster, clay, metal, wood
Durchmesser diameter 25 cm
Leihgabe courtesy of the Rosetta
collection, Amsterdam
Courtesy Arndt & Partner, Berlin

22 Portrait No. 58, 2005
Öl auf Leinwand oil on canvas
50,3 x 40,2 cm
Leihgabe aus Privatbesitz
courtesy of private collection

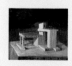

23 Ohne Titel Untitled, 2003
Öl auf Leinwand oil on canvas
78,5 x 94 cm
Leihgabe aus Privatbesitz
courtesy of private collection

24 PORTRAIT NO. 56, 2005
Öl auf Leinwand oil on canvas
60 x 50,3 cm
Leihgabe aus Privatbesitz
courtesy of private collection

25 BLUMENSTILLEBEN NO. 289, 2005
Öl auf Leinwand oil on canvas
40,2 x 40,4 cm
Leihgabe Privatsammlung D. und A. R.,
Schweiz courtesy private collection D.
und A. R., Switzerland
Courtesy Wohnmaschine, Berlin

26 STILLEBEN MIT FRÜCHTEN NO. 13
2003
Öl auf Leinwand oil on canvas
40 x 70 cm
Leihgabe aus Privatbesitz
courtesy of private collection

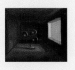

27 BLUMENSTILLEBEN NO. 288, 2005
Öl auf Leinwand oil on canvas
50,3 x 60 cm
Leihgabe aus Privatbesitz courtesy of
private collection Amsterdam
Courtesy Wohnmaschine, Berlin

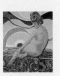

28 BEAUTY IN THE EYE OF THE BEHELD
2005
Öl auf Leinwand oil on canvas
188,7 x 157 cm
Leihgabe aus Privatbesitz courtesy of
private collection

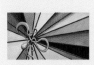

29 BLUMENSTILLEBEN NO. 295, 2005
Öl auf Leinwand oil on canvas
144 x 262,2 cm
Leihgabe aus Privatbesitz courtesy of
private collection London
Courtesy Wohnmaschine, Berlin

30 QUADRINOM NO. 1, 2005
4 Gemälde Öl auf Leinwand, Holz,
Metall, Leuchtelemente
4 paintings oil on canvas, wood, metal,
lighting elements
268,5 x 257,5 x 153,5 cm

Leihgabe Sammlung Essl Privatstiftung,
Klosterneuburg, Wien
courtesy of the Essl collection, private
foundation, Klosterneuburg, Vienna
Courtesy Arndt & Partner, Berlin

31 INTERIEUR NO. 294, 2005
Öl auf Leinwand oil on canvas
140 x 460 cm
Leihgabe Sammlung Sanders courtesy
of the Sanders collection, Amsterdam
Courtesy Arndt & Partner, Berlin

32–33 MINTREX, 2005
Holz, Glas, Leuchtelemente, Kunststoff,
Silikon wood, glass, lighting elements,
synthetic material, silicone
51,5 x 92,5 x 52 cm
Leihgabe aus Privatbesitz
courtesy of private collection

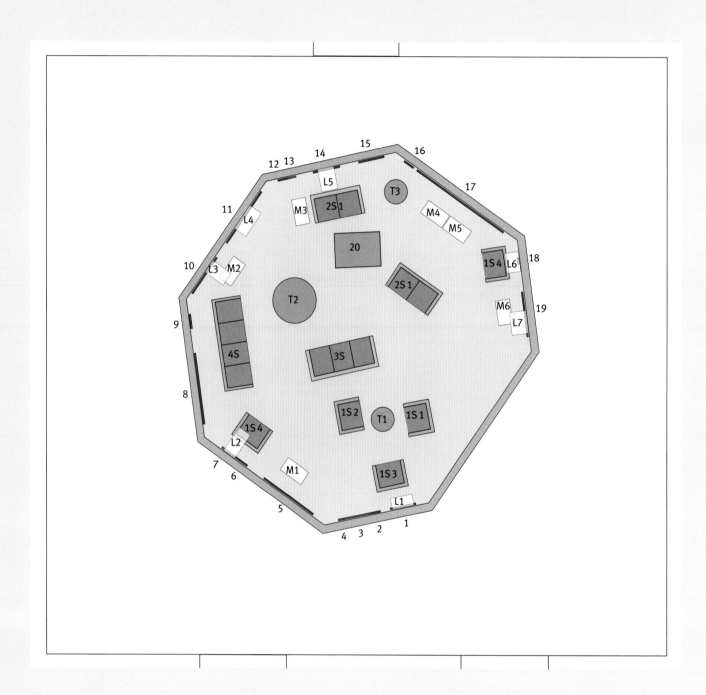

Oktogon für Herford

Die Skulptur OKTOGON, 2005 ist Leihgabe des Künstlers
The sculpture OKTOGON, 2005 is on loan from the artist

 1 Pin-up No. 77, 2003
Öl auf Leinwand oil on canvas
141 x 94,3 cm

 2 Portrait No. 59, 2005
Öl auf Leinwand oil on canvas
50,3 x 40,2 cm

 3 Fliegen No. 4, 2003
Öl auf Leinwand oil on canvas
125,5 x 157,3 cm

 4 Stilleben mit Früchten No. 29
2005
Öl auf Leinwand oil on canvas
30,1 x 24,3 cm

 5 Interieur No. 303, 2005
Öl auf Leinwand oil on canvas
188,7 x 220 cm

 6 Interieur No. 200, 2003
Öl auf Leinwand oil on canvas
78,8 x 109,5 cm

 7 Abendlied 21.15 Uhr, 2005
Öl auf Leinwand oil on canvas
40 x 30 cm

 8 Pin-up No. 68, 2003
Öl auf Leinwand oil on canvas
204 x 250 cm

 9 Blumenstilleben No. 239, 2004
Öl auf Leinwand oil on canvas
60 x 50 cm

 10 Ohne Titel Untitled, 2005
Öl auf Leinwand oil on canvas
129,3 x 154,3 cm

 11 Interieur No. 230, 2004
Öl auf Leinwand oil on canvas
188,5 x 220 cm

 12 Ohne Titel Untitled, 2005
Öl auf Leinwand oil on canvas
40,2 x 40,4 cm

 13 Blumenstilleben No. 296, 2005
Öl auf Leinwand oil on canvas
93,5 x 67,5 cm

14 Pin-up No. 71, 2003
Öl auf Leinwand oil on canvas
78,5 x 100 cm

 15 Ohne Titel Untitled, 2005
Öl auf Leinwand oil on canvas
125,8 x 94,3 cm

 16 Ohne Titel Untitled, 2002
Öl auf Leinwand oil on canvas
30 x 40 cm

 17 Interieur No. 298, 2005
Öl auf Leinwand oil on canvas
282 x 376 cm

 18 Blumenstilleben No. 232, 2004
Öl auf Leinwand oil on canvas
30 x 24,3 cm

19 Pin-up No. 92, 2004
Öl auf Leinwand oil on canvas
125 x 157 cm

20 Quadrinom No. 2, 2005
4 Gemälde Öl auf Leinwand, Holz,
Metall, Leuchtelemente
4 paintings oil on canvas, wood, metal,
lighting elements
234 x 170 x 122 cm

M1–6 Mintrex, 2004
Holz, Glas, Leuchtelemente, Kunststoff,
Silikon
wood, glass, lighting elements, synthetic material, silicone
92,5 x 52 x 50 cm

1S1–5 1-Sitzer, 2005
Holz, Stahl, Leder, Schaumstoff,
Daunenfedern
wood, steel, leather, plastic foam, down
feathers
64 x 117 x 90 cm

2S1–2 2-Sitzer, 2005
Holz, Stahl, Leder, Schaumstoff,
Daunenfedern
wood, steel, leather, plastic foam, down
feathers
64 x 187 x 90 cm

3S1 3-Sitzer, 2005
Holz, Stahl, Leder, Schaumstoff,
Daunenfedern
wood, steel, leather, plastic foam, down
feathers
64 x 257 x 90 cm

4S1 4-Sitzer, 2005
Holz, Stahl, Leder, Schaumstoff,
Daunenfedern
wood, steel, leather, plastic foam, down
feathers
64 x 327 x 90 cm

T1 Ohne Titel Untitled (Tisch table)
2005
Acryl auf Holz acrylic on wood
Höhe height 45 cm, Durchmesser diameter 90 cm

T2 Ohne Titel Untitled (Tisch table)
2005
Acryl auf Holz acrylic on wood
Höhe height 45cm, Durchmesser diameter 161 cm

T3 Ohne Titel Untitled (Tisch table)
2005
Acryl auf Holz acrylic on wood
Höhe height 36 cm, Durchmesser diameter 91 cm

L1–7 Künstlerlampe, 2005
Holz, Pergamin, Leuchtelement
wood, glassine, lighting element
60 x 50 x 80 cm; 70 x 60 x 80 cm;
60 x 50 x 100 cm; 40 x 100 x 50 cm;
50 x 80 x 40 cm; 50 x 60 x 80 cm;
60 x 70 x 50 cm

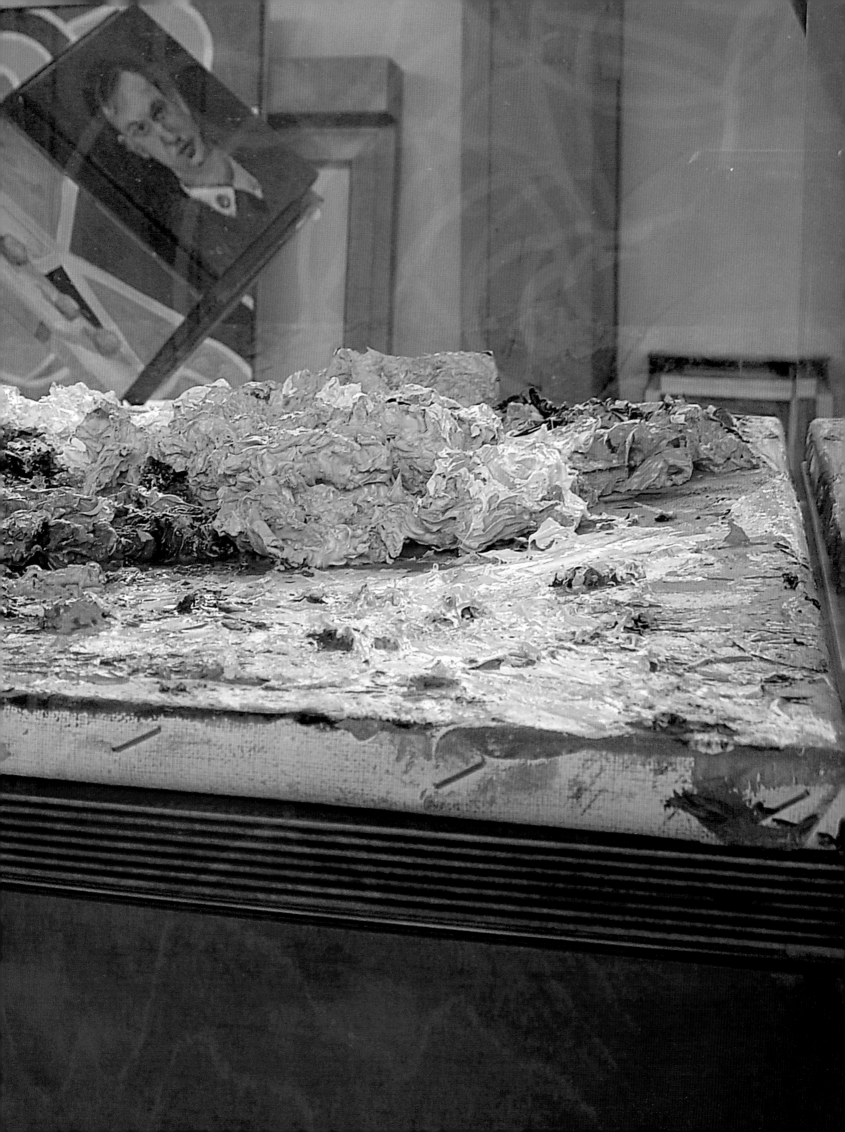

Biographie Biography
Bibliographie Bibliography

Anton Henning

1964 geboren born in Berlin
lebt lives in Berlin und and Manker

Einzelausstellungen Auswahl
Solo exhibitions selection

2005
OKTOGON FÜR HERFORD, MARTa Herford
31 APOTHEOTISCHE ANTIPHRASEN FÜR HAUS ESTERS,
Museum Haus Esters, Krefeld
27 ÜBERWIEGEND RECHT GELUNGENE SKULPTUREN, Arndt &
Partner, Berlin
RETOUR DE LA CONFÉRENCE, Wohnmaschine, Berlin
SANDPIPERS, LIZARDS & HISTORY, Haunch of Venison,
London
FRANKFURTER SALON, Dornbracht Installation Projects®
2005, Museum für Moderne Kunst, Frankfurt am Main

2004
ELF FAST MAKELLOSE MALEREIEN, Galerie Bob van Orsouw,
Zürich

2003
SCRUMMAGE, Vous Etes Ici, Amsterdam
WAS IHR WOLLT!, Christopher Grimes Gallery, Santa
Monica
SALON, Arndt & Partner, Berlin
SOMMERTAGSTRAUM, Wohnmaschine, Berlin
ZIEMLICH SCHÖNE MALEREIEN, Kunstmuseum Luzern

2002
SURPASSING SURPLUS, De Pont Foundation, Tilburg

2001
INTERIEUR NO. 117, Städtische Ausstellungshalle am
Hawerkamp, Münster
INTERIEURS 2001, Vous Etes Ici, Amsterdam
INTERIEURS 2001, Wohnmaschine, Berlin
INTERIEUR NO. 97, Kunstverein Ulm
INTERIEUR NO. 79 & METABOLISM AT DUSK, Entwistle,
London

2000
NACH INDIEN, Galerie Andreas Schlüter, Hamburg

1999
THE MANKER MELODY MAKERS LOUNGE, Galerie für
Zeitgenössische Kunst, Leipzig
TOMORROW IS THE COOL, Galerie Eugen Lendl, Graz

1998
TOO MUCH OF A GOOD THING…, Kasseler Kunstverein;
Espace des Arts, Chalon-sur-Saône; Kunstverein Heilbronn

1997
SOME DAY MY PRINCE WILL COME, Galerie Wohnmaschine,
Berlin

1995
Soup, White Columns, New York

1990
New Work, University Art Museum, Oklahoma; Vrej Baghoomian Gallery, New York

1989
Photoüberarbeitungen, Galerie Hilger, Wien

Gruppenausstellungen Auswahl
Group exhibitions selection

2005
Schönheit der Malerei, Städtische Galerie Delmenhorst
Ergriffenheit, Kunstmuseum Luzern
Blumenstück. Künstlers Glück, Museum Morsbroich Leverkusen
(my private) Heros, MARTa Herford
Direkte Malerei/Direct Painting, Kunsthalle Mannheim

2004
Die Wirklichkeit in der Falle, Künstlerverein Malkasten, Düsseldorf

2003
Franz von Lenbach und die Kunst heute, Museum Morsbroich Leverkusen
Adieu Avantgarde – Willkommen zu Haus, Ludwig Forum Aachen
Ornament, Luitpoldblock, München

2002
La Biennale de Montreal, Montreal
The image in use, Künstlerhaus Palais Thurn und Taxis, Bregenz
Stories. Erzählstrukturen in der zeitgenössischen Kunst, Haus der Kunst, München
Bilder aus Berlin, Christopher Grimes Gallery, Santa Monica

2001
Kunst und Kur. Ästhetik der Erholung, Kunsthaus Meran
Fotografierte Bilder. Wenn Maler und Bildhauer fotografieren, Museum Bochum
Szenenwechsel XX, Museum für Moderne Kunst, Frankfurt am Main

Imagination – Romantik, Stadtmuseum Jena; Kunstmuseum Brunn; Galway Art Center
Das flache Land, Brandenburgische Kunstsammlungen Cottbus
Viel Spass. Aspect de la scène actuelle allemande, Espace Paul Ricard, Paris
playing amongst the ruins, Royal College of Art, London
Offensive Malerei, lothringer 13, München

2000
Malkunst, Fondazione Mudima, Mailand
Dia/Slide/Transperency, Neue Gesellschaft für Bildende Kunst, Berlin
One of those days, Mannheimer Kunstverein
Premio Michetti 2000, Museo Michetti, Francavilla al Mare
Ich ist etwas anderes. Kunst am Ende des 20. Jahrhunderts, Kunstsammlung Nordrhein-Westfalen, Düsseldorf
Szenenwechsel XVII, Museum für Moderne Kunst, Frankfurt am Main

1999
Colour me blind!, Württembergischer Kunstverein Stuttgart; Städtische Ausstellungshalle am Hawerkamp, Münster; Dundee Contemporary Arts
Fremdkörper – Fremde Körper, Deutsches Hygiene-Museum, Dresden
Missing Link, Kunstmuseum Bern
Szenenwechsel XVI, Museum für Moderne Kunst, Frankfurt am Main
De Coraz(i)ón, Tecla Sala, Barcelona

1998
Das Versprechen der Fotografie/The Promise of Photography. Die Sammlung der DG Bank, Haramuseum, Tokio; Kestner Gesellschaft, Hannover

1996
Surfing Systems, Kasseler Kunstverein

1992
Surface Tension, The Art Museum, Florida International University, Miami

Bibliographie Auswahl
Bibliography selection

2005
Schönheit der Malerei, Beauty of Painting. Ausst.-Kat. exhib. cat. Barbara Alms (Hg. ed.), Texte von texts by Barbara Alms, Jean-Christophe Amman, Annelie Pohlen, Städtische Galerie Delmenhorst, Bremen 2005.

(my private) Heroes. Ausst.-Kat. exhib. cat. MARTa Herford, Bielefeld 2005.

Blumenstück Künstlers Glück, Vom Paradiesgärtlein zur Prilblume. Ausst.-Kat. exhib. cat. Texte von texts by Gerhard Finck, Gerhard Graulich, Alexandra Kolossa, Julia Lenz, Ute Riese, Museum Morsbroich, Leverkusen 2005.

Anton Henning, Sandpipers, Lizards & History. Ausst.-Kat. exhib. cat. Haunch of Venison, London 2005.

2004
Les vingt ans du CIAC. Centre international d'art contemporain de Montréal (Hg. ed.), Canada 2004.

Ten Years 1994–2004. Kat. cat. Arndt & Partner, Berlin 2004.

Made in Berlin. Messe Berlin GmbH; Weltkunst Verlag GmbH (Hg. ed.), Text von text by Zdenek Felix, München 2004.

Sammlung Plum. Ausst.-Kat. exhib. cat. Text von text by Roland Mönig, Museum Kurhaus Kleve 2004.

New German Painting. Ausst.-Kat. exhib. cat. Regina Art, Moskau 2004.

2003
Anton Henning, Ziemlich schöne Malereien. Ausst.-Kat. exhib. cat. Texte von texts by Jean-Christophe Ammann, Susanne Neubauer, Kunstmuseum Luzern 2003.

Adieu Avantgarde – Willkommen zu Haus. Ausst.-Kat. exhib. cat. Texte von texts by Martin Henatsch u.a. et al, Ludwig Forum, Aachen 2003.

Die ganze moderne Kunst über den Haufen zu werfen – Franz von Lenbach und die Kunst heute. Ausst.-Kat. exhib. cat. Museum Morsbroich Leverkusen, Köln 2003.

2002
Anton Henning, Surpassing Surplus. Ausst.-Kat. exhib. cat. Text von text by Dominic van den Boogerd, De Pont Foundation, Tilburg 2002.

Stories, Erzählstrukturen in der zeitgenössischen Kunst. Ausst.-Kat. exhib. cat. Stefanie Rosenthal (Hg. ed.), Texte von texts by Söke Dinkla, Christoph Hochhäusler, Thomas Jäger, Matías Martínez, Haus der Kunst, München, Köln 2002.

Thomas, Karin: Kunst in Deutschland nach 1945, Köln 2002.

2001
Bee, Andreas (Hg. ed.): Zehn Jahre Museum für Moderne Kunst. Museum für Moderne Kunst, Frankfurt, Köln 2001.

Kunst und Kur, Arte e Benessere. Texte von texts by Andrea Domesle u.a. et al, Kunsthaus Meran 2001.

Fotografierte Bilder, Wenn Maler und Bildhauer fotografieren. Ausst.-Kat. exhib. cat. Texte von texts by Beate Söntgen u.a. et al, Museum Bochum 2001.

Imagination – Romantik. Ausst.-Kat. exhib. cat. Jenoptik AG; Kulturamt (Hg. ed.), Texte von texts by Hanne Loreck u.a. et al, Jena 2001.

Das Flache Land, Positionen einer unspektakulären Sicht. Ausst.-Kat. exhib. cat. Perdita von Kraft (Hg. ed.), Brandenburgische Kunstsammlungen, Cottbus 2001.

Viel Spass, Aspect de la scène allemande actuelle. Ausst.-Kat. exhib. cat. Text von text by Charlotte Laubar, Espace Paul Ricard, Paris 2001.

Anton Henning, Interieurs 2001. Ausst.-Kat. exhib. cat. Texte von texts by Martin Clark, Hanne Loreck, Vous Etes Ici, Amsterdam; Wohnmaschine, Berlin 2001.

playing amongst the ruins. Ausst.-Kat. exhib. cat. Royal College of Art, London 2001.

OFFENSIVE MALEREI, MALEREI IM SPANNUNGSFELD NEUER
MEDIEN. Ausst.-Kat. exhib. cat. Texte von texts by Gernot J.
Gearman u. a. et al, lothringer 13, München 2001.

2000
Heidenreich, Stefan/Hoffmeister, Birgit (Hg. ed.):
MALKUNST. Berlin, Mailand 2000.

DIA/SLIDE/TRANSPARENCY, MATERIALIEN ZUR
PROJEKTIONSKUNST. Ausst.-Kat. exhib. cat. Texte von texts
by Claudia Lenssen u. a. et al, Neue Gesellschaft für
Bildende Kunst, Berlin 2000.

ONE OF THOSE DAYS. Ausst.-Kat. exhib. cat. Andreas Bee,
Martin Stather (Hg. ed.), Mannheimer Kunstverein 2000.

EUROPA, DIFFERENT PERSPECTIVES IN PAINTINGS. Ausst.-
Kat. exhib. cat. Michele Robecchi (Hg. ed.), Museo
Michetti, Francavilla al Mare 2000.

ICH IST ETWAS ANDERES, KUNST AM ENDE DES 20. JAHRHUN-
DERTS. Ausst.-Kat. exhib. cat. Kunstsammlung Nordrhein-
Westfalen, Düsseldorf, Köln 2000.

Lindner, Ute/Huber, Patrick (Hg. ed.): COPYRIGHT, NO. 2,
Gift, Berlin 2000.

1999
COLOUR ME BLIND! Ausst.-Kat. exhib. cat. Ralf Christofori
(Hg. ed.), Württembergischer Kunstverein Stuttgart;
Städtische Ausstellungshalle am Hawerkamp, Münster,
Köln 1999.

MISSING LINK, MENSCHEN-BILDER IN DER FOTOGRAFIE.
Ausst.-Kat. exhib. cat. Christoph Doswald (Hg. ed.),
Kunstmuseum Bern, Thalwiel, Zürich, New York 1999.

FREMDKÖRPER – FREMDE KÖRPER. Ausst.-Kat. exhib. cat.
Annemarie Hürlimann, Martin Roth, Klaus Vogel (Hg. ed.),
Deutsches Hygiene-Museum, Dresden, Ostfildern-Ruit
1999.

Lindner, Ute/Huber, Patrick (Hg. ed.): COPYRIGHT, NO. 1,
Copyright, Berlin 1999.

Christophori, Ralf: DAS SUCHENDE AUGE. (Faltblatt) Galerie
Wohnmaschine, Berlin 1999.

1998
DAS VERSPRECHEN DER FOTOGRAFIE, DIE SAMMLUNG DER DG
BANK. Ausst.-Kat. exhib. cat. Luminita Sabau (Hg. ed.),
Texte von texts by Ursula Prinz u. a. et al, Kestner
Gesellschaft, Hannover, München 1998.

THE PROMISE OF PHOTOGRAPHY, THE DG BANK COLLECTION.
Ausst.-Kat. exhib. cat. Texte von texts by Mario Kramer,
Atsuo Yasuda, Hara Museum of Contemporary Art, Tokyo
1998.

ANTON HENNING, TOO MUCH OF A GOOD THING... Ausst.-Kat.
exhib. cat. Texte von texts by Bernhard Balkenhol, Peter
Herbstreuth, Ellen Seifermann, Elke Grützmacher, Maïté
Vissault, Kasseler Kunstverein; Espace des Arts, Chalon-
sur-Saône; Kunstverein Heilbronn, Kassel 1998.

1996
KÖRPER & BETRUG. Ausst.-Kat. exhib. cat. Interview von
with Julian Scholl, Galerie Wohnmaschine, Berlin 1996.

SURFING SYSTEMS. Ausst.-Kat. exhib. cat. Kasseler Kunst-
verein, Kassel 1996.

ANTON HENNING. Ausst.-Kat. exhib. cat. Text von text by Eli
Gottlieb, Galería Ramis Barquet, Monterrey 1996.

1995
ANTON HENNING, SOUP. Ausst.-Kat. exhib. cat. Text von
text by Wolf-Günter Thiel, White Columns, New York,
Berlin 1995.

BILD-MALEREI. Ausst.-Kat. exhib. cat. Galerie Wohn-
maschine, Berlin 1995.

1994
TROIS PHOTOGRAPHES BERLINOIS. Ausst.-Kat. exhib. cat.
Text von text by Stefan Raum, Espace des Arts Chalôn-sur-
Saône, Berlin 1994.

GALERIE WOHNMASCHINE IN THE RUSSIAN ETHNOGRAPHIC
MUSEUM. Ausst.-Kat. exhib. cat. Galerie Wohnmaschine,
Berlin 1994.

1993
ANTON HENNING, VERGLEICHSWEISE KOMPATIBLE DNS ODER
OB DIE FLIEGE AUCH RICHTIG SITZT. Ausst.-Kat. exhib. cat.

Interview mit with Albrecht Kastein, Galerie Wohn-
maschine, Berlin 1993.

1992
AMERICAN ART TODAY, SURFACE TENSION. Ausst.-Kat. exhib.
cat. Text von text by Stephen Westfall, The Art Museum,
International University Florida, Miami 1992.

1991
ANTON HENNING. Ausst.-Kat. exhib. cat. Text von text by
Charles Merewether, Vrej Baghoomian Gallery, New York
1991.

1990
ANTON HENNING, NEUE ARBEITEN 1990. Ausst.-Kat. exhib.
cat. Text von text by Alan J. Hanson, Galerie Hilger, Wien
1990.

ANTON HENNING, NEW WORK. Ausst.-Kat. exhib. cat. Text
von text by Harry F. Gaugh, University of Oklahoma
Museum of Art; Vrej Baghoomian Gallery, New York 1990.

KORRESPONDENZEN, ZEHN KÜNSTLER AUS SCHWEDEN UND
BERLIN. Ausst.-Kat. exhib. cat. Texte von texts by Ursula
Prinz, Tomas Lindh, Boras Kunstmuseum; Berlinische
Galerie, Berlin 1990.

1989
ANTON HENNING, PHOTOÜBERARBEITUNGEN 1989. Ausst.-
Kat. exhib. cat. Text von text by Ursula Prinz, Galerie
Hilger, Wien 1989.

ANTON HENNING, ARBEITEN 1988/89. Ausst.-Kat. exhib.
cat. Text von text by Ernst A. Busche, Galerie Hilger, Wien
1989.

ANTON HENNING, BILDER UND ZEICHNUNGEN. Ausst.-Kat.
exhib. cat. Text von text by Jens Christian Jensen, Galerie
Heinz Holtmann, Köln 1989.

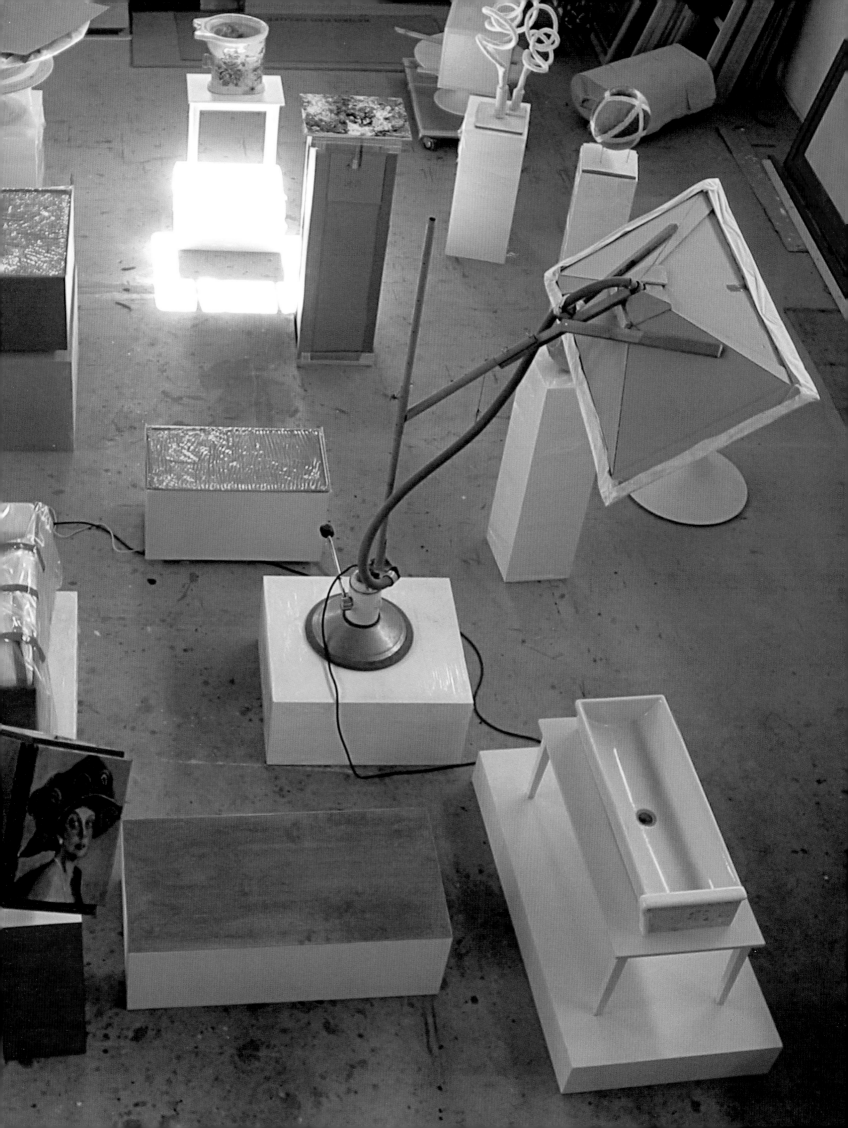

Impressum Colophon

Dieser Katalog erscheint anläßlich der Ausstellungen von Anton Henning: Frankfurter Salon im Museum für Moderne Kunst, Frankfurt am Main, 31 Apotheotische Antiphrasen für Haus Esters, Kunstmuseen Krefeld / Museum Haus Esters, Krefeld sowie Oktogon für Herford im MARTa Herford

This catalogue accompanies the exhibitions of Anton Henning: Frankfurter Salon at Museum für Moderne Kunst, Frankfurt am Main, 31 Apotheotische Antiphrasen für Haus Esters at the Kunstmuseen Krefeld / Museum Haus Esters, Krefeld and Oktogon für Herford at MARTa Herford

AUSSTELLUNGSDATEN EXHIBITION SCHEDULE

Seit 19. März 2005
since March 19, 2005
Museum für Moderne Kunst, Frankfurt am Main
Domstraße 10
60311 Frankfurt am Main
Tel.: +49 (0) 69 / 21 23 04 47
Fax: +49 (0) 69 / 21 23 78 82
mmk@stadt-frankfurt.de
www.mmk-frankfurt.de

30. Oktober 2005 – 29. Januar 2006
October 30, 2005 – January 29, 2006
Kunstmuseen Krefeld / Museum Haus Esters
Administration
Karlsplatz 35
47798 Krefeld
Tel.: +49 (0) 21 51 / 97 55 80
Fax: +49 (0) 21 51 / 97 55 82 22
kunstmuseen@krefeld.de
www.krefeld.de/kunstmuseen

29. Oktober 2005 – 8. Januar 2006
October 29, 2005 – January 8, 2006
MARTa Herford
Goebenstr. 4–10
32052 Herford
Tel.: +49 (0) 52 21 / 9 94 43 00
Fax: +49 (0) 52 21 / 99 44 30 18
info@marta-herford.de
www.marta-herford.de

AUSSTELLUNGSORGANISATION
EXHIBITION ORGANIZATION

Museum für Moderne Kunst, Frankfurt am Main
Udo Kittelmann [Direktor director]
Udo Kittelmann / Mario Kramer [Kuratoren curators]
Bernd Reiß [Logistik registrar]
Andreas Bee [Presse- und Öffentlichkeitsarbeit public relations]
Heike Andersen, Uwe Glaser, Andreas Janik, Johanna Piltz, Tobias Riemenschneider, Simon Schäfer, Götz Schauder, Stephanie Thielen [Ausstellungstechnik installation]
Ulrich Lang [Restaurator restorer]
Katja Schmolke [Verwaltung, Sekretariat administration, secretary]

Kunstmuseen Krefeld
Martin Hentschel [Direktor, Kurator director, curator]
Sylvia Martin [Co-Kurator co-curator]
Thomas Janzen [Bildung und Kommunikation education]
Marion Roggelin [Transport, Versicherung, Finanzen transport, insurance, finances]
Claus-Dieter Kraemer, Thomas Larisch, Abdul Razak Hakimi, Jürgen Schmitz [Ausstellungsaufbau exhibition installation]
Sebastian Köhler [Restaurator restorer]

MARTa Herford
Jan Hoet [Direktor director]
Michael Kröger [Kurator curator]
Ute Willaert [Ausstellungsmanagement exhibition management]
Friederike Fast [kuratorische Assistentin assistent to the curator]
Ulrike Goll / Julia Dornfeldt [Kuratorinnen Bildung und Kommunikation curators of education]
Nils Vandré [Presse- und Öffentlichkeitsarbeit public relations]
Michael Train, Hans Schröder [Ausstellungstechnik technicians]
Wolfgang Baumann, Gunther Grabe, Ulrich Graupner, Hassan Haider, Steffen Hülsmann, Thomas Meiswinkel, Sascha Meyerkort, Fabian Milz, Martin Mühlhoff, Malte Nies, Phillip Ottendörfer, Thorsten Rach, Dennis Sander, Fine Twele, Christian Vossiek [Aufbauteam installation team]
Julia Hartogs, Ellen Vogel [Verwaltung, Sekretariat administration, secretary]

KATALOG CATALOGUE

Herausgeber Editor
Martin Hentschel, Jan Hoet, Udo Kittelmann

Redaktion Editorial work
Martin Hentschel, Sylvia Martin

Übersetzungen Translations
Stefan Barmann, Köln (englisch english/deutsch german)
Malcolm Green, Heidelberg (deutsch german/englisch english)

Lektorat Proofreading
Thomas Krause, Moers

Fotografie Photography
Jörg von Bruchhausen, Berlin (Installationsansichten installation views MARTa Herford, Werkliste list of works, Studio Manker S. p. 133, 145, 153, 155)
Volker Döhne, Krefeld (Installationsansichten installation views Museum Haus Esters, Krefeld, Umschlagfoto cover photo)
Axel Schneider, Frankfurt (Installationsansichten installation views Museum für Moderne Kunst, Frankfurt am Main)
Martin Hentschel, Krefeld (Studio Manker S. p. 5, 145, 155)

Kataloggestaltung, Litho Catalogue Design, Lithography
Harald Richter, Hamburg

Printed and published by
Kerber Verlag, Bielefeld/Leipzig
Windelsbleicher Str. 166–170
33659 Bielefeld
Germany
Tel.: +49 (o) 5 21/9 50 08 10
Fax: +49 (o) 5 21/9 50 08 88
info@kerber-verlag.com
www.kerber-verlag.com

US Distribution
D.A.P., Distributed Art Publishers Inc.
155 Sixth Avenue 2nd Floor
New York, N.Y. 10013
Tel.: 001 212 6 27 19 99
Fax: 001 212 6 27 94 84

DANK THANKS

Die Ausstellungen in Krefeld und Herford und der Katalog wurden großzügig gefördert durch die Kunststiftung NRW.
Die Ausstellung in Frankfurt und der Katalog wurden großzügig gefördert durch Dornbracht Installation Projects®.
The exhibitions in Krefeld and Herford and the catalogue were generously supported by Kunststiftung NRW.
The exhibition in Frankfurt and the catalogue were generously supported by Dornbracht Installation Projects®.

KUNSTSTIFTUNG ➡ NRW

Dornbracht Installation Projects®

Anton Henning widmet das Buch seiner Familie und besonders seiner Frau Ingela-Toa Henning.
Anton Henning dedicates this book to his family and particularly to his wife Ingela-Toa Henning.

Sein besonderer Dank gilt:
Special thanks to:
Jean-Christophe Ammann, Matthias Arndt, Jörg von Bruchhausen, Alex Coles, Creixell Espilla,
Hans Gieles, Christopher Grimes, Angelika Guhs, Helmut Hahn, Dr. Martin Hentschel, Jan Hoet,
Udo Kittelmann, Dr. Mario Kramer, Dr. Michael Kröger, Friedrich Loock, Angelika Mattner,
Dr. Sylvia Martin, Michael Opitz, Bob van Orsouw, Jarek Pawlowsky, Christiane Pfennig, Harald
Richter, Christiane Ruppert, Hans Schröder, Graham Southern, Thorsten Tack, Karin und
Michael Thoma, Michael Train und allen Leihgebern and all lenders.